A MEXICAN FOLK POTTERY TRADITION

A MEXICAN FOLK POTTERY TRADITION

Cognition and Style in Material Culture in the Valley of Puebla

FLORA S. KAPLAN

Southern Illinois University Press CARBONDALE AND EDWARDSVILLE

A Mexican Folk Pottery Tradition: Cognition and Style in Material Culture in the Valley of Puebla is a revised and enlarged edition of the book originally entitled *Una tradición alfarera: conocimiento y estilo* by Flora S. Kaplan, published by Instituto Nacional Indígenista, Mexico, copyright © 1980 by Flora S. Kaplan

Designed by Edward D. King

Production supervised by Natalia Nadraga

Library of Congress Cataloging-in-Publication Data
Kaplan, Flora S.
 A Mexican folk pottery tradition : cognition and style in
material culture in the Valley of Puebla / Flora S. Kaplan.
 p. cm.
 Includes bibliographical references and index.
 1. Pottery, Mexican. 2. Folk art—Mexico. I. Title.
NK4031.K3 1994
738.3'0972'48—dc20 91-15267
ISBN 0-8093-1730-3 CIP

This book is dedicated to my family:

To Elizabeth and Jonathan, who accompanied me in the field

—*Mis buenos compañeros, siempre*!

CONTENTS

PLATES

FIGURES

TABLES

ACKNOWLEDGMENTS

I **wish to** acknowledge my debt of gratitude to the potters and crewmen of the barrios of La Luz and La Acocota and their families, who taught me with patience and humor to understand the tradition of pottery making.

The early interest and advice of Sr. Eugenio Pesquiera, Consul General of Mexico, New York City, and of Srta. Dolores Carrillo-Flores, Cultural Attaché, greatly facilitated my work in Mexico. Dr. Gonzalo Bautista O'Farríll, Governor of the State of Puebla at the time of my fieldwork, gave this investigation his personal attention and encouragement, for which I remain most grateful.

Alberto Beltrán has my warmest thanks for his enduring friendship. Srta. Laura Reynoso Fernandez chose to become my companion and assistant, which made the long afternoons in chilly churches a more bearable journey into the past.

The following persons in Mexico generously shared their knowledge and experience with me and made the services of their offices available at the time: Lic. Francisco Adame, Director of the Department of Crafts and Organized Cooperatives of the State of Puebla; Sr. Alberto Beltrán, Director of the Office of Folk Art, Department of Public Education, Mexico; Fernando Cámara, Assistant Director, National Institute of Anthropology and History, Mexico D.F.; Dr. Efraín Castro, Director, Puebla Institute of Anthropology and History; Sr. Eduardo Ganime, Director of the Department of Tourism, State of Puebla; Capt. Rodolfo Vernis, Director of Crafts, Municipality of Puebla; and Sr. Rubén Vidál, Director of the Organized Cooperative Bank of Puebla. I also thank: Senator Eduardo Cue Merlo and Sr. Abelardo Sánchez of the Puebla Moral and Civic Improvement Society; Dr. Peter J. Schmidt and Sra. Rauna De Larrauri of the German Foundation in Puebla; Dr. Carlos Espejel, Director of the Museum of Folk Art, Mexico D.F.; Dr. Barbara Dahlgren, Curator of Ethnographic Collections, National Museum of Mexico; Sr. Tonatiuh Gutierrez, Director, Organized Cooperative Bank of Mexico; and Dr. Leonard Manrique, Department of Linguistics, National Museum of Mexico. I am deeply appreciative to them all for their assistance.

Gerald I. Spielholtz, Department of Chemistry, Herbert H. Lehman College, The City University of New York (CUNY), and David M. Levine, Department of Statistics, Bernard M. Baruch College, CUNY, were consulted and provided technical expertise for the chemical analyses and statistical programs, respectively. Dennis Ischia, Senior Quantitative Analyst of the City of New York, made useful suggestions regarding data tabulation.

Henry Orenstein, Mervyn Meggitt, and Ronald Waterbury of The Graduate Center, CUNY, contributed valued advice; and Thomas H. Charlton generously made available comparative data from the Valley of Teotihuacán.

Special appreciation is due to Judith M. Treistman, Edgar Gregersen, and Eric Wolf for their advice and to Fernando Cámara, Dale Eickelman, and Howard Winters for reading earlier drafts. Marti Goldstein provided an initial editorial review. Isa Soto brought insight and dedication to the completion of the manuscript for which I am deeply grateful. Kathryn Koldehoff and Susan Wilson fortunately gave this manuscript their thoughtful and lucid editorial treatment.

INTRODUCTION

This work, a study of style in a Mexican folk pottery tradition, draws on several disciplines and techniques to deal with the description, classification, and interpretation of the pottery. It is motivated by a search for meaning in group style and for a replicable methodology for the systematic analysis and comparative study of style in material culture. Ethnology, archaeology, history, and linguistics have each contributed to the research presented here.

The study differs from most studies of Mexican folk pottery in that it focuses on an urban tradition of utilitarian ware in the city of Puebla de los Ángeles among full-time traditional craft specialists who are organized into workshops. It also differs in that it focuses on the pottery itself, its history, technology, materials, style, and meaning in the wider cultural and historical contexts. Other studies usually focus on more remote rural communities, based on family units of production and among part-time producers, and on the pottery as a means of looking at other aspects of the society, such as political, social, and economic organization or social change.

The ideas for this study of art style, of folk pottery, and of style and cognition are to be found in a personal and enduring affinity that I have for the *things* of culture, the tangible and visual manifestations of peoples' ideas and values. It began, I recall, on a fifth-grade class trip to the American Museum of Natural History in New York, where I was transfixed by the great Northwest Coast canoe, a paean to Boas's early collecting. The Indian oarsmen and the shamans at the bow in headdresses and patterned robes, amid boxes and carved and woven goods that filled the canoe, seemed to slice through the invisible waters of the 77th Street museum entrance hall, carrying those unknown persons to an undefined destiny in an eternal journey. It marked my entry into anthropology, although I did not know its name then. Later, at the Brooklyn Museum, in the Department of Primitive Art and New World Cultures (now the Department of Africa, Oceania, and New World Art), I curated collections from Siberia to Alaska, from the far north of the Americas to the tip of Tierra del Fuego, from Africa to the north and south of the Sahara, and from the Pacific. The experience in art and material culture during those seven years at the museum were joined to my curiosity about the diversity and similarity of human expression. When I considered doctoral research topics in 1969 at CUNY, Henry Orenstein was the most vocal in urging me to abandon an already-approved topic on Mexican migrant workers and to pursue questions of art, in detail, because of my museum experience. I decided to try. The results were subsequently accepted for publication in Spanish in 1976 by Alfonso Villa Rojas, then Director of the Instituto Nacional Indígenista (INI), and later published (1980).

When I first went into the field in 1971–1973, and then again in 1974 and 1979, the questions I had formulated were a combination of my studies in ethnology and archaeology, my interest in linguistic theory, and my intensive work with museum collections of art and material culture. Ethnoscience was of interest to many persons at that time and was related to my ongoing interests in classification and indigenous systems of thought. Some ethnographers were beginning to be attracted once again to the serious study of art and society, after a hiatus of some thirty years. In Africa (David and Henning 1972; Faris 1972) and in the Americas (Deetz 1965; Dethlefsen and Deetz 1966; Foster 1960, 1965; Friederich 1970; Glassie 1969; Lévi-Strauss 1964; Munn 1971; Turner 1967), some anthropologists were giving attention

to the past through the present. The archaeologists themselves led the way (Arnold 1971; Cowgill 1968; Hill 1967, 1968, 1970; Mateson 1965; Muller 1966, 1971). These were individual initiatives not yet perceived as or organized around the rubric of ethnoarchaeology, which was to emerge (along with ethnohistory) in the late 1970s as a major new research direction. My study of Puebla domestic pottery was among those early researches that, at the end of the 1960s and the beginning of the 1970s, marked a renewed and respectable interest in material culture and art among ethnologists and that was informed by archaeology and history.

The concept of style is widely used in archaeology, ethnology, and art history, but it is often so vaguely defined that it is difficult to develop an empirical methodology for its study and to illuminate something of the creative and cognitive processes in human beings. These processes underlie problems of classification and typology in archaeology, group solidarity and social change in ethnology, and aesthetics and creativity in art history.

In this study, I describe a single functioning style of utilitarian folk pottery produced in Puebla, Mexico. My aims are to explicate the conditions in which creative and cognitive processes take place, provide the bases for a testable methodology, and thereby lead toward a more rigorously defined concept of style.

The ethnographic and ethnohistoric description of the Puebla pottery suggests that it expresses the identity and in some ways the ethos of a group of people. On the one hand, its emergence as a new pottery style following the Spanish Conquest may be seen in terms of colonialism and crown policy that, because of separatism and exploitation, served to heighten Indian consciousness and induce the potters to draw upon earlier elements that they incorporated into a new style. On the other hand, the florescence of the style in the nineteenth century, following independence from Spain, may be seen in terms of a new sense of national identity, which led to the fusion of formerly separate Indian and Spanish pottery traditions. Through distribution in space, the pottery extended this new sense of identity, and in both periods it served to define social relations between realigned groups in the region, as well as in the nation.

Several methods were developed and applied in the course of this study to test the following notions of style that arose from the ethnographic and ethnohistoric descriptions: that style conveys the ideas and feelings of a group and that style is not the by-product of technique and an innate creative impulse but a system that is held in the mind and shared and transferred through learning and interaction through time and space. Lin-

guistic models, especially emic analyses, were applied in the study of style in material culture. Statistical techniques, including cluster analysis and nonmetric multidimensional scaling, were also applied. The results support the notion of style as a system.

A single class of folk art was chosen for description: a black-on-red glazed utilitarian ware. The entire range of the ware was explored. Folk art was chosen, rather than ethnic or modern art, because folk art is, by definition, the traditional product of a group that is part of a complex society existing in nation-states. Consequently, it is relevant in terms of ongoing change in many parts of the world today. In contrast, ethnic art, one of several unsatisfactory terms for what has also been called *tribal* and *primitive* art, generally has been disrupted under the impact of outside contact and state formation and has been affected by tourist demand. In some instances, it appears to be in the process of being transformed into folk art as different ethnic groups are incorporated into newly formed or existing nation-states. Modern art, the product of individuals working in Western art-historical traditions in developed and developing countries, is generally idiosyncratic and international in character; and it presents too many variables for an initial study such as this one. Folk art was chosen for study because its traditional techniques of hand manufacture preserve a direct relationship between craftsman and medium; and group style, manifested in folk art, is relevant to problems associated with cognition and creativity since such a style is traditional by virtue of having been shared and transmitted over time.

Folk art, then, in the sense meant here, is essentially traditional in both its origin and its mode of production. In addition, it exists only in the context of a state or complex society. As Glassie has pointed out, material folk culture is traditional in origin and "nonpopular and nonacademic" in the nature of its production (1969:6). He uses *popular* to mean the elite and progressive aspects of culture, as well as of material culture (1969:4–5). I define the *visual arts* as those plastic and graphic forms elaborated beyond functional necessity through the skillful control of a medium to create an affect.

This definition means that the study of art is not limited only to decorative and ceremonial pieces and that material folk culture is not viewed solely as the product of isolated, small-scale communities. I define *folk* in terms of origin and mode of production to broaden the range of material culture that may be investigated; and, as Glassie points out, such a focus shifts attention away from both society as an entity and the system of exchange in determin-

ing what constitutes material folk culture (1969:6–7). Likewise, defining art as I have done here broadens the range of material that may be investigated and includes utilitarian pottery, made and sold for profit by urban potters, as folk art. Thus, folk art differs from ethnic and modern art by the skillful and established mode of executing traditional forms and designs in material culture, imbued with affect, within a state or complex society. For these reasons, folk art is of special interest with regard to the problems outlined in archaeology, ethnology, and art history.

Pottery was chosen as the medium for study because of its acknowledged importance in the reconstruction of culture history and because its plasticity imposes few physical limitations on the expression of a style. Utilitarian pottery was chosen because it is used and thrown away without having had much conscious importance attached to it. The rubbish heaps of the past and present are piled high with broken pottery, which was once used to cook and store food. Being functional and expendable, such pottery is less likely to be a vehicle for an individual's virtuosity and more likely to convey a group style. Utilitarian pottery tends to be conservative, exhibiting few changes in a given time period; and it has relatively simple variables for consideration in developing a methodology for the analysis of style.

Among urban potters in the city of Puebla, only the famed blue and white Talavera-style glazed earthenware, or majolica, has been described in detail (Cervantes 1939:I and II). The black-on-red glazed cooking pottery of the barrio of La Luz has not been the subject of intensive study until now. The description of the cooking pottery is as follows: the nature and extent of the community formed by the potters of black-on-red ware and its history (chapter 1); a detailed description and classification of the pottery and raw materials (chapter 2); an account of pottery making and the role of learning and specialization in the transmission of style (chapter 3); the patterns of present pottery distribution, the daily and ceremonial contexts of use, plus an analysis of symbolism in terms of form and design (chapter 4). The ethnography suggests that style in material culture is a system that embodies group identity and provides a basis for group action. A methodology was developed to test this suggestion (chapter 5). The test results are discussed in detail in the final chapter of this study.

A MEXICAN FOLK POTTERY TRADITION

1 A POTTERY TRADITION

St. Jeremiah was asked to make a washbasin.
But when he tried, he found the earth too dry,
and he could not work it. The saint began to cry,
and as he cried his tears fell upon the earth, wetting it.
With this water he found he could work the earth,
and he made the washbasin.

—*A legend concerning the origin of pottery
making in the barrio of La Luz, Puebla*

The potters and inhabitants of Puebla believe that their distinctive regional style of black-on-red glazed pottery originated centuries ago in the early days of the Spanish Conquest. *Loza poblana* or *loza corriente*, and *loza de La Luz*, or *loza colorada*, as it is known locally, is famous throughout the region and Mexico for its excellent cooking qualities and for its durability and lustrous appearance. It is intimately associated with the national dish *mole poblano*, a complicated and rich mixture of several kinds of roasted and ground chilies, chocolate, spices, and peanuts blended into a thick sauce for the traditional turkey, *guajolote*, or chicken. It is the quintessential festival dish, which must be cooked in pottery, preferably in *loza poblana*. So powerful are the associations called up by this pottery and the dishes associated with it, that once, while I was struggling to board a plane in Mexico City, trailing luggage, and a rather large mole pot, too large to pack at the last minute (a parting gift from the potters), I was given unexpected assistance from an airport attendant. Seeing the pot, he exclaimed, "Ah! Mole!" and rushed to locate a hand truck to load my things for me. All the while he talked, he smacked his lips and recalled aloud the succulent memories of past feasting and extolled the virtues of family and home. All of this was unleashed because of the sight of my large mole pot. I should add that such voluntary assistance, for which he refused payment, is rare in a culture where struggle goes largely unnoticed. *Viva Mole Poblano! Viva Loza Poblana!*

The pottery of Pueblas La Luz and La Acocota is red, plain, or decorated with black splashes and lines in crisscross patterns on a variety of types and sizes. Some decorative pieces made for gifts and for Easter are embossed with flowers and fish, names and sayings, *dichos*—like *Recuerdo de Puebla*; *Recuerdo de Gloria*; and others—emblazoned on the sides of large jars or on the bottoms of serving dishes to be displayed or hung on kitchen walls. The sizes range from very large to miniature: there are jars more than a meter high, to store water and hold *pulque* and flavored waters for fiestas; there are very large pots, more than a meter across to hold as many as three turkeys for mole. The miniatures are used as toys, in curing, and for display.

The methods of manufacture are essentially the kick wheel and the two-part mold, with potters specializing in one technique only. All black, highly glazed pottery is made on the wheel for *Todos Santos* (All Saints Day), celebrated from the end of October to early November each year; it is made and sold only in Puebla at this time, beginning in late August–early September by wheel potters who fire the ware in special kilns reserved for the purpose. These kilns stand unused for the remainder of the year. Miniatures are made for deceased children. They are painted pink and blue with flowers by special painters who come to Puebla for that purpose.

The Community of Potters

The potters of *loza de la Luz* work and live in two of the oldest barrios of the city of Puebla de los Ángeles. They share a sense of belonging and identity and act together as a group for religious festivals and rituals. They are native Spanish speakers, and most are literate, having had at least some education in the city's public school system. The potters number about 150 persons, including their helpers, most of whom are family members; others are hired but come from the barrios. They are not a *folk community* in Redfield's sense of the term (1941); they are instead full-time specialists

who produce for the market and for profit. The potters have always been part of the larger urban whole, citizens of the city of Puebla.

The potters constitute a community in that they occupy an area that is spatially defined, though not homogeneous, and they have a strong sense of group identity. They may be considered "folk" potters in that they produce traditional wares, using traditional techniques of manufacture, with forms and designs that originated centuries ago. Folk wares exist only in the context of state societies or complex cultures; they are neither popular nor academic and elite wares—they are traditional products. Black-on-red glazed cookware, then, is folk pottery, and the potters, folk potters.

I have chosen to focus on utilitarian pottery in this study of style for two reasons: first, because it constitutes the bulk of remains at archaeological sites; and second, because it constitutes the bulk of pottery in use in contemporary societies. Therefore, its study may increase our knowledge of technology; of craft specialization; and of social, political, and economic change; and it may enhance our understanding of the symbolic significance and "meaning" of folk pottery in society. It may also enhance our understanding of its persistence and resistance to change. Whereas folk pottery can disappear altogether under conditions of rapid change and industrialization, it can exhibit extraordinary tenacity in style and usage, which is only partly attributable to function and economics. Puebla folk pottery does cost less than the industrially produced cooking pots, but as I demonstrate, the ideas and values associated with the pottery and the ethos and the worldview that it reinforces and communicates are responsible for the remarkable continuity of this folk pottery over the generations and the centuries.

The number of potters engaged in manufacture today is gradually diminishing, and it is increasingly difficult for them to find places to live and work. Many people object to the smoke and heat of kilns in living compounds, especially as modern housing is replacing colonial compounds where pottery manufacture has been conducted until now. New materials, like plastics and enamels, are cheap, available, relatively unbreakable, and easy to carry. The children of potters, whose fathers, grandfathers, and great-grandfathers worked the clay, are being better educated; and many of them are finding jobs in factories, banks, and offices. The pottery tradition of generations is now being threatened by social and economic change.

Historical Background

Just when the black-on-red pottery style emerged was difficult to deter-mine. Historical documentation is scarce, and there has been virtually no historical archaeology of the city and its immediate environs.* Some pottery, dating to the fifteenth and sixteenth centuries, as well as to the colonial periods, from neighboring Cholula and Tlaxcala, have been classified but were not available for examination when I was in Puebla (Efraín Castro, personal communication 1973; Acosta 1971:6–7, 9, 12, 18; Marquina 1971:25–40; Müller 1971:41–42, 49, 50–59). Some connections might be made between well-established Precolumbian centers of manufacture, the Borgia group of codices, and pottery making in Puebla. We do know that many of the first Indians who came to work and settle in the new Spanish city of Puebla de los Ángeles (Carrión 1897 I:20–21) were from Cholula and Tlaxcala. Cholula, especially, was already renowned for its pottery when the Spaniards came ashore at Veracruz in 1519. An eyewitness to the Spanish Conquest, Bernal Díaz del Castillo, after giving an account of Indian treachery at Cholula during the Spanish march inland to the Aztec capital of Tenochtitlán (Mexico City), made the following observation: "the land is full of magueys from which they make their wine. They make very good pottery in the city of red and black and white clay with various designs and which supply Mexico and all the neighboring provinces" (Díaz del Castillo 1968:181).

Cholula was the major center of the famed Mixteca-Puebla ceramic tradition in the mesoamerican Central Highlands from A.D. 900 until the Spanish Conquest (Tolstoy 1974:58). Cholula was part of a long-lived pottery tradition in the Central Highlands. Evidently, black-on-red clay pottery was already widespread, as Díaz del Castillo observed. The mesoamerican pottery shapes appeared as early as 2300 to 2000 B.C. in the Tehuacán Valley, Puebla. These basic shapes are the following: a globular, restricted-mouth jar, *tecomate*; a flat-based pan or dish; a simple hemispherical bowl; and a necked jar, *olla* (see Figure 1-1). These shapes are still produced in black-on-red glazed ware, with some additions and modifications, and they are distinguished with assigned names as separate types in the potters' taxonomy.

The contemporary pottery of Puebla, however, is not simply a continuation of a Precolumbian tradition. The Spanish introduced their own earlier folk prototypes that, in both metal and ceramics, had originated in Spain and the Near East: ceramic pitchers, flower vases and pots, jars for wine and milk, and flat-bottomed cooking pots were among the forms produced. Some of these forms were made in molds. Spanish and Indian traditions

* Alberto Beltrán confirmed that the only prior work on La Luz is a brief description in a survey of Puebla pottery. (See Lameiras et al. 1968:92, 95–96, 100, 108, 112.)

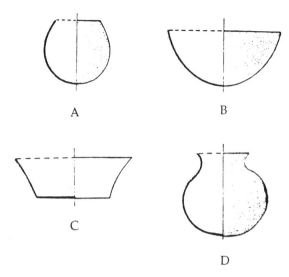

Figure 1-1. Earliest shapes of mesoamerican pottery. (A) *tecomate*, (B) simple hemispherical bowl, (C) flat-based pan or dish, (D) *olla* (after Tolstoy 1974:54).

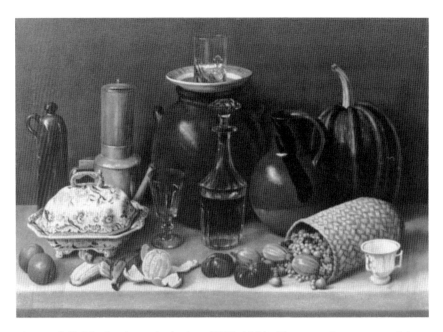

Plate 1. *Still Life*, by Agustín Arrieta (1809–1867). Photograph courtesy of the Museo José Luis Bello, Puebla, Puebla, Mexico.

combined in new ways in the centuries following the Conquest as the demand for cheap cooking pottery increased with the expansion of the city of Puebla.

Based on my own ethnohistoric research and on the existing historical accounts, it is likely that the Indians continued to use their own pottery after the Conquest, although we do not know exactly what the pottery looked like then. No historical archaeology of Puebla has been undertaken. Eighty kilometers north of Puebla, however, just outside Mexico City, excavations by Thomas H. Charlton in the Valley of Teotihuacán show that Aztec pottery types continued to be made well into the eighteenth century, alongside Spanish and modified Spanish pottery types (1972b). The earliest known hard evidence for the existence of the black-on-red Puebla pottery style is from the mid nineteenth century and was obtained while I researched collections of pottery in Puebla's museums. In the Museo Bello, I found two still-life paintings by Agustín Arrieta (1809–1867), a regional painter of some note (see Plate 1).

At first, the Spanish crown attempted to maintain separate spheres of Indian and Spanish manufacture and trade; it endeavored to protect and encourage Indian crafts and markets. The Indians were allowed to produce and trade freely among themselves, but the crown was unable to keep the two spheres truly separate. Enterprising Spaniards tried from the beginning to interfere with native trade and to take advantage of the lower prices of foodstuffs and goods. They bought directly from the Indians at a low price for resale to the colonists at a high price, or they simply took Indian goods by force (Gibson 1964:360, 399). From the beginning, too, entrepreneurs who owned Spanish ceramic workshops tried to bring Indian potters into their spheres of production and distribution. Other enterprising Spaniards engaged skilled Indian craftsmen to copy European products and then sold them as originals in competition with licensed Spanish producers (Gibson 1964:400). The Indians themselves competed with the Spaniards (Gibson 1964:399, 583–584). Actually, there were many conflicts regarding these practices from the sixteenth century onward (Gibson 1964:401).

Licensed Spanish producers in Mexico tried to meet the growing competition of unauthorized production by organizing guilds and restricting membership and supervisory positions to those either born in Spain or of Spanish parents (Cervantes 1939 I:12; Gibson 1964:399–401). In Puebla, Spanish workshops generally excluded Indians from using the wheel (Cervantes

1939 I:23), but those Indians who were employed there or who were manual laborers had ample opportunity to observe the potter's wheel in use and to see the technique of glazing pottery.

Both the wheel and glazing were unknown in the New World prior to their introduction by the Spaniards in the sixteenth century. One of the earliest documents extant with regard to glazed pottery in the New World concerns Indian efforts to thwart such attempted takeover by Spanish colonial potters. The document, dated April 23, 1583, was sent by the viceroy in Mexico City to the *alcalde mayor* (chief mayor) of Michoacán to tell him that supervisors (*veedores*) were being sent at the request of a group of Indian potters (*indios olleros*) to oversee the production of glazed plates and bowls in the town of Pátzcuaro (Cervantes 1939 I:18). The viceroy noted that the ware was made by Indians who "are not, nor have been, nor can be skilled workers in that craft" (Cervantes 1939 I:18). It appears that the Indians still had some collective identity at the time because they acted together as a group on behalf of the *indios olleros* in Pátzcuaro. The Indians clearly wished to be left in peace to produce for their own market or they would not have sought the protection of the viceroy in Mexico.

Potters of black-on-red glazed utilitarian pottery are concentrated in a six-block area of the city of Puebla in two of the oldest barrios, La Luz and La Acocota, on the east side of the city, which is considered the Indian side (Figure 1-2). Puebla de los Ángeles was founded by the Spaniards in 1531 as an agricultural settlement for landless Spaniards by the Second Audencia of New Spain. The site was located outside the Indian strongholds of Cholula and Tlaxcala, between three rivers: Alseseca, Almoloya, and Atoyác. The land had been left vacant as a result of a genocidal Indian war at the end of the fifteenth century. The war scattered even those few heads of households who remained alive out of an indigenous population estimated at 30,000. The new Spanish city was planned as a safehold and resting place for travelers of the main road from Veracruz, the seaport on the east coast, to the capital of the viceroyalty (Mexico City), in the Central Highlands.

At first, the city was located on the east bank of the Almoloya River, since renamed the San Francisco River by the friars who helped found Puebla. Within a few months, however, heavy rains and flooding forced the planners to shift the main site to the higher west bank. Here, on September 29, 1531, a central square and surrounding streets were laid out in a grid pattern. A regal cathedral and government buildings quickly transformed the west bank into the Spanish heart of the new city. The east

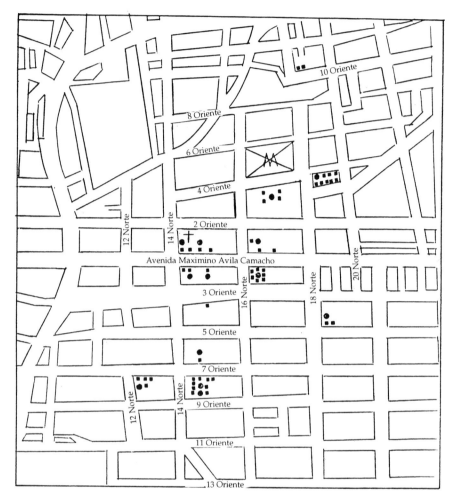

Figure 1-2. Detail of barrios showing locations of kilns and potters, Puebla, Mexico: *solid circles*, kilns; *solid squares*, potter (unit of production); *M*, market of La Acocota; *cross*, Church of Our Lady of La Luz.

bank became identified with the Indians and was the source of labor, crafts, and services. Charcoal makers, bakers, wool carders, leather tanners, animal tenders, and laborers who lit the fires, built the houses, wove the cloth, who generally provided food, shelter, and clothing for the ever-growing numbers of Spanish and European citizens, were concentrated on the east bank. The Almoloya or San Francisco River acted as a natural buffer

between east and west, between the Indian and the Spanish populations of the city. Small footbridges provided the only direct access from one side to the other. This east-west division has continued to characterize the city over the centuries. Not until 1965 were the dark sluggish waters of the San Francisco, which winds through the city, finally covered over—when the Boulevard of the Heroes of the Fifth of May was built—and the two sides of the city at last joined.

From the beginning, the city depended on Indian labor. An initial work force of 16,000 Indian men camped with their wives and children on the outskirts of the site, providing periodic service in construction. Early records show that religious leaders of the surrounding towns were responsible for sending men and supplies to the building site. Fray Luís de Fuensalida sent 8,000 Indians and building materials from Tlaxcala; Fray Diego de La Cruz sent 5,000 Indians from Calpa and Cholula along with supplies; and Fray Alonso Juarez sent 3,000 Indians and materials from Tepeaca (Carrión 1897 I:20–21). After their service, these original Indian workers returned home and were replaced by others, who continued the construction work. The pace of construction in the city increased in the seventeenth and eighteenth centuries, when most of the major buildings in Puebla were completed (Castro 1966:9–10).

The wives of the Indian laborers undoubtedly brought their cooking pots and other household goods with them. There was little reason for them to do otherwise. The staples of the Indian diet remained essentially the same: beans, chilies, and tortillas; fish, fowl, and meat cooked in sauces and stews; chocolate; a thin cornmeal gruel (*atole*) and the fermented juice of the maguey cactus (pulque) (Gibson 1964:322–323, 334, 348–349, 353, 356). Corn for tortillas, the staple of life throughout Mexico, is prepared today as it was before the Conquest. Maize kernels are soaked in lime and water in pottery jars (*ollas*) and the prepared kernels ground into flour on a three-legged stone surface with a stone roller (*metate y mano*); the tortillas are then toasted on a flat pottery plate (*comal*) over a fire. Some mechanization in the grinding of corn and the shaping of tortillas has been introduced in recent decades, and metal *comales* are in use. The metal vessels introduced by the Spanish were scarce and costly, putting them out of the reach of Indians for daily use and thus encouraging the colonists themselves to use available Indian pottery (Gibson 1964:354, 561; Véytia 1931 I:318).

Indian foods and their associated preparation techniques were continued and adopted by the colonists; traditional techniques of preparation and cooking tend to perpetuate the use of the pottery forms associated with them. In fact, women in present-day Puebla are still reluctant to cook Indian-style stews (moles) in modern pressure cookers and metal pots. Irrespective of social class, most women cook such dishes in traditional clay pots. Their families know and can differentiate the taste of food cooked in metal from that cooked in pottery vessels. Modern glass, metal, and enamel vessels, containers, and pots, as well as drinking glasses and cups, are associated with European foods and beverages. Traditional drinks of Indian origin, chocolate, *atole*, and pulque, are preferred in pottery jars.

At the beginning of my study of *loza poblana*, nearly everyone I met in the city tried to discourage me. "This is just ordinary cooking pottery," they said. Why did I not prefer to study the more important (i.e., prestigious) and refined Talavera ware? At the same time, it was apparent to me that everyone insisted this common pottery be used to prepare certain drinks and foods for rituals and celebrations, even for daily meals if certain dishes were cooked. Consciously, however, they ascribed little importance to it, being the stuff of daily life. The pottery was readily available in the barrios and markets; it was relatively inexpensive; and, I surmised, it was deeply rooted in Indian traditions that had low prestige value in some respects. The more they talked, the more convinced I became that I had made the right choice. Here was a traditional ware that had, apparently, a long history, that was widely used, that was emotionally regarded, and that was so deeply embedded in the culture that it was taken for granted and not self-consciously manipulated solely for tourists or display. It was, therefore, a perfect vehicle for a study of in-context group style.

In tracing the history of this pottery style (and I had wished to go beyond contemporary description and analysis), I soon encountered several problems. The pottery was said to be many centuries old in Puebla; however, in the interviews and genealogies I collected, I found a time line in the mid nineteenth century. Evidence was lacking for the style's existence and manufacture before that time. There were no written records, deeds, transfers of property, or correspondence among the potters, who had been mostly nonliterate in the past. The problem is a familiar one to anthropologists. Some of us have begun to turn more and more to the records of travelers, missionaries, colonial officials, collectors, and dealers.

The one collection I had located in New York was temporarily housed in the American Museum of Natural History. This collection consisted of several dozen pieces with virtually no documentation, only the name of the person who collected them, now deceased, and the market or city where purchased. A similar situation obtained in Mexican museums. I investigated

the history of pieces used to decorate and furnish the famous kitchens of the Convent of Santa Rosa and the Casa de Alfeñique in Puebla. The pottery, directors and curators assured me, was very old, from the seventeenth and eighteenth centuries. But, beyond the name and number of each piece, there was no documentation of any kind in the catalog. When I later inquired about these vessels among the potters in the barrios where they were traditionally made, the potters were highly amused. The elder potters remembered that the wife of a former museum director had come down to the barrios in the 1930s and purchased all the pottery then, when the houses and convent were being refurbished.

My search was extended to ethnohistoric sources in municipal, local, and ecclesiastical archives, although I was initially unsure I would find anything. These searches did prove valuable in reconstructing a history of this pottery style, which otherwise seemed impenetrable. Together with fieldwork, these sources informed and enriched my eventual picture of colonial life and change among the potters. At the outset, I had no way of knowing the nature and extent of available archival material. It was desperation that drove me to the cold and dank recesses of the local churches and cathedrals. In the absence of archaeology in the city and of record keeping among the utilitarian-ware potters, plus a certain shallowness in the oral tradition, I turned to the historical records, documents, letters, and the like to glean what I could. My search and persistence were rewarded: there were records dating from the founding of the city, and they were in usable condition. The earliest records were fortunately the fullest and, so, were useful in reconstructing the history of the pottery and its makers.

In my search for the beginnings of utilitarian ware, I concentrated on the east side of the city, in the parish of Santo Angel in which the barrio of La Luz is located. This parish, historically identified with the Indians, was a major source of craft production in general. Elder potters point to a hill near the barrio on the outskirts of the parish as the ancient source of clay used to make this pottery. For these reasons and because I was convinced that the style had to have had its roots in the Indian past, my search was concentrated within the Indian side of the city. Use of the wheel, glazing in manufacture, and similarities of form between Spanish blue-and-white Talavera ceramics and black-on-red pottery all served to show that the style also had Spanish roots. The two ceramic traditions, Indian and Spanish, had doubtless been intertwined; and their relationship will only be fully understood after archaeological excavations of early manufacturing and home sites have been completed. Published and unpublished historical records lent support to my decision to concentrate the search on the east side of the city, the side associated with the Indian populations and crafts. A tentative outline of the development of black-on-red pottery style is presented here, although its origins still lie buried beneath the city streets of Puebla.

Development of Black-on-Red Ware

In the first 150 years following the founding of Puebla in 1531, Indians were drafted to help build the city. They may have used pottery purchased from nearby towns; they may have purchased pottery for daily use from traders and Indians who came to sell goods in the city; they may have used pottery that they had with them among their household items; or they may have obtained pottery in any or all of these ways. On-site manufacture existed as well, though cooking pottery may not have been manufactured in the city from its founding, and it may not have been of a style similar to black-on-red ware.

The majority of Indians brought into the city were employed in manual labor, in construction work, in personal service, in baking, and in weaving. They also made shoes, glass, soap, and charcoal; they tanned hides and tended animals. No evidence of pottery making before the seventeenth century exists in the church parishes where the manufacture of black-on-red ware is located. There are, however, data for Spanish potters—ownership papers of workshops and property, last wills and testaments, contracts for purchases—which simply do not exist for their Indian counterparts. Early census data lack detail. Likewise, early municipal records relating to Indians are scant. The archives of the Cathedral of Puebla contain the earliest records of births, deaths, and marriages for the entire city. From the end of the seventeenth century, only those who lived in the center of the city continued to be registered at the cathedral. The others were kept in local parishes. In the cathedral there are separate volumes for "Indians," "Negroes and Mulattoes," and "Spaniards." They reveal the pulse of a fast-growing city in the sixteenth and early seventeenth centuries, with the quickening flow of young men and women from the countryside, local rulers (caciques), orphans, widowers, and slaves, who married, begot children, and died.

Marriage records proved most revealing of social and economic change among potters. Up to the mid nineteenth century these records, both in the

cathedral and in the parishes, contain the following information for the partners: place of birth, residence at the time of marriage, legitimacy of birth, age, occupation, "racial" category (*casta*), and previous marital status (single or widowed). All information other than age was omitted if one marriage partner was previously widowed. In the cathedral volumes, the entries of Spanish marriages lack the detail of the records for Indians and for Negroes and mulattoes. Parish records note all entries in the same volume arranged chronologically according to year.

The outline that follows is based on all records examined and is consistent with historical events in Mexico. Changes in the status and function of potters, derived from marriage records, reflect broader changes in the society. These records enabled me to trace a tentative outline of the historical development of style in black-on-red ware.

The first reference to an "Indian" potter appears in the parish records of Santo Angel, in which the barrios of La Luz and La Acocota are physically located. The man, who used the wheel, called a *tornero*, was married in 1680 (Book 1, 1657–1699:10). Evidently, he was part of Spanish ceramic production because the potter's wheel, or the kick wheel, was unknown before the Conquest. Next, an Indian jar maker (*indio ollero*), Juan Diego, was married in 1683 (Book 1, 1657–1699:12). His designation by type of pots identifies him with Indian production.

In all important and early documents from the state of Michoacán, *indios olleros* are pitted against Spanish potters who, as early as 1583, were attempting to invade their spheres of production and exchange (Cervantes 1939 I:18). The same term, *ollero*, is used today for jar makers, specialists of black-on-red glazed ware in Puebla. They use two- and three-part molds for jars, comparable to Preconquest manufacture. The 1683 entry in the Parish of Santo Angel, Puebla, is the first piece of historical evidence, thus far, of Indian pottery making on the east bank of the (San Francisco) Almoloya River, in the vicinity of the present pottery-making barrios in Puebla (Book 1, Santo Angel, 1657–1699:12).

At about the same time, in 1681, in cathedral archives, an Indian potter, Diego Muñoz, a skilled potter of white ware (*oficial de lo blanco*), was married (Book 1, Cassamientos de los naturales, 1657–1681). In the same year, another Indian potter, Juan Salvador (*lozero*), was married. The general term *lozero* for his occupation gives no clue to the kind of ware he made. A volume of marriages of Negroes and mulattoes, from 1629 to 1699, includes only one potter, a mulatto slave, Agustín Melendez Ortíz. He married in 1687 (Book 1, 1629–1699). At this time, marriages recorded in the cathedral usually took place among those living in the center of the city on the west bank of the San Francisco River.

Lozero, the general term for potter, is found in entries of marriages among Spaniards, mestizos, Indians, Negroes, and mulattoes. It seems to have been applied to all potters, to those who used molds and the wheel, and to those who made bricks. The term, therefore, is revealing only when it is qualified. For example, *lozero de lo blanco* refers to a potter of white ware and *lozero de lo amarillo*, to a potter of yellow ware. These denote, respectively, manufacture of fine and ordinary Spanish ceramics. *Tornero*, the term for wheel potters, similarly denotes Spanish manufacture, since the potter's or kick wheel was unknown in the New World prior to its introduction by the Spanish in the sixteenth century. *Ollero*, the term for jar maker, refers to Indian manufacture using molds. *Manero*, one of the terms employed today for those who work by hand using molds, appears to be a new category: it was not found in church records. There was a reference, however, in an eighteenth-century document, in which Indians referred to themselves as hand potters (*lozeros de mano*) (Archives of the Municipality of Puebla, Document 22, 1797). Over time, there is clear and continuing association of hand manufacture and molds with Indians and of the wheel with the Spanish. Among present-day potters of black-on-red ware, an existing threefold division into jar maker (*ollero*), pot maker (*manero*), wheel potter (*tornero*) may be traced back to the separation between Indian and Spanish techniques and markets in the colonial period.

The virtual absence of entries for Indian potters in church records before the end of the seventeenth century seems to indicate little or no indigenous pottery making in the city until that time. It is possible that it was not reported, or perhaps it was practiced on a part-time basis; and it is also possible that pottery was made in another part of the city altogether. The latter was true of brick making, which was concentrated in the northwest part of the city, near the sources of sandy clay used in manufacture. The clays, sand, and other raw materials for utilitarian pottery, however, were obtained from within the Parish of Santo Angel, in Puebla, until about 1950. The kilns used to fire the pottery required installation and maintenance. It seems reasonable, therefore, to expect some evidence of the existence of craft activities in the parish records of Santo Angel—if pottery making was actively pursued in the parish before the late seventeenth century.

As noted earlier, the first reference to an Indian potter in the parish records of Santo Angel dates from 1680; he appears to have taken part in Spanish ceramic production (Book 1, 1657–1699:10). About the same time,

the first Indian potter was noted in the cathedral records. The next earliest entry is for an Indian jar maker, Juan Diego (*indio ollero*), who married in the parish in 1683 (Book 1, 1657–1699:12). It should be recalled here that an earlier reference to Indian potters (*indios olleros*) in Michoacán is dated 1583; they were clearly part of the Indian tradition and of the Indian sphere of production and exchange (Cervantes 1939 I:18). The same term for jar maker (*ollero*) is still used by those who make black-on-red ware in Puebla. These are specialists who use two-part and three-part molds to make jars (*ollas*). The 1683 entry in the parish of Santo Angel in Puebla constitutes the first piece of historical evidence uncovered thus far to establish Indian pottery making on the east bank of the San Francisco River in the present vicinity of the barrio of La Luz (Book 1, Santo Angel, 1683:12). Prior to this date, and in the absence of historical archaeology, when Indian manufacture began in the city and whether the style or styles first produced resembled present black-on-red ware remain uncertain.

In the parish of Santo Angel, from the latter part of the seventeenth century, marriage records always included potters. Between 1683 and 1699, 18 potters and 4 brick makers (*ladrilleros*) were married in addition to the jar maker. They were all living in what were apparently the "Indian" suburbs of the city that made up the parish: Yancuictlalpan and Huilocaltitlan. Bakers, metal workers, and those who made and sold charcoal were among the other Indian inhabitants of these suburbs. After the eighteenth century, there is no further mention of Yancuictlalpan and Huilocaltitlan in parish records.

Puebla historian Mariano Fernandez de Echevarría y Véytia (1718–1779), who wrote in the mid eighteenth century, mentions the suburbs, *arrabales*, as two of the four *tlaxilacalis* that made up the Parish of Santo Angel (1931:285). The four *tlaxilacalis* he lists are Xancuitlalpan (*tierra nuevo*, or new earth); Cuilocautlan (*paloma*, or dove); Xochititlan (*sobre flores*, or over flowers); and Tepetlapan (*tierra firme*, or solid earth). The spellings of the names differ from the parish records, but they refer to the same suburbs. Tepetlapan is the original name of the Avenida Maximino Ávila Camacho, which has been and still is the center of manufacture and distribution of black-on-red ware (Leicht 1934:449). The historian Francisco Véytia, writing in the mid 1700s, tells us that Tepetlapan was the source of fine clay, well suited for cooking pots and jars of common use. This cookware was sold throughout the kingdom because nowhere else was it made as well (1931:285). These claims are the same as those made for black-on-red cooking pottery today.

The distinctions between other clays and wares noted by Véytia in the mid to late eighteenth century closely resemble those made by potters today. He distinguishes a white clay used to make white ware or Talavera (1931:318). He also distinguishes a sandy clay used for making bricks, kilns, roof tiles, and pipes (1931:307). Of special interest to this study is Véytia's report of a glazed buff-color ware, made of fine black clay. This ware was made in factories on the east side of the city in the parish that adjoined Santo Angel. It was for everyday use, but Véytia's description of the delicacy of the clay, the fineness of the glaze, and the skill with which the pieces were fashioned would seem to indicate the use of the wheel and, therefore, Spanish manufacture (1931:318). When the clay source used for this pottery was exhausted, another clay produced a red ware (Véytia 1931:262).

Véytia makes no mention of factories connected with the production of common cooking pots and other needed vessels for daily use (*cazuelas y demás vasijas necesarias para el uso común*) (1931:285). Tepetlapan is mentioned only as the place where "they get fine clay" (*de donde sacan el barro fino*) (1931:285). This description by Véytia, made in the context of "Indian" suburbs where "they" get clay for a presumably distinct ware, suggests Indian manufacture. He does not note, however, the color of the common cookware.

The first mention of red ware (*loza colorada*) was found in marriage records of the Parish of Santo Angel at about the same time that Véytia reports the change from buff or yellow-toned ware, at the end of the eighteenth century (1931:262). These records initially referred only to mestizo and Spanish potters (*lozeros de colorada*) (Book 5, 1777–1805), which suggests that red ware was made on the wheel in Spanish workshops. Ordinances and records from 1796 to 1810 detail the formation of a new guild, the Guild of Potters of Red and Yellow Wares (*Gremio de Lozeros de Colorado y lo Amarillo*) (Archives of the Municipality of Puebla, Castillero 5, Tomo 227, Legajo 2689, fojas 51/280:295–330). Originally, when the guild of potters of white ware was founded in 1653, potters of yellow ware were included (Cervantes 1939 I:20). At that time, the guild's provisions called for a strict separation between fine ware (white) and ordinary ware (yellow) and between large jars, pots, vessels, and small jars (red)(Cervantes 1939 I:23). The provisions required each person to be examined by guild officials in only one type of ware. Apparently, those who made red ware were not included in the guild because there is no further mention of them until the end of the eighteenth century, at least in the parish records I examined. In the interim, from the mid seventeenth century, I could find no mention of their activities.

The first entry of an Indian potter of red ware is for Bernabél Antonio Romero, and he appears in the Archives of the Parish of Santo Angel in 1820 as *indio, lozero de colorada* (Book 7, 1817–1828:41). He was born in the city of Puebla and is an ancestor of one of my informants, a wheel potter of black-on-red ware. (Today's pottery is still called red ware [*loza colorada*] in the parish.) The same parish records from 1817 to 1828 contained other entries of interest to the history of the style. For example, in 1817 an Indian painter of pottery (*indio cocolero*) was married (Book 7:1). The term used to describe his occupation then, *cocolero*, is the same term used now for a particular black design: the *cocol* is a design applied to the exterior of large jars and to the interior of cooking pots. Two other entries, one in 1820 and one in 1823, made specific reference to Indians who glazed pottery (*indio vidriante*) (Book 7, 1817–1828:41, 55).

Within the 1817 to 1828 parish records, the record keepers made a change in the racial category they assigned to Indians. In this period, for the first time in the Parish of Santo Angel (in 1823), an Indian was called an American (*americano*) (Book 7:80). The practice continued until 1837 (Book 33, 1833–1840). Thereafter, anyone making pottery was called simply a potter (*locero*). The change in racial category, from Indian to American, also marked a change in craft specialization: the wheel came into increased usage among those formerly prohibited from using it. Adopting the general term for potter officially blurred all evidence of racial distinctions from the mid nineteenth century onward.

The change in racial categories in the pottery-making barrios reveals that the struggle for independence from Spain brought to the Indian population a new recognition of themselves as Americans, or really, as Mexicans. The same records reveal the emergence of the present-day style of black-on-red glazed pottery and the fusion of formerly separate Indian and Spanish production.

There is, however, some evidence that before the end of the eighteenth century a similar style existed among Indian and Spanish potters. In a document dated December 29, 1797, the Indians who used molds exclusively (*lozeros de mano*) made a formal protest to the viceroy against an attempted takeover of their style by guild potters who used the wheel. This is probably the most important document used in this study, as well as the most important for understanding the historical development of the present style of black-on-red glazed ware. The document is signed by two potters, Don Andrés de Molina and José Ramos, on behalf of the other Indians who did not know how to sign their names (*los otros no firman por no saben*) (Archives of the Municipality of Puebla, Document 22, 1797:10).*

They began their argument against the guild of red-ware potters by deprecating the skill needed for mold making. They said that, although the wheel was truly an "art" requiring a period of apprenticeship and examination, the use of molds is only an "honest job." Requiring them to be apprentices, they said, would be as ridiculous as requiring water sellers to serve first as apprentices. They declared themselves free agents in the manufacture and sale of mold-made pottery, which had been their heritage since "time immemorial" and by the laws of the Indies (1797:4).

Their reply to charges of inferior Indian workmanship contains revealing insights into the reasons for the attempted takeover and a picture of the style of the pottery in question. If Indian pottery is so inferior in quality, Molina and Ramos asked, why do the guild potters buy it, fire it, and sell it themselves (1797:8)? Why has no one noticed the poor quality until now, and why does it sell so well (1797:7)? The Indians rejected the guild's attempt to force them to sell only to the guild, rather than directly to the public. They also vigorously rejected the attempt to restrict the use of black designs (*el manchada de negro*) to guild members because they had always used these designs, it having been their custom (*habiendo como ha habido siempre uso de esto propio*) (1797:5). They denied that the black designs were made to attract "the vulgar taste of the consumer" who could not tell the difference between Indian mold-made pots and guild wheel-made pots (1797:61); they denied that the black designs hid defects of the pottery. If these accusations are true, they asked, why then do the guild potters want to use the same designs? The Indians suggested that the guild should supervise those potters who now use the wheel without being examined and leave the Indians in peace to use molds and continue in their accustomed ways (1797:10).

Evidently, the two techniques of production, the Spaniards' and the Indians', were distinct, but the products must have looked enough alike for the public to mistake one for the other. It appears that the Indian pots were outselling those of the guild, or at least they were selling to the extent that the sales of the guild potters were affected. Finally, it appears that the use of black designs on red pottery was well established among the Indians,

* This 1797 document, concerning a dispute over rights to use black designs on red pottery, strongly suggests that the style was already well established. However, no physical evidence exists at the present time comparable to the paintings of Agustín Arrieta.

as was the use of molds. These findings are relevant to the discussion of symbolism and group identity.

Red ware, or black-on-red ware as it is referred to in this study, became increasingly popular as the nineteenth century progressed. Its popularity was reflected in the numbers of potters found in the marriage records as the century drew to a close and in the increased numbers of workshops in the city. There were only six workshops making red ware in 1835; by 1910, there were 13 (Leicht 1934:449). The years of the "Porfiriato," the period when the dictator Porfirio Díaz controlled Mexico, from 1876 to 1880 and again from 1884 until the Revolution of 1910, were the years in which black-on-red ware reached its peak of popularity, which agrees with the recollections of elder potters: that the street where pottery making was concentrated, Avenida Maximino Ávila Camacho, was lined with workshops and kilns around the turn of the century. Then, they say, the streets nearby were filled with carts and burros loaded with pottery, which was sent to all parts of the world. "Then, people knew what Mexico was like!"

By examining local, municipal, and ecclesiastical archives, I was able to detect the emergence and florescence of black-on-red utilitarian pottery against a background of social, economic, and political change in Puebla. Separation and exploitation of the Indians by the Spaniards in the colonial period served to heighten and perpetuate Indian consciousness. Pottery and the native foods associated with it were at once a necessity and a subtle means of expressing an ancient heritage and an Indian identity. The pottery itself became widespread as colonists adopted native foods, ingredients, and techniques of preparation and cooking. With independence from Spain, after 1821, a new awareness of a common American identity served to forge the creation of Mexico as a nation. Economic and social change led to the fusion of formerly separate Indian and Spanish domestic pottery manufacture.

Studying these records gave me an insight into a puzzling story told to me by elder potters. They had told me they were taught to use the wheel by the Mexican hero Miguel Hidalgo. This was unlikely. The wheel was already known and widely used in Puebla long before Padre Hidalgo lived (1753–1811). To my knowledge, there is no clear evidence that Padre Hidalgo was ever actually in Puebla. Had he passed through Puebla on his march to Mexico City, it is unlikely he would have had the time to teach the Indians to use the wheel before he was executed in 1811. It is even more unlikely that he knew how to use the wheel. But Padre Hidalgo was deeply concerned for the welfare of the Indians. He adopted the symbol of the Virgin of Guadalupe as his standard in battle. And he began the fight for freedom from Spain and for equality among the social classes of Mexico. Thus, when the elder potters told me that "they" were taught to use the wheel by Miguel Hidalgo, they were really saying that he had set the Indian potters free to learn and had ended their state of racial segregation.

What is noteworthy here is that over time the pottery style itself does not appear to have undergone dramatic changes. Rather, elaboration of features, shapes, and sizes seems to have taken place, along with an increase in the number of pieces produced. The "meaning" of pottery, therefore, must be derived by us from a full consideration of the cultural and historical contexts in which it exists. The study of folk pottery must be guided by theories that extend and deepen our understanding of all artifacts in society. The deep roots of a folk tradition must be uncovered, where possible, through the energetic search of all available archival and historical materials. These efforts will contribute to an understanding of the meaning of pottery to a society, hence the value of its study and collection by museums.

Distribution of Pottery

We can look at the distribution of black-on-red glazed ware against the historical backdrop of the city of Puebla and the push-pull forces exerted on the population of the region by changing social conditions. After it was founded, its population kept pace with the rapid expansion of the city itself (Castro 1966:10). From a total of just 34 in 1531, the Spanish population reached 800 in 1570 (1966:8–9). The original Indian work force of 16,000 in 1531 had increased to 25,000 by 1618. The Indians lived in the barrios surrounding the center of the city (1966:9). Most of them had come from towns and villages within a radius of 25 km; they came in larger numbers from Tlaxcala and Cholula, from Xonaca, and according to church records, from Mixteca Alta and Mixteca Baja as well (Carrión 1897 I:20; Leicht 1934:70). By 1678 the total population of Puebla had reached 68,000, although what percentage of the total was Indian is not clear (Castro 1966:9).

The early and rapid growth of the city took place at a time when the Indian population of the Central Highlands was actually declining drastically. Owing to diseases of epidemic proportions, nearly six-sevenths of the indigenous population died out during the sixteenth and seventeenth centuries (Wolf 1959:195–197, 284). In this same period, the southern part of the state of Puebla, including the slopes of the volcano Malinche near

the city of Puebla, became deforested (Plate 2) (Castro 1973:25, 42; Gibson 1964:303–306). The wood was burned to make the lime needed for the new, elaborate gesso and gilt church altars. It is estimated that an entire forest was consumed just to make the main altar of the Cathedral of Puebla. Depopulation of Puebla and deforestation, with its attendant lack of groundwater and rainfall, were also accompanied by drastic social and economic changes after the Conquest (Gibson 1964:323–326, 334, 366). These conditions served to redistribute the Indians over the landscape and to push the labor force of the surrounding towns into the city (1964:242–245). The need for labor doubtless exerted as strong a pull in Puebla as it did in Mexico City; Spanish merchants, manufacturers, and homeowners competed with landowners for the existing labor supply (1964:230–231).

Toward the end of the eighteenth century, outbreaks of violence in the countryside increased because of armed seizures of lands, sporadic fighting, and homicides. A movement for independence from Spain grew steadily. The fight for independence erupted into open rebellion in 1810, when the famous "Cry of Dolores" (*Grito de Dolores*), the call to arms, was sounded by the aforementioned priest, Father Miguel Hidalgo, who marched with his army of farmers over the mountains to Mexico City. Even after independence was won in 1821, in Puebla fighting continued sporadically throughout the next three decades. Further disturbances shook the countryside before and after the arrival in 1865 of the Emperor Maximilian and his wife Carlota in Mexico (Sierra 1969:323–324). During the French Intervention, as this period is called, soldiers "recruited" men by seizing them at random in the countryside. This practice, plus continued fighting and increased banditry in the mid to late nineteenth century, served to push people either into the cities or into the hills for safety. The relative stability of

Plate 2. View of Puebla de los Ángeles, with the sleeping volcano Malinche rising majestically above the valley. The fourth-largest industrial city in the Mexico, with a population greater than 300,000, Puebla de los Ángeles was founded in 1531 by the Spaniards as a safe refuge on the overland route from Veracruz on the coast to the former Aztec capital of Tenochtitlán (Mexico City).

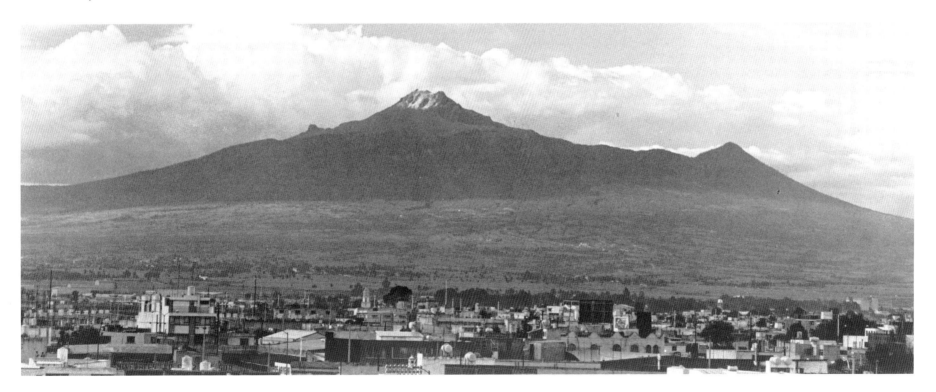

the "Porfiriato," which followed the French Intervention, lasted until the Revolution of 1910.

There had always been industry in Puebla (Castro 1973:24; Gibson 1964:354, 361). But a marked change in production took place with the opening of the first cotton mill, La Constancia, in Puebla in 1835, signaling the beginning of the industrial revolution in Mexico (Leicht 1934:115). Other mills were opened in the region through the latter part of the nineteenth century, creating several smaller urban centers within a 25-km radius of Puebla (1934:186–187). All of these urban centers attracted workers for wages. The region within this radius continues to expand as an urban industrial area today. A new industrial park in the northwestern part of the city of Puebla has brought several hundred million dollars (pesos) into the region with chemical plants, assembly plants, and other manufacturing factories. An extensive highway and road system now links these urban centers (Nutini 1970:84, 88).

The coming of the railroads to Puebla in the second half of the nineteenth century meant, among other things, faster and better distribution of pottery. Traders and potters loaded bundles of their wares onto trains and sold them at points along the train route. Pottery was sold to the sugarcane plantations, where it was given to migrant workers so that they could prepare their own meals. This practice continues in the cane fields of Izúcar de Matamoros and south (Agusto Jaen, personal communication 1972). With the twentieth century, buses have also been increasingly used for the distribution of pottery. Traders and potters pay a fee in addition to their own fares for each bundle of pottery loaded on top of the bus.

Earlier, before independence and the coming of the railroads, wheeled carts and animals were used to transport and distribute pottery. Most of the important routes that were used to and from the Valley of Mexico had been established long before the time of the Conquest. They were, however, enlarged and modified later (Gibson 1964:361). Thus, the distribution of pottery noted by the Spanish conquistador Bernal Díaz del Castillo in 1519 is not unlike the pattern that can be discerned today. Puebla continues to supply pottery to "Mexico and all the neighboring provinces" (Díaz del Castillo 1968:181).

Today, jars and all other cookware of black-on-red pottery are produced in the barrios of La Luz and La Acocota. Within this area are two centers of manufacture: La Luz, on Avenida Maximino Ávila Camacho, between 2 and 3 Oriente and 12 and 18 Norte; and La Acocota, from 2 to 6 Oriente and from 16 to 20 Norte. All the potters, however, think of themselves as residents of La Luz. They take their name from the Church of Our Lady of La Luz on the corner of 2 Oriente and 14 Norte.* In 1930, Avenida Maximino Ávila Camacho was lined with a dozen workshops. Today, in the two barrios, only four workshops are left (Figure 1-2).

Most potters are born, raised, married, and buried within these barrios. Of the 70 potters and 25 crewmen active in La Luz and La Acocota at the time of this study in 1971, 1972, and 1973, only four were not born in the barrios: two elderly men, who came to the city in the turbulent years following the Revolution of 1910; and two young men, who are from pottery-making families in neighboring towns and travel to the city each workday. However, young men between the ages of 18 and 25 or 30 often try their hand at other work or travel outside the city or state in search of adventure, before eventually returning to marriage, to the wheel, the molds, and the kilns of the potters' life. Since the 1970s, the number of rural migrants to the city has increased, but they have become squatters on undeveloped private lands northwest of the barrios. They have sought factory work. Few, if any, have turned to pottery making.

Each May, potters of black-on-red ware in both centers celebrate the Festival of Our Lady of La Luz, though there are no formal religious organizations among them. A month or so before the festival, one potter, a man with a reputation for being a sober and serious person, is asked by a group to collect money from others. He collects about 75 pesos from each potter to pay for the rockets and fireworks, flowers and paper streamers used to decorate the streets outside of the Church of Our Lady of La Luz. The streets fill with people; children clamor for rides on the little Ferris wheel set up at one side; the barbecued meats, sodas, and flavored fruit drinks are sold from small stands. At night the bare electric bulbs that light the stands illuminate the glazed blue, white, and yellow tiles of the church's facade, which seem to shimmer and dance along with the crowd. This area outside the church is set aside as the potters' domain; it is the "profane" area. Before 1930, when there were still many pottery workshops flourishing in La Luz and La Acocota, the potters decorated the streets with examples of their craft, and pottery was displayed along with food and drink for sale. The area inside the church is "sacred." The flowers, candles, and masses inside the church are paid for by the Catholic Action Society. The potters do, of course, take part in the sacred activities inside the church, but they do so strictly on an individual basis.

* The Church of Our Lady of La Luz was begun in 1767 and dedicated in 1805.

On the day of the festival, the streets are filled with people and the noise of fireworks and rockets, music and puppet shows, races and games. Young men compete with one another for the prizes donated by local merchants—shoes, clothes, money, and other items—contained in a barrel at the top of a greased pole in the middle of the street. The competition is similar to festivals held in Precolombian times, when young men scaled greased poles in honor of the goddesses of the earth and reproduction; the rewards for their bravery and devotion then were flowers, cloaks, and weapons.

According to elder potters, March 19, the Festival of San José, patron saint of the potters, was once observed in the workshops. But this was before the advent of gas stoves, enameled cookware, and modern cabinets led to a decline in pottery production, beginning about 1930. Then, there were still many patrons who employed a number of potters in the barrios. Employees were invited to hear mass, paid for by the patron, and they did no work that day. Many potters still have altars to San José in their workshops.

The way in which utilitarian potters work and live today, concentrated in the barrios in one section of the city, offers some interesting insights into the possible composition and organization of Preconquest urban craft specialization and workshops. Recent mappings of Indian cities at Teotihuacán, Uxmal, and Mexico City show patterned concentrations of craft specialists and workshops, which look on the ground remarkably similar to those found in Puebla. The dramatic changes that followed the Conquest, however, make generalizations from present to past overly simple. Neverthe-less, observable similarities coupled with ethnographic data do suggest possibilities for future research. For example, the following organization of labor is found in present-day Puebla. Employees who use molds work separately from those who use the wheel. Some rooms have only one wheel, while others may contain two to four wheels. Rooms used to make pottery in molds are often occupied by a single potter and may also be used to dry pottery on shelves against the walls or on the floor. The arrangement of rooms around a courtyard is the same for patrons who employ other potters, for the individual potters who work independently of each other, and for families of potters who cooperate and work together as a production unit.

The ethnographic study of these potters reveals that the physical arrangement of work space and specialization of craft production may not always reflect the social and economic relationships that exist among the potters. It is true that potters are concentrated in one section of the city. Homesites are interspersed with work sites in the building of housing and workshops, but these are not always the homes of the potters, who often live two or more blocks away from where they actually work. The spatial arrangements in the barrios reflect the division of labor and specialization among potters; they do not necessarily reflect the social and economic relationships among potters. The physical arrangement of space does reveal a concentration of potters within a delimited area of the city (Figure 1–2), a mix of homesites amid the work sites, though not necessarily those of the potters, and a division of labor based on existing specialization in the manufacture of the pottery.

2 THE POTTERY

I use several techniques here to analyze and describe Puebla domestic pottery from the outside observer's viewpoint; they represent some of the ways archaeologists have traditionally looked at and ordered pottery among the material remains of previously existing cultures. The techniques employed include the following: a typological schema; quantitative and qualitative analyses of the clays (D.C. arc emission spectroscopy, atomic absorption spectroscopy, and X-ray diffraction); and measurements of potters' types. While these techniques do not exhaust the available possibilities, they are frequently applied, and they yield data for comparison with other sites and with the cognitive systems of the culture bearers.

The measurements provide an objective basis for comparing the typological schemata devised and presented in this chapter with the typologies employed by Puebla potters. The qualitative and quantitative analyses, likewise, can be compared with the ordering of related schemata or with the ethnotaxonomy of clay and pottery within the culture. These data, together with the ethnography of this pottery tradition, offer insights into the relationships among systems of classification, cognition, and material culture with reference to style. These data are compared with the way in which potters in the barrios think and organize their behavior with regard to clays and the pottery they produce.

Since the early 1970s, investigators have been turning to ethnoarchaeology, applying detailed investigations, experiments, and observations to the behavior concerning artifacts among living peoples. They have been studying technology and manufacture, function and spatial distribution, use and wear patterns of individuals and groups, and social ordering of relationships relative to things, or artifacts. The results are refining and extending our interpretation of the past, the techniques and assumptions that have guided research, and in so doing, are extending our knowledge and generating meaningful questions.

Typological Schema

Where pottery remains are uncovered, archaeologists order or classify sherds into typologies. The sherds may either come from excavations or be collected as surface samples in field surveys. Whole or nearly whole pots are sometimes encountered or may be reconstructed from sherds, but they are rarely sufficient to form the basis of typology and measurement. They serve instead to corroborate and illustrate. Ethnoarchaeologists, however, have an expanding corpus of whole pots to classify and analyze. Their investigations can tell us much about distinctive features of typologies and about functions, uses, and distributions that cannot be inferred from or directly observed in the archaeological record. Other ethnographic research, such as this study of Puebla pottery, can focus on the systems of classification within a culture, as well as on the contexts, ideas, and meanings associated with the pottery. Utilizing ethnohistoric records, as I have done and which has been done increasingly in recent Mexican and mesoamerican research projects, supports and connects the prehistoric record with contemporary research. The various aims of archaeological and ethnoarchaeological investigations—such as identifying and interpreting the nature and extent of interaction among potters, potter communities, and others; the impact of social, political, and economic contact and change; and other questions—are addressed in this ethnography of Puebla pottery. These

questions are treated directly, historically, and ethnohistorically in chapters 1, 3, and 4. The results may inform future archaeological investigations and interpretations.

A primary aim of this chapter is to describe Puebla cooking pottery from an outside investigator's point of view and to compare some aspects of this description with the insider's ordering of pottery (chapter 5) in an effort to explore and understand better the nature of style posited here as a system of affective communication.

Puebla Typology

The pottery produced in Puebla constitutes a single, technical, stylistic unit. Potters throughout the barrios avail themselves of the same raw materials and techniques of manufacture, and they produce the same style of black-on-red glazed pottery. This unitary view of *loza poblana* is shared not only by the potters but also by the people of the region who use it. The people believe this pottery to be superior to others manufactured elsewhere in Puebla and Mexico; they consistently pay higher prices for it wherever it is sold. The pottery is valued for its appearance and for its being well fired and durable and is known by the names of the city and the barrios where it is made. People's use of names reflects their degree of participation and identification with the style. For example, *loza poblana* is the term most widely used throughout Mexico, the region, and the neighboring towns and villages by people who know, use, and recognize the style. *Loza de La Luz* and *loza de La Acocota* are barrio names indicating greater proximity and closer association with the pottery; they denote regular users and people from the city and its environs. The most generic terms used are *loza colorada* and *loza corriente*, and they indicate considerable distancing from this style and its usage; these terms are also applied to glazed utilitarian folk pottery produced in different styles and types (usually also of red ware) by various ethnic communities and in other geographic regions.

Loza poblana is described on the basis of selected attributes that are frequently employed in setting up typologies. These attributes are observable characteristics, and they are assumed to reflect overt behavior patterns (though not necessarily native cognitive categories). The typology devised is synchronic and descriptive. The attributes that form the basis of the typology of black-on-red glazed ware, if subjected to statistical analysis as Spaulding proposed some time ago (1953:305), would yield, it is assumed, comparable "types" based on a "consistent assemblage" of attributes. This assumption

is based on the abundant archaeological literature that reports research using similar attributes and appropriate statistical techniques. From Tylor (1889), Kroeber (1940), Krieger (1944, 1960, 1964), and Ford (1954), to the present day (Read 1974; Whallon 1972; and so on), all investigators have treated *types* as clusters of attributes that are significantly associated (Read 1974:241) to establish the validity of typological schemata. The search for significant associations applied to an increasing number of questions, including but not limited to typology, and the varied and sophisticated statistical techniques made possible through computer applications indicate that this approach continues to be a useful and central concern of archaeology. Notwithstanding, the selection of any attribute must be seen as the product of the investigator's perception and judgment, taking current and accepted disciplinary practice into account (aside from the methods used to measure the attributes) and the "objectivity" of the methods themselves.

Based on the variables of shape (Table 2-1), rim form (Table 2-2), and ear form (Table 2-3), Table 2-4 outlines a typology of Puebla black-on-red glazed pottery. With some additions and modifications, the terminology follows Shepard's general system of shape classification, which is based on geometric solids as reference norms for vessel description (1956:228, 233–235, 245). I have given consideration to ear form (Table 2-3) because of my observations of whole pottery in the ethnographic corpus and following Deetz's archaeological data and results (1965), which reflect the hitherto overlooked importance of ears as variables. Puebla black-on-red glazed pottery is a single ware that uses color and finish as distinguishing criteria. It is further subdivided by technique of manufacture, wheel-made and mold-made pots being separately classified.

Examination of Table 2-4 shows an apparent overlap of variables in some instances (types 1AM, 1BW, and 1CW: 1Aa #1; 1Ca #1; 1Cb #1; 1Cc #1, #3). Closer examination shows that, in the first instance, 1AM: 1Aa #1, the ellipsoid restricted independent composite shape, occurs only in one wheel-made vessel; in the second instance of overlap, 1Ca #1; 1Cb #1, the direction and shape of the ears, common to mold-made and wheel-made jars, are linked together, though they are shown as separate variables. In the third instance of overlap, 1Cc #1, the number of ears that do not occur and that occur most often, 1Cc #3, coincide, although the technique of manufacture differs. In fact, all medium to large vessels of wheel and mold manufacture have either two ears or none; only the largest mold-made vessels may also have four ears; and only the medium to small wheel-made vessels may have one ear. No jars or pots have three ears. Thus,

Table 2-1 Shape Classification of Black-on-Red Glazed Utilitarian Pottery, Puebla, Mexico

Type	Subtype	Shape Classification
1Aa	#1	Ellipsoid restricted independent composite (*velorio huevito:* wheel; *olla:* mold)
	#2	Sphere restricted independent composite (*velorio:* wheel; *jarro:* wheel; *olla:* wheel)
	#3	Sphere restricted independent complex (*capulixtle:* wheel; *jarro cachucho:* wheel)
	#4	Ovaloid restricted independent inflected (*jarro cántaro:* wheel; *jarro cantimplora:* wheel)
1Ab	#1	Ovaloid unrestricted vertical (*cazuela:* mold; *cajete:* mold)
	#2	Ovaloid unrestricted dependent (*caso:* mold)
	#3	Ovaloid unrestricted horizontal (*pescadera:* mold)
	#4	Cone unrestricted (*tortera:* mold)
	#5	Sphere unrestricted (*cazuela:* wheel)
	#6	Sphere restricted independent inflected (*tecomate:* wheel)
	#7	Hyperboloid unrestricted (*maceta:* wheel)
	#8	Cylinder unrestricted dependent (*borcelana:* wheel)
	#9	Cylinder unrestricted independent (*bacín:* wheel)

Table 2-2 Rim Classification of Black-on-Red Glazed Utilitarian Pottery, Puebla, Mexico

Type	Subtype	Shape Classification	
1Ba		*Direction (in relation to vessel contour)*	
	#1	Gradual curve outward horizontal	
	#2	Abrupt angle outward horizontal	
	#3	Abrupt angle outward down	
	#4	Direct	
1Bb		*Thickness (in relation to vessel wall)*	
	#1	Exterior short thin elliopsoid rim thickened at lip	
	#2	Exterior short medium ellipsoid rim thickened at lip	
	#3	Exterior short thick ellipsoid rim thickened at lip	
	#4	Exterior long medium rectangle rim thickened at lip	
	#5	Exterior long medium rectangle rim thickened at lip, with triangle projection	
	#6	Exterior short thick sphere rim thickened at lip	
	#7	Exterior short thin ellipsoid rim thickened at lip, with triangle projection	

ears that are functional, as well as decorative and definitive of types, are sometimes related to technique of manufacture—but sometimes not. Borrowing may be represented here, with wheel-made pottery mirroring mold-made types of earlier origin—except where function and technique are overriding. The largest and heaviest pots to be lifted and carried are always mold-made; the wheel is impractical for such sizes. Only the largest mold-made vessels may also have four ears. All medium to large vessels of both techniques, molds and wheel, have either two ears or none; and only medium to small wheel-made vessels may have one ear.

There is less overlap in Table 2-4 between types 3AM, 3BM, 3CM and

Table 2-3 Ear Classification of Black-on-Red Glazed Utilitarian Pottery, Puebla, Mexico

Type	Subtype	Shape Classification
	Direction (in relation to vessel contour)	
1Ca	#1	Gradual curve inward down
	#2	Abrupt angle outward horizontal
	#3	Direct outward horizontal
	#4	Gradual curve inward horizontal
	Shape (in relation to vessel contour)	
1Cb	#1	Short wide rectangular S-curving ear
	#2	Long wide ellipsoid U-angled ear
	#3	Short narrow ellipsoid S-curving ear
	#4	Long narrow sphere U-angled ear
	#5	Short wide rectangular U-angled ear
	Number	
1Cc	#1	No ears
	#2	One ear
	#3	Two ears
	#4	Four ears
	#5	Eight ears

between 3DW, 3EW (Table 2-2, type 1Ba #2) and types 2AM and 3FW (Table 2-3, type 1Cc #1). The vessels are distinctive, but the rims are all at an abrupt outward and horizontal angle to the pots' bodies. Of the mold-made vessels, only type 2AM is without ears, as is only type 3FW of the wheel-made vessels. Both wheel-made and mold-made vessels, however, most frequently have two ears; and again, only the largest and most decorative mold-made vessels have more than two ears.

Function may account for overlaps in the typological schemata presented here: either two ears or handles for lifting (1Cc #3) or none (1Cc #1) for vessels that remain primarily stationary; and the same kind of ears for this lifting (1Ca #1; 1Cb #1). The same applies to serviceable rims (1Ba #2) and to two handles (1Cc #3) for types 1AM, 3AM, 3BM, 3CM, 3DW, 3EW; and for 1BW and 3FW.

Vessel shape and rim direction and thickness appear to be more important than ears in distinguishing kinds of vessels (Table 2-4, types 1AM, 1BW, 1CW, 1DW). Vessel shape rather than rim direction seems to be more important in distinguishing major types (Tables 2-1 and 2-4). Rim thickness and either no ears or multiple ears further distinguishes kinds of vessels (Table 2-4, types 1AM, 2AM, 3AM, 3BM, 3CM, 3DW, 3EW, and 3FW).

To summarize, it appears that overlapping variables in types may be the result of function, whereas specific differences in shape are the result of mode of manufacture, as well as of intended use. Mode of manufacture also seems to affect rim direction and thickness.

The typology that incorporates the variables of shape, rim, and ear classifications of black-on-red glazed pottery organizes a complex array of features based on the ethnographic corpus. We can see, too, that shape distinctions are accurate reflections of types produced on the wheel and in molds. These ethnographic results support the widespread usage of criteria commonly applied by archaeologists for pottery typologies. It is understood, however, that the full range of variables used here would seldom be available among excavated sherds to form a similar typology.

The Clay

Potters in the barrios of Puebla use only certain clays for certain techniques of manufacture. The clays are obtained from several sources in towns close to the city: Amozóc, Los Álamos, and San Pablo Xochimehuacán. Years ago, clay was obtained from some hills near the barrios. These sources are no longer used because they are now house sites or were depleted a generation or more ago.

Potters distinguish two kinds of clay from each site: fine and coarse. Both are obtained close to the earth's surface from exposed and weathered banks of streams and small rivers. Some potters dig their own clay after making an agreement with the landowner. Most, however, purchase it from local merchants, who deliver the clays in sacks or by the truckload.

Table 2-4 Typology of Black-on-Red Glazed Utilitarian Pottery, Puebla, Mexico

Mold (M)	Wheel (W)	Mold (M)	Wheel (W)
Type 1AM	*Type 1BW*	*Type 3BM*	*Type 3DW*
1Aa #1	1Aa #2	1Ab #3	1Ab #5, #6
1Ba #2	1Ba #1	1Ba #2	1Ba #2
b #2	b #1	b #2	b #3
1Ca #1, #4	1Ca #1	1Ca #3	1Ca #2
b #1, #5	b #1	b #4	b #2
c #1, #3, #4	c #1, #3	c #3, #4, #5	c #3
Type 2AM	*Type 1CW*	*Type 3CM*	*Type 3EW*
1Ab #1	1Aa #1, #2, #3	1Ab #4	1Ab #8, #9
1Ba #4	1Ba #1	1Ba #2	1Ba #2
1Cc #1	b #1	b #4	b #3
—	1Ca #1	1Ca #3	1Ca #1
—	b #3	b #4	b #1
—	c #2	c #3, #4, #5	c #2, #3
Type 3AM	*Type 1DW*	——	*Type 3FW*
1Ab #1, #2	1Aa #4	—	1Ab #7
1Ba #2	1Ba #3	—	1Ba #3
b #4	b #5, #6, #7	—	b #5
1Ca #3	1Ca #1	—	1Ca #1
b #4	b #1	—	b #1
c #3	c #2	—	c #1, #3

The fine and coarse clays sell at the same price; in fact, clays from all sources command the same price.

The potters' system for classifying clay (color and texture) is based on its functional qualities, which include consistency, moisture content, and resistant workability (see Williams and Ortíz-Solorio 1981:358). Vegetation cover is not considered as clays are derived from stream banks and riverbanks. However, sterile soil is noted (*tepelcate*) in Puebla and is contrasted with cultivable earth called *tierra*. Clay occurs in layers (*capas*) beneath the top crust of a stream bank. Coarse clay is identified as yellow (*amarillo*); fine clay is identified as brown to black (*café, negro,* or *prieto*). According to the potters, *amarillo* clay contains more sand (*arena*) and is removed from the top and bottom *capas* of earth in the stream bank. Black to brown clay characteristically contains less *arena* as it is removed from the middle layer between the bands of *amarillo* clay. Especially good clays of both types are recognized by the presence of veins or streaks (*vetas*) within the layers. Noncultivable, hard, sterile earth (*tepelcate*) may occur at the top or bottom

Table 2-5 Potters' Criteria and Classification of Clay Used for Utilitarian Pottery, Puebla, Mexico

Texture	Color	Usage
Fine *(barro fino)*	Black or Brown *(negro, prieto, or café)*	Wheel manufacture *(de torno)*
Coarse *(barro corriente)*	Yellow *(amarillo)*	Mold manufacture *(de mano)*

of a bank. This "clay," is a taxon of the class "earth." The potters' criteria and classification of clay are summarized in Table 2-5.

The generic color terminology of yellow and black applied by potters is associated with other cultural concepts that relate to the earth and to fertility not elaborated on in this chapter. The generic terminology of yellow and black contrasts two kinds of clay based on observable qualities. Three levels of taxonomy are distinguished, and they vary according to local conditions. The profile of a stream bank at Los Álamos shows five layers above the stream (see Figure 2-1).

The working qualities of a clay are tested at the stream banks by rolling a piece into a ball between the fingers; it is the same ball-of-clay test for plasticity used by Western ceramicists. One master potter told me that good clays rolled thus adhere well, forming a tight, sticky ball.

At the stream banks and in the workshops (*talleres*), potters classify clay by sight, as well as by touch, and they are equally adept at evaluating clay in its dry, hard state. They select a piece, then handle it and study it before commenting on its color and texture. They often break the dry piece open to observe it more closely. They neither reported, nor did I observe, reliance on taste and smell in classifying clay. Potters take great pride in their visual powers, calling attention to their ability to make fine distinctions by sight alone (*pura vista*) in identifying and selecting clays, as well as in judging stages of firing of pottery.

Technical Analyses

Analytical techniques were applied to representative samples, ranging from crude clays of known origin to fired and finished pieces. One purpose

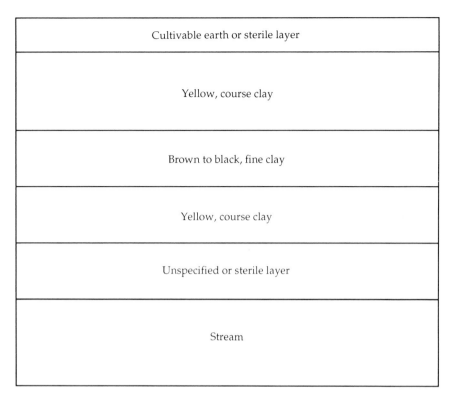

Figure 2-1. Profile of a stream bank at Los Álamos showing potters' classification of clay and nonclay layers.

was to trace the changes in clay at each stage of manufacture to discover what information, if any, is being lost as a result of firing. A second purpose was to determine to what extent the native categories (with regard to the identification, selection, and use of clay) and the distinctions derived from technical analyses (D.C. arc emission spectroscopy, atomic absorption spectroscopy, and X-ray diffraction) are correlated. Technical analyses provided scientific descriptions of the clays used by this community of potters at various stages and made possible comparison with potters' criteria and classification of raw materials. These data may provide insights into other studies of ethnotaxonomies, as well as into the cross-cultural processes in which are embedded such cognitive systems. These results may ultimately contribute to the recovery of cultural phenomena from excavated material culture, allowing better archaeological reconstructions.

The qualitative and quantitative spectrochemical techniques, applied as part of the scientific analyses of the clays, were capable of identifying accurately up to 70 elements and minor constituents, here referred to as *trace elements*, in the parts-per-million (ppm) range. These techniques were selected because they are, along with radiochemical techniques, among those most usefully applied to problems of origin and style provenance in archaeology and, presumably, the most revealing of cultural distinctions (Arnold 1971; Brill 1971; Hall 1971; Harbottle 1970; Perlman and Asaro 1969; Sayre et al. 1971; Smith 1971; Weymouth 1973). Chemical analyses generally have been concerned with questions of provenance and style distribution (Perlman and Asaro 1969:11, 23), temper and fired sherds (Shepard 1956:26–31, 51–54, 131–132, 156–168, 378–384). My results do have a bearing on these questions and on some of the techniques employed.

X-ray diffraction analysis supports the potters' color classification of clay. Yellow or coarse clay is associated with kaolinite. Kaolinite has a relatively simple structure; and the presence of sand and rocks in it, as well as its large grain size, all contribute to a light color, called *amarillo* (yellow) by Puebla potters. Black to brown fine clay is associated with illite, which has a more complex structure than does kaolinite. Illite has greater potential water and metal contents, characteristics that tend to produce clay of a dark color, called *café*, *negro*, and *prieto* (brown to black) among the potters.

Munsell Soil Color Charts were used to identify colors of clays in the crude, prepared, and fired stages of production, based on samples collected in 1972. The samples for coarse, crude clay (potters' yellow clay) varies from brown-dark brown (10YR 4/3) to brown (7.5YR 5/4); for coarse prepared clay, a light yellowish brown (10YR 6/4) (see also Williams and Ortíz-Solorio 1981:341). Crude clay refers to clay in its dry, hard state; prepared clay, to its moist state after water has been added and the clay kneaded to the desired working consistency. Coarse fired-clay color is light red (2.5YR 6/8) after the first firing and red (2.5YR 5/6) or yellowish red (5YR 5/8; 5YR 5/6) after glazing, painting, and second firing of mold-made pieces.

Fine clay, potters' black-brown clay, varies from reddish gray (5YR 5/2) to brown (10YR 5/3) or pale brown (10YR 6/3) in the prepared stage; and from reddish yellow (5YR 6/6) after the first firing to yellowish red (5YR 5/8) after the second and final firing of wheel-made pieces.

Unfired glaze is pale yellow (5YR 8/4) on the Munsell scale and yellowish red (5YR 5/8) or reddish yellow (5YR 6/8) after the second firing. Applied black paint is black on the Munsell scale after firing (5YR 2/1; 7.5YR 2/0).

Fine and coarse clays are associated with different techniques of manufacture in Puebla. Fine clay is used for the wheel. It is characterized by the potters as delicate, lively clay that "breathes." It cannot, however, be stretched over molds without breaking. The two main sources for this kind of clay near Puebla are Amozóc and Los Álamos. All the local potters agree that the best fine clay comes from Los Álamos.

Coarse clay is used for the mold-manufactured vessels. The potters of Puebla describe this clay as being thick, compact, and strong; it can be stretched over the molds without breaking. After a few minutes in the sun, this clay will hold its shape when the mold is removed for the remainder of the drying period indoors. Drying may take from a few hours to several days for the larger pots. (In the rainy season, all vessels take longer to dry.)

Puebla black-on-red ware has coarse-textured but untempered paste. That is, no nonplastic materials are added to the paste; although the potters do sometimes add coarse clay to fine clay to give strength and to achieve the desired working qualities on the wheel. Technically, it inhibits cracking during the drying process. One potter reported adding crushed sherds to his paste on occasion, but this practice was never observed by me and was not widely reported. Only water is added to the coarse clay. Sand is occasionally added, but they do so only for clay coils used separately to form the rims and ears of large mold-made pieces.

Vessels are worked when they are "leather-hard" (partially dry). Hard and smooth tools, such as a waterworn pebble, are used to help form mold-made pieces; sharp-edged scrapers, such as a sherd, gourd rind, or piece of metal, are used on wheel-made vessels.

The techniques used to make pottery are the kick wheel, for medium- to small-size cooking pots and jars of various shapes, and simple convex molds for cooking pots. More complex two-part convex molds are used for jars, and a mushroom-type mold is used for small eating bowls. Mold-made vessels range in size from the very largest ones made (up to a meter in diameter and height) to the medium and small sizes.

Black paint is made by mixing copper oxide with powdered glaze (a lead oxide), chalk, clay, and water. The solution is applied to the pottery from a little tin can which has a side spout. Using these cans, called *pistoleros*, the firing team applies color by allowing the paint to run down the sides of the cooking pots and jars as the vessels are slowly spun in the hand (Plate 3). The paint is applied after each piece has first been dipped into a yellow glaze-and-chalk solution and allowed to dry. The painted and glazed pottery is then restacked for a second (final) firing.

All paints and glazes used today in the barrios are purchased from

commercial manufacturers in the northern states by three local suppliers, who, in turn, sell them to the potters. The same methods of mixing and applying paint and glaze are used throughout the community. The glaze used is a lead oxide. I tested none of these commercial materials.

Qualitative chemical analysis of the clay sample was accomplished using a 1.5 M Bausch & Lomb emission spectograph with D.C. arc source. The technique permits the accurate identification of up to 70 elements. It is the proper, logical preliminary to a quantitative analysis. Twelve elements were identified in the sample as present in detectable amounts: aluminum, magnesium, silicon, calcium, iron, sodium, chromium, copper, nickel, lead, vanadium, and titanium. None is an especially rare element. It is interesting that titanium, vanadium, and nickel occur in this sample only in the coarse clay from San Pablo Xochimehuacán and that two of the four samples from this source also lack aluminum. Whether the elements present or absent are characteristic of Puebla is difficult to ascertain owing to the paucity of comparable data from this and other regions of Mexico. Arnold's data for Ticul, Yucatán, subjected to X-ray diffraction analysis, indicate that the clays there, which are mostly montmorillonite, are distinct from those analyzed here (1971:22, 25). Qualitative analysis of the Puebla sample by D.C. arc emission spectroscopy, however, neither reveals the potters' native categories of clay types nor distinguishes sufficiently between the sources of clays. (Two types of clay from three sources are represented in the sample.) The determination of the percentage of trace elements in the clays does, at times, prove to be significant in determining the origin of clays (Harbottle 1970).

The utility of this technical approach to problems of origin, production, and trade has to be qualified, despite the long-established use of laboratory procedures in ceramic description in archaeology. Anna O. Shepard pointed out that the assumption that "each clay mineral has a distinct pattern of associated trace elements . . . is untested as yet" (1971:56); and E. T. Hall observes, "little attempt has been made to date to trace ceramic compositions back to their clay sources" (1971:161). In general, much work remains to be done in amassing a body of comparable data on clays and clay sources.

Quantitative chemical analysis was accomplished using a Perkin-Elmer 303 atomic absorption spectrophotometer. The relative proportions of six minor constituents in the Puebla sample were determined, and measurements were taken in the ppm range. The results are given in Tables 2-6 and 2-7. The major constituent of clay is silica (SiO_2), and certainly the

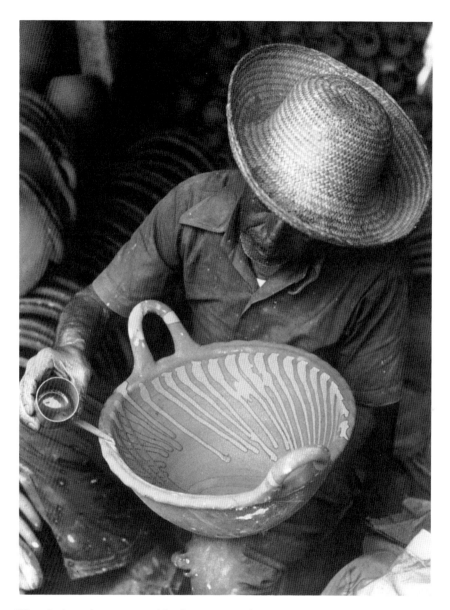

Plate 3. An urban potter of La Luz, a specialist in decorating and firing *loza poblana*, also known as *loza colorada*, uses a *pistolero* to decorate a two-handled open vessel, *cazuela*, before final glazing and firing. The *cazuela* is considered indispensable for cooking *mole poblano*.

Table 2-6 Atomic Absorption Analysis, Iron, Magnesium, and Nickel

Sample	Source	Percentages Trace Elements		
		Iron	Magnesium	Nickel
Barro corriente/crude	Amozóc	4.19	.70	.0260
Barro corriente/prepared	Amozóc	4.16	.66	.0300
Barro corriente/crude	Amozóc	4.19	.71	.0370
Barro corriente/crude	Los Álamos	3.98	.54	.0080
Barro corriente/crude	Los Álamos	8.63	1.26	.0097
Barro corriente/fired once, no glaze	Amozóc	4.16	.87	.0170
Barro corriente/fired twice, glazed	Amozóc	4.13	.86	.0170
Barro fino/crude	Amozóc	3.41	1.12	.0220
Barro fino/crude	Los Álamos	3.94	.84	.0130
Barro fino/crude	Los Álamos	4.35	.71	.0062
Barro fino/crude	Los Álamos	4.71	.84	.0750

Table 2-7 Atomic Absorption Analysis, Calcium, Chromium, and Copper

Sample	Source	Percentages Trace Elements		
		Calcium	Chromium	Copper
Barro corriente/crude	Amozóc	.150	.0150	.0093
Barro corriente/prepared	Amozóc	.120	.0140	.0080
Barro corriente/crude	Amozóc	.150	.0150	.0150
Barro corriente/crude	Los Álamos	.022	.0130	.0016
Barro corriente/crude	Los Álamos	.056	.0250	.0033
Barro corriente/fired once, no glaze	Amozóc	.640	.2600	.0048
Barro corriente/fired twice, glazed	Amozóc	.330	.3100	.0120
Barro fino/crude	Amozóc	.058	.0089	.0110
Barro fino/crude	Los Álamos	.350	.0160	.0032
Barro fino/	Los Álamos	.043	.0160	.0089
Barro fino/	Los Álamos	.037	.0250	.0025

predominant characterizing element present is silicon (Si). The preliminary data show all these clays to be rich in iron ore. Three of the six trace elements tested are found in different concentrations, distinguishing the sources of the clays but not the potters' clay categories. Copper (Cu) and nickel (Ni) are present in greater quantities in the clay from Amozóc. The latter contains 10 times more copper and from 2 to 4 times more nickel than does the clay from Los Álamos. Los Álamos clay contains almost 10 times more calcium (Ca) than the clay from Amozóc. Other research suggests that calcium contributes to the crystallization process in firing (Wertime 1973:876). The result, presumably, would be harder and stronger pottery (E. W. Shaw, personal communication 1974). It appears that calcium could prove to be the most interesting element among the minor constituents tested and in future investigations.

I have no comment at this time concerning chromium (Cr). Aluminum (Al) was not subjected to quantitative analysis, and lead (Pb) has been reported elsewhere (Kaplan and Spielholtz 1977). Sodium (Na) was not considered useful for analysis because of its abundance in the sample.

Limited qualitative analysis was applied to seven clay samples represen-

tative of each stage of production from two to three sources of clay. Several X-ray diffraction mount techniques were applied, but the least-desirable method was used because it was applicable to the samples, to the time element, and to the machine. The samples were pulverized by hand with a porcelain mortar and pestle, then mounted in a pressed-glass sample holder, and finally X-rayed under the following conditions: 27 kv; 19 ma; range = 1,000; time constant = 2.5; copper radiation; 2 20/min.; three medium-resolution slits were used. The peaks obtained using this technique were for the most part well defined (Spielholtz and Kaplan 1980:999). The intensity of the peaks registers the relative amount of the mineral present (Table 2-8). Nine minerals were identified: illite, kaolinite, albite, calcite, hematite, magnetite, lead chromate, mullite, and quartz. Illite was identified in fine clay (Table 2-8, samples 1 and 5); it is a mineral with greater plasticity and bonding strength than kaolinite. Coarse clay used for molds either does not contain illite (sample 4) or does so only when it occurs together with kaolinite (samples 2 and 3). Mullite is found in samples of coarse fired clay (samples 5 and 7), and it presumably represents the high-temperature phase of kaolinite (E. W. Shaw, personal communication 1974).

Table 2-8 X-Ray Diffraction Analysis

Sample No.	Stage	Source	Illite	Kaolinite	Albite	Calcite	Hermatite	Magnetite	Lead Chromate	Mullite	Quartz
1	Crude clay	Los Álamos	W[b]	W	S	W	—	M	—	—	W
2	Crude clay (molds)	Amozóc	W	W	S	W	—	W	—	—	—
3	Prepared clay	Amozóc	W	M	S	W	—	W	—	—	—
4	Crude clay (molds)	Amozóc	—	W	S	W	—	M	—	—	W
5	Crude clay (wheel)	Amozóc	W	—	S	W	—	W	—	W	W
6	Fired once, no glaze	Amozóc	W	—	S	W	S	W	—	M	W
7	Fired twice, glazed	Amozóc	W	—	S	W	—	M	M	W	W

[a]Formulas are as follows: illite $Al_2Si_4O_{10}(OH)_2 \cdot H_2O$ $KAl_2(AlSi_3O_{10})(OH)_2$; kaolinite $AlSi_2O_5OH$; albite $NaAlSi_3O_8$; calcite $CaCO_3$; hematite Fe_2O_3; magnetite Fe_3O_4; lead chromate $PbCrO_4$; mullite $3Al_2O_3 \cdot 2SiO_2$; and quartz SiO_2.

[b]S = strong; M = medium; W = weak.

X-ray diffraction supports an important distinction maintained by potters between fine and coarse clays.

Further quantitative X-ray work would undoubtedly reveal different proportions of illite and kaolinite in samples 1, 2, and 3 and would perhaps allow us to distinguish among the sources of fine and coarse clay.

A summary of the technical analyses shows that, of the several analytical techniques applied, X-ray diffraction, which identifies illite and kaolinite in the samples, reflects the potters' native categories. Neither X-ray diffraction nor qualitative analysis, however, identifies clay sources. Quantitative analysis by atomic absorption spectroscopy chemically distinguishes between two sources of clay in Amozóc and Los Álamos. This result shows, as have Perlman and Asaro (1969:36–37), that useful quantitative analysis of minor elements does not always depend on the size of the sample tested. A more general problem is trying to obtain "clay fingerprints" at all (Harbottle 1970:28). Some problems to be considered are the possibility that the elements selected for quantitative analysis did not generate the most significant data; the absence of local geologic maps with sufficient detail; and the proximity of two of the clay sources sampled (within 15 km of each other and, therefore, not distinguishable geologically). Qualitative analysis by D.C. arc emission spectroscopy, as well as quantitative elemental analysis of clay and fired sherds, showed no loss in the firing process, a result that resembled Hall's findings (1971:161). Only additional lead and lead chromate were found later (sample 7), as a result of glazing after firing.

Measurements of Pottery Types and Sizes

Tables 2-9 and 2-10 provide the measurements of pottery taken in 1972, 1973, and 1974. Only complete vessels were measured; and only those types and sizes that were still recognized by the potters were measured. As far as possible, representative pieces were included.

The conditions under which the measurements were made were extremely difficult; the size and weight of many pieces precluded the use of instruments that might otherwise have been employed in a laboratory. Most measuring was done either in the workshop itself or in the courtyard. When pieces were too large and heavy to move, measurements were taken in storage rooms. In taking measurements, I was assisted at various times by my husband, by my children, and by the children of potters who wrote down the dimensions on forms I had prepared in advance. No matter where we worked, usually in the hot searing sun out in the courtyard, we always seemed to be in the potter's way. I was aware throughout the fieldwork of the extent to which I interfered with the potters' normal activities, which

Table 2-9 Field Measurements and Volume Calculations of *Cazuelas*

Type	Rim Diameter 1 to Ears	Rim Diameter 11 to Ears	Overall Ht.	Ht. to Rim	Rim Ht.	Rim Wdt.	Body Circ. Rim	Body Circ. Middle	Base Dia.	Ht.	Ears Width	Ears Brth.	Ears Thick	Vol. (Liters) Calc.	Vol. (Liters) Liq. Meas.	Potter
Cazuelas (mold-made)																
de a real	76.3	75.3	44.5	40.0	4.5	4.7	211.5	197.7	22.0	21.5	32.0	4.8	4.8	109.300	—	J.A.
de a medio	55.0	58.0	34.0	31.0	3.0	3.7	163.0	145.7	20.0	15.3	20.0	3.8	3.0	47.800	—	"
" " "	60.0	61.0	32.8	27.8	5.0	3.9	175.0	154.0	20.0	17.0	25.0	4.0	3.7	51.600	48.600	P.R.
de a cuartilla	50.5	54.0	27.3	23.8	3.5	3.5	151.0	132.6	20.0	14.7	19.0	3.0	3.0	29.100	—	J.A.
de a claco	49.0	50.0	24.3	21.3	3.0	3.0	141.0	124.9	19.0	14.0	17.5	3.0	2.6	25.700	—	"
" " "	48.3	48.0	24.5	21.5	3.0	3.0	139.3	123.5	18.0	14.0	16.5	2.8	2.8	25.100	22.500	P.R.
de a diez	41.0	41.7	20.0	17.0	3.0	3.0	118.0	104.5	14.0	11.5	14.0	2.3	2.3	14.400	—	J.A.
" " "	41.5	43.0	20.8	18.0	2.8	3.0	118.5	105.0	13.0	11.5	14.5	2.7	2.5	15.000	13.500	P.R.
de a ocho	36.0	37.4	15.3	13.8	1.5	2.0	107.8	93.0	14.0	11.0	12.0	2.0	2.0	9.100	—	J.A.
" " "	35.4	37.2	18.2	15.6	2.4	2.0	101.5	90.7	12.0	9.6	13.0	2.5	2.1	9.900	9.000	P.R.
de a ochito	33.1	33.2	13.5	12.2	1.3	2.0	96.6	84.5	11.5	11.5	10.0	2.0	2.0	6.900	—	J.A.
de a medio ochito	27.5	28.0	12.3	10.8	1.5	2.0	81.5	72.3	12.0	8.5	10.0	1.7	1.9	4.400	—	"
casito molero	27.0	26.8	13.4	12.1	1.3	1.8	81.6	73.8	9.0	7.0	9.5	1.9	2.0	4.700	3.600	P.R.
" "	20.5	20.5	9.8	8.8	1.0	1.3	60.4	51.5	8.5	6.8	8.5	1.7	1.6	1.600	—	J.A.
casito molerito	16.2	16.0	6.5	5.6	0.9	1.1	47.0	37.0	6.5	5.8	7.0	1.3	1.2	0.680	—	"
caso dedal	7.8	8.2	3.0	3.0	—	0.3	25.2	21.5	3.0	1.3	3.5	0.5	1.0	0.095	0.071	P.R.
Torteros (mold-made)																
de a medio	57.2	57.5	13.6	10.9	2.7	—	165.5	150.0	39.0	16.0	21.5	3.5	3.2	23.600	19.800	P.R.
de a cuartilla	47.0	47.3	14.3	11.8	2.5	—	135.8	122.0	27.0	12.0	16.5	2.6	2.5	15.600	12.600	"
Cazuelas (wheel-made)																
china	32.3	33.3	13.6	11.6	2.0	2.4	91.4	89.0	7.5	7.3	14.0	2.5	1.6	6.300	5.500	V.M.
arrocera	23.7	24.1	8.8	7.8	1.0	1.7	68.3	61.8	5.5	5.0	9.5	2.0	1.1	2.100	1.900	"
tránsito grande	19.1	19.5	7.5	6.8	0.7	1.4	54.1	48.0	4.5	3.4	6.0	1.5	0.9	1.100	1.000	"
media tránsita	13.9	13.6	4.8	4.2	0.6	1.5	38.0	33.0	5.0	2.4	4.5	0.8	1.2	3.360	—	J.A.
de capulixtle	13.5	13.5	5.0	4.4	0.6	1.2	37.3	33.7	4.5	1.5	4.5	1.1	0.7	0.370	0.260	V.M.
" "	7.3	7.5	2.3	2.1	0.2	0.4	23.0	21.0	4.5	2.0	2.5	0.4	0.8	0.070	—	J.A.
dedal	6.9	6.7	3.0	2.6	0.4	0.3	21.0	16.5	3.0	1.2	2.5	0.5	0.8	0.600	0.040	V.M.

continued

Table 2-9 (continued)

Type	Rim Diameter 1 to Ears	Rim Diameter 11 to Ears	Overall Ht.	Ht. to Rim	Rim Ht.	Rim Wdt.	Body Circ. Rim	Body Circ. Middle	Base Dia.	Ht.	Ears Width	Ears Brth.	Ears Thick	Vol. (Liters) Calc.	Vol. (Liters) Liq. Meas.	Potter
Cazuelas (mold-made)																
de a medio ochito	27.6	28.6	13.0	12.0	10.0	1.6	84.5	75.4	11.0	8.4	9.0	4.4	2.0	4.900	—	R.L.
" " " "	29.1	29.0	12.5	11.5	10.0	2.1	83.2	72.8	11.0	9.0	10.0	4.4	2.0	4.500	—	"
" " " "	29.2	29.0	12.2	11.2	11.0	2.0	83.6	75.0	11.0	8.8	9.5	3.5	1.9	4.600	—	"
" " " "	28.3	28.0	12.8	11.8	11.0	1.9	83.8	74.4	11.0	8.8	10.0	4.3	2.0	4.800	—	"
" " " "	28.0	27.6	13.0	12.0	11.0	1.8	82.8	74.0	11.0	8.0	10.0	4.3	1.8	4.800	—	"
" " " "	27.4	27.8	11.5	10.3	1.2	1.8	78.0	72.3	10.5	9.3	7.0	3.0	2.0	3.900	—	G.L.
" " " "	27.0	27.8	11.5	10.5	1.5	1.9	77.0	70.2	10.5	8.9	7.0	3.2	2.0	3.800	—	"
" " " "	27.5	28.0	12.3	11.2	1.1	2.0	78.5	70.4	10.0	8.6	7.0	3.2	2.1	4.000	—	"
" " " "	27.1	27.0	12.0	10.6	1.4	1.6	78.5	70.6	10.0	8.4	7.3	3.3	2.2	4.000	—	"
" " " "	27.0	27.5	13.0	11.8	1.2	2.0	80.0	71.5	10.0	8.5	7.0	3.0	2.2	4.400	—	"

were being carried out in already-cramped quarters. There was much coming and going around us, if not by the potters themselves, then by the innumerable children, neighbors, and vendors who always seemed to be attracted by our activities. Instruments for measurement were portable and simple: a metal metric tape, a seamstress's cloth tape, and glass beakers. I acquired the beakers from a medical supply house in the city of Puebla; they were used to measure volume by pouring water into those vessels I had collected for photographing, in the only quiet place I enjoyed during this phase of the study: my shower. The volumes of other vessels were calculated based on measurements taken in the field. Points and formulas are given in Tables 2-9 and 2-10.

The widest selection of pottery for measurement was to be found after a kiln had been fired. But in 1972 and 1973, extremely heavy rains had prevented kilns from being fired for many weeks. I had a problem collecting pottery types for photographing. Because I wished to acquire pottery from known sources, I did not buy any in the Puebla markets. After some three weeks, I decided to begin preliminary testing and went to the markets only to find there was no pottery in stock. When the kilns finally began to be fired, the men and women who sold pottery in the markets, on the streets,

and in the villages literally descended like the proverbial locusts on a wheat field and carried away the entire contents of a kiln in less than an hour. To have attempted to measure pottery under these circumstances would have been not only unsuccessful but also dangerous to life and limb.

Originally, in 1972, I began to take the overall lineal dimensions to try to account for the different sizes identified by potters. This method soon proved confusing. While potters assigned distinct labels to a wide range of sizes, linear measurements yielded only small differences (e.g., 1 to 5 cm) in height, width, or diameter between pieces. If you allow for individual variation between different potters for the same sizes, it is even less clear what is being distinguished. The measurements actually present a full range of varying dimensions along a size continuum.

I considered the possibility that distinct labels for stated and presumed pottery-size differences did not represent any measurable reality; and I could have, as would an archaeologist faced with a collection of sherds, made arbitrary divisions in the measured continuum. But I assumed that the potters were distinguishing something, and I wished to discover what that something was, as well as a technique for recovering it. I instinctively, subjectively, and stubbornly felt that such an elaborate terminological sys-

Table 2-10 Field Measurements and Volume Calculations of *Ollas*

Type	Rim Dis.	Overall Ht.	Neck Circ.	Neck Ht.	Neck Thick	Body Circ.	Body Ht.	Base Dia.	Ears Ht.	Ears Wdth.	Ears Brt.	Ears Thick	Volume Calcul.	Volume Liq. Meas.	Code	Potter's Initials
Ollas (mold-made)																
mescalera	47.5	88.0	123.0	19.0	1.5	196.0	69.0	30.0	10.0	15.0	4.0	2.5	131.00	—	100.0	J.A.
de a real	42.8	76.0	113.0	24.0	1.5	169.0	52.0	26.0	9.0	14.0	4.0	2.5	75.00	—	50.0	"
de a medio	37.5	63.2	90.8	23.0	1.6	133.5	40.2	23.0	8.0	12.0	3.3	2.0	38.00	—	30.0	"
de a cuartilla	33.0	56.0	84.6	19.6	1.5	120.5	40.0	16.0	9.0	13.0	3.5	2.0	229.00	—	25.0	"
de a tlaco	28.0	54.0	68.7	15.5	1.2	112.0	39.0	16.0	7.5	10.0	3.3	1.8	24.00	—	15.0	"
de a tlaquito	17.6	27.0	46.5	6.3	0.7	68.3	20.7	13.5	10.0	4.0	3.3	0.9	12.00	5.80	5.0	"
Ollas coloradas (mold-made)																
de a tres	25.0	41.7	64.5	12.0	0.5	96.0	30.0	14.5	—	—	—	—	14.00	—	15.0	J.A.
de a dos	23.0	36.0	59.4	10.0	0.5	87.6	26.0	12.0	—	—	—	—	10.00	—	12.0	"
de a tresito	21.0	32.5	51.5	9.5	0.5	76.5	23.0	11.0	—	—	—	—	7.00	—	8.0	"
de a tlaquito (jalapeña)	17.7	29.8	43.0	7.6	0.5	69.0	22.2	10.0	—	—	—	—	5.00	—	5.0	"
" " " "	18.3	27.5	45.5	7.6	0.9	64.7	19.9	13.6	—	—	—	—	5.00	—	5.0	"
de a diecito	16.5	24.0	38.8	7.3	0.5	58.0	18.0	11.5	—	—	—	—	3.00	—	3.0	"
Ollas (wheel-made)																
de a doce	15.0	20.5	46.5	5.2	0.6	69.6	15.3	9.0	8.0	2.7	1.6	1.0	3.62	2.85	—	J.A.
" " "	15.3	24.1	41.5	5.1	0.6	70.2	19.0	6.5	8.0	2.9	1.6	0.8	4.12	—	—	V.M.
" " "	14.7	22.2	38.6	5.5	0.6	58.5	16.7	8.0	7.0	2.7	1.9	0.6	2.81	—	—	J.A.
" " "	14.0	22.0	37.8	6.0	0.7	59.0	16.0	8.0	—	—	—	—	2.70	2.90	—	V.M.
Velorio ollito (wheel-made)																
arrocero	9.8	16.4	26.8	3.2	0.4	48.6	13.2	6.0	—	—	—	—	1.40	1.55	—	P.R.
tránsito grande	9.3	14.8	25.0	3.1	0.4	44.2	11.7	6.0	—	—	—	—	1.06	1.05	—	"
medio tránsito	7.2	9.4	17.5	3.0	0.3	28.7	6.4	4.5	—	—	—	—	0.26	0.25	—	"
Velorio a huevito (wheel-made)																
tránsito grande	9.4	14.8	26.0	2.7	0.4	40.2	12.1	6.0	—	—	—	—	0.97	1.05	—	P.R.
Ollas jarro (wheel-made)																
de a sope	12.7	20.5	34.9	4.5	0.5	59.7	16.0	10.0	7.5	3.5	1.2	1.5	2.82	3.15	0.3	J.A.
" " "	13.0	20.6	35.1	4.5	0.4	59.8	16.1	10.0	7.0	4.7	1.7	1.2	2.85	—	—	"
de a arrocero	10.5	17.5	28.9	4.0	0.5	16.5	13.5	7.5	7.0	3.0	1.2	1.5	1.59	1.95	0.2	"
" " "	10.8	17.6	29.0	4.0	0.4	49.6	13.2	7.0	6.0	3.1	1.5	0.6	1.84	—	—	"
de a tránsito	9.2	13.5	25.4	3.8	0.5	39.4	9.7	6.0	6.0	2.7	0.8	1.0	0.75	0.80	0.1	"
" " "	9.2	13.2	26.5	3.7	0.4	39.4	9.5	5.0	5.5	2.6	1.2	0.5	0.72	—	—	"

continued

Table 2-10 *(continued)*

Type	Rim Dis.	Overall Ht.	Neck Circ.	Neck Ht.	Neck Thick	Body Circ.	Body Ht.	Base Dia.	Ears Ht.	Ears Wdth.	Ears Brt.	Ears Thick	Volume Calcul.	Volume Liq. Meas.	Code	Potter's Initials
Ollas jarro (wheel-made) *(continued)*																
de a medio-tránsito	7.5	9.8	20.4	3.1	0.4	29.5	3.7	4.0	4.5	2.5	0.7	0.9	0.29	0.29	0.5	"
(or *jarro cafetero grande*)	7.6	9.7	20.3	3.2	0.3	29.5	6.5	4.0	5.0	2.3	1.0	0.6	0.28	—	—	"
" " "	7.5	9.4	23.2	2.4	0.3	31.0	7.0	4.5	4.5	2.5	1.4	0.6	0.35	—	—	"
jarro capulixtle	5.7	8.4	17.4	2.4	0.3	22.3	6.0	4.0	3.5	1.5	0.8	0.5	0.17	—	—	"
(or *jarro cafetero chico*)	5.8	8.0	18.0	2.4	0.3	25.8	5.6	4.0	4.5	2.3	1.0	0.7	0.19	—	—	"
jarro dedal	3.5	5.2	10.0	1.6	0.2	15.3	3.7	2.3	2.3	1.7	0.9	0.5	0.04	0.03	—	"
" "	3.5	5.3	10.0	1.6	0.2	15.3	3.7	2.3	2.3	1.7	0.9	0.5	0.04	—	—	"
Cantimplora (wheel-made)																
de a doce	5.0	26.8	13.3	6.8	0.4	85.2	20.0	10.6	9.2	4.5	1.9	1.4	5.24	2.90	—	P.R.
Bacínes (wheel-made)																
bacínitos de a doce	18.7	15.7	48.5	1.4	0.7	47.7	14.3	13.0	7.0	3.3	1.7	1.0	2.43	1.80	—	P.R.
Maceta (wheel-made)																
de a doce	21.0	17.4	65.6	1.7	0.8	48.4	15.7	13.6	—	—	—	—	3.34	2.25	—	P.R.

tem, as I was then painfully reconstructing from the bits and pieces of potters' information, had to be manifested in the material world.

In 1973, having mastered their system of pottery types and sizes (I hoped), I prepared a diagram of the potters' emic view of the universe of black-on-red ware (Figure 2-2). I then presented the diagram to four master potters and four elder potter employees for their changes and confirmation. Once they confirmed my representation of their emic schema, I then proceeded, in 1973, to measure the types and sizes. This time, realizing that linear measurements had not reproduced the distinctions I was seeking, I decided to include additional measurements, which would enable me to calculate volume: circumference at the midpoint and at the rim of the vessel body and circumference at the base of the neck and at the vessel base, calculated to the flattest, widest plane (Figures 2-3 and 2-4).

The vessels I was able to carry back to the privacy of my shower were measured by beaker for liquid volume both to the rim and to the calculated use levels in cooking. These volumes were then compared with those calculated by the method devised and illustrated in Figures 2-3 and 2-4, to test the accuracy of the method. It was not possible to use beakers in the field. The results suggest that the method used to calculate volume yielded a fairly accurate approximation of the volume measured. A further result was the discovery that the volumes and the labels and the system of classification used by the potters corresponded; and, if volume was included, the native taxonomy reflected categories discoverable in material culture and was the result of observable behavior. Nonetheless, the categories contained in the terminology remained covert among the potters.

I wished to take this discovery a step further and compare the same size and type of pottery made by two or more potters to see if the same label reflected the same volume. This comparison proved difficult to undertake. Potters specialized to such an extent that it was almost impossible to find two or more of them making the same sizes, especially at the same time.

In the fall of 1974, on a short visit to the barrios and with the added advantage now of *compadrazgo* relationships with the potters, I was finally

Figure 2-2. Potters' emic view of pottery, black-on-red glazed utilitarian pottery, Puebla, Mexico.

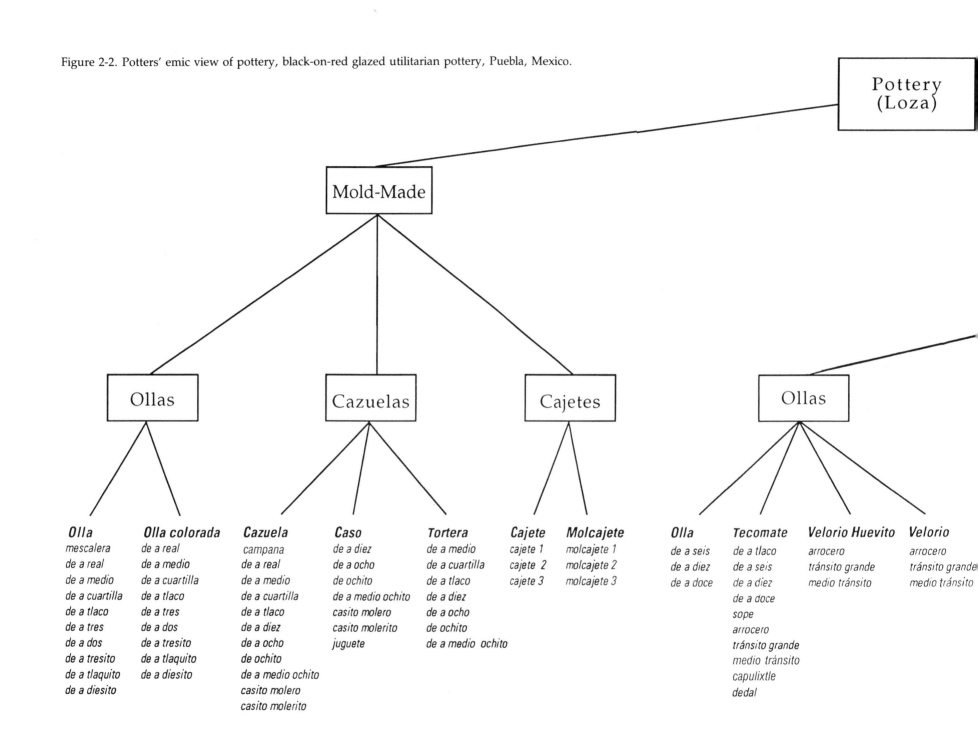

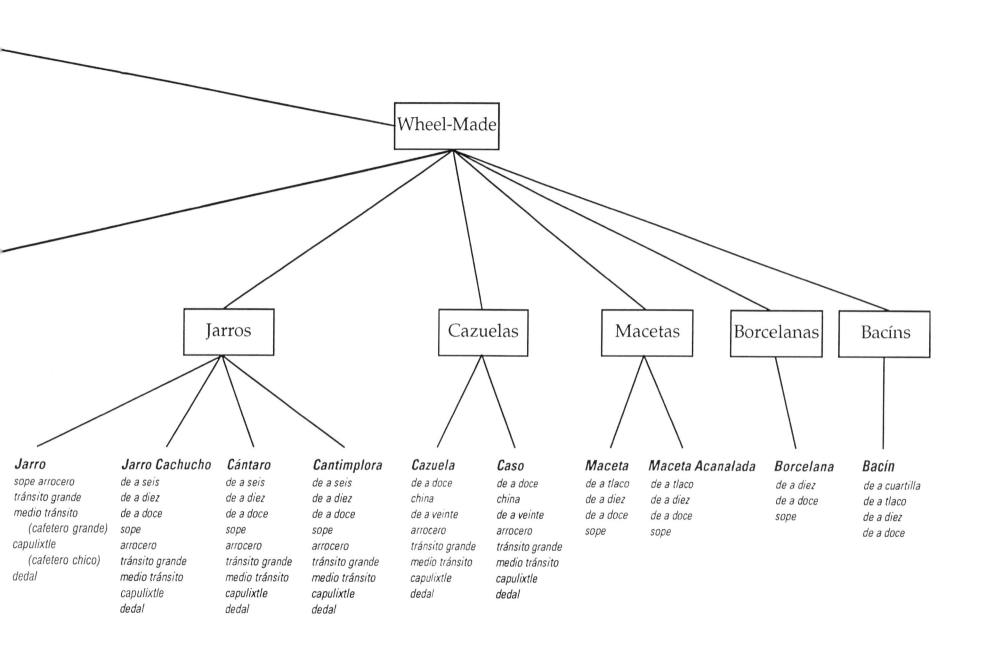

Jarro
sope arrocero
tránsito grande
medio tránsito
 (cafetero grande)
capulixtle
 (cafetero chico)
dedal

Jarro Cachucho
de a seis
de a diez
de a doce
sope
arrocero
tránsito grande
medio tránsito
capulixtle
dedal

Cántaro
de a seis
de a diez
de a doce
sope
arrocero
tránsito grande
medio tránsito
capulixtle
dedal

Cantimplora
de a seis
de a diez
de a doce
sope
arrocero
tránsito grande
medio tránsito
capulixtle
dedal

Cazuela
de a doce
china
de a veinte
arrocero
tránsito grande
medio tránsito
capulixtle
dedal

Caso
de a doce
china
de a veinte
arrocero
tránsito grande
medio tránsito
capulixtle
dedal

Maceta
de a tlaco
de a diez
de a doce
sope

Maceta Acanalada
de a tlaco
de a diez
de a doce
sope

Borcelana
de a diez
de a doce
sope

Bacín
de a cuartilla
de a tlaco
de a diez
de a doce

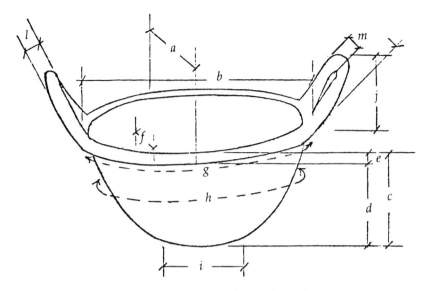

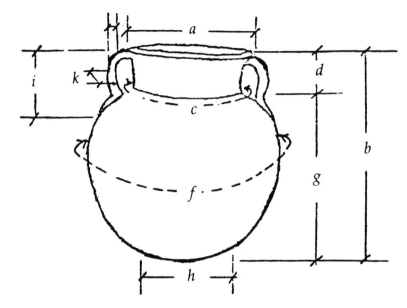

Figure 2-3. Method used to approximate volume of *cazuelas*.

Formula for volume of a frustum of a right circular cone:

$$V = \frac{\pi a\,(r_1^2 + r_2^2 + r_1 r_2)}{3}$$

Where

 V = volume
 a = altitude
 r_1 = small radius
 r_2 = large radius

Volume of a *cazuela*

$$V = \frac{\pi d/2\,(r_g^2 + r_h^2 + r_g r_h)}{3} + \frac{\pi d/2\,(r_h^2 + r_i^2 + r_h r_i)}{3}$$

Where

 V = volume of *cazuela*
 d/2 = 1/2 height from the base to rim
 r_g = radius at rim
 r_h = radius at midpoint
 r_i = radius at base

Figure 2-4. Method used to approximate volume of *ollas*.

Formula for volume of a frustum of a right circular cone:

$$V = \frac{\pi a\,(r_1^2 + r_2^2 + r_1 r_2)}{3}$$

Where

 V = volume
 a = altitude
 r_1 = small radius
 r_2 = large radius

Volume of an *olla*

$$V = \frac{\pi g/2\,(r_c^2 + r_f^2 + r_c r_f)}{3} + \frac{\pi g/2\,(r_f^2 + r_h^2 + r_f r_h)}{3}$$

Where

 V = volume of *cazuela*
 g/2 = 1/2 height from the base to neck
 r_c = radius at neck
 r_f = radius at midpoint
 r_h = radius at base

able to obtain two series of five pots each with the same label from two different potters. It was additionally advantageous that each of these series of pots was the product of a single mold. Thus, I could compare the two series, in terms of volume with regard to label and size, and compare the variation exhibited by each potter in a series using the same mold. The results are given in Table 2-9.

Although the same mold was used, each of the five pots in the series varies in some or all of its dimensions from the other four, yet each varies from and overlaps with pots in the comparable series. The pots in a given series from the same mold and by the same potter, however, resemble each other more than they resemble the pots in the other series, produced in a different mold and by a different potter. In addition, the volumes calculated for both series, despite the differences in individual measurements and dimensions, turned out to be remarkably consistent.

My initial reliance on linear measurements, not volume, arose from past experience and training. Complete vessels are scarce in archaeology, so I was certainly influenced, at the outset, by having worked with archaeological materials and museum collections and techniques. To the living, however, the contents of the pots are more important than the specifications after all.

Summary

The typological schema devised here provides mutually exclusive categories of black-on-red pottery. Eleven types (Table 2-4) have been determined on the basis of 45 variables: shapes (Table 2-1), rims (Table 2-2), and ears (Table 2-3). These types were then recast according to manufacturing technique (see Table 2-11). The variables found to be most descriptive of technique of manufacture were vessel shape, rim direction, and rim thickness. The number of ears proved useful in distinguishing between kinds of jars, as did either a multiplicity of ears or none in distinguishing between kinds of pots. This typology if desired could be subjected to statistical verification, although no attempt was made to quantify the sample. Like all schemata originated by outside investigators, this typology was devised to order a profusion of material. Typologies, despite increasing methodological sophistication, do not themselves make possible generalizations about a given culture.

The potters' taxonomy, that is, their emic view of the universe of black-on-red glazed ware, distinguishes 20 types, of which 7 are mold-made and

Table 2-11 Recast Typology of Black-on-Red Glazed Utilitarian Pottery, Puebla, Mexico

Mold (M)	Wheel (W)
Type 1AM	*Type 1BW*
1Aa #1	1Aa #1, #2, #3, #4
1Ba #1	1Ba #1, #3
b #2	b #1, #5
1Ca #1, #4	1Ca #1
b #1, #5	b #1, #3
c #1, #3, #4	c #1, #2, #3
Type 2AM	*Type 1CW*
1Ab #1, #2, #3, #4	1Ab #5, #6, #7, #8, #9
1Ba #2	1Ba #2, #3
b #4	b #3, #5
1Ca #3	1Ca #1, #2
b #4	b #1, #2
c #1, #3, #4, #5	c #1, #3

13 are wheel-made; there are 137 sizes and 94 variables associated with these types and 5 additional decorative types. The variables were found to be covert categories. They had to be elicited from potters by the methods developed and described in chapter 5. The potters treated types based on these categories as part of a more comprehensive schema, a hierarchy branching out from simple and basic forms to more complex and elaborate ones, arranged in descending size order. Their taxonomy, which is treelike, conveys a historical sense of development, a relationship in time between types. My typology provided a detailed but static schema, albeit one that might be subjected to statistical analysis, to establish the validity of the types created.

Both typological schemata, mine and the potters', resembled each other with regard to the types distinguished by shape. Technique of manufacture was used by both and reflected existing specialization among potters. Rim variables and technique of manufacture, as already noted, do correlate, but

rim variables were not important to the potters' system of classification. Ears were used by me in classifying contemporary pottery. (They might not, however, be available to archaeologists who customarily rely on such schemata.)

As an outsider, my typology is simpler; it produces fewer types and is based on fewer variables than that of the potters'; and it does not include size categories. The latter would have to be determined arbitrarily by me; and, if linear measurements were used, as is common practice, the results would be different, with fewer size categories than those recognized by the potters. Whereas a treelike diagram seemed to represent the potters' cognitive system best with regard to black-on-red glazed cookware, my efforts produced an aggregate of types, dividing up a linear spectrum of material.

Technical analyses have revealed that the potters' system for the selection and use of clays was based on a sophisticated understanding of the physical properties and working qualities of the raw materials. The analyses have also revealed that important cognitive and cultural distinctions were not only manifested in material objects but were retrievable, using replicable scientific techniques. Quantitative analysis indicated a difference in the two sources of clay; X-ray diffraction indicated a difference in the two clays recognized by potters as distinct, with regard to color, type, and technique of manufacture.

Measurements of pottery types and sizes were included initially as part of the description. These measurements (e.g., height, width, diameter, etc.) are the usual ones taken of pottery. The results indicated variation along a continuum. If size categories had been desired, I would have had to make an arbitrary division within the continuum, like that made by outside investigators.

Measurements failed to provide points of reference for the numerous size categories of pottery distinguished by the potters themselves. They varied in any one dimension, in any one size, regardless of whether they were produced by the same or different potters. However, I later decided to take measurements in the field that would permit me to calculate the volume of the pots (Figures 2-3 and 2-4). My method of calculating volume was tested by checking the calculated volume against the actual volume of liquid each pot held: it was found to be a fair measure.

The results given in Tables 2-9 and 2-10 yielded discrete size categories based on volume; these results and the sizes labeled in the potters' taxonomy, in turn, correlated. The usual measurements, taken initially, reflected a linear conception of pottery, a conception that arose, at least in part, from the predominance of sherds in archaeological collections; and it has been the archaeologist who has been most concerned with measurements, as well as with the physical and written description of pottery.

The potters' taxonomy, however, reflects a three-dimensional conception based on volume. The potters of Puebla did not make this conception explicit. They communicated in terms of the taxonomic labels among themselves and, in terms of relative volume, only with consumers. The latter, almost always women, used gestures to indicate the size desired, or they referred to the item and quantity to be cooked (e.g., two kilos of rice, three turkeys, etc.).

The potters recognized the limitations imposed on the expression of style by the clays, as well as by the techniques employed. The largest pieces produced were made in molds; they were jars and pots of coarse yellow clay that could be stretched without breaking and could support their own weight when the molds were removed. Fine black clay was used on the wheel; it was delicate and tended to crack when stretched over molds and to collapse when the molds were removed. The size of wheel-made pieces, then, was limited by the technique: a potter seated at his wheel finds it difficult to control the shape, to close the vessel, and to thin the clay if his arm enters the vessel above his elbow. Still, the potential for variation on the wheel is extensive. Current forms are a result of tradition and, to some extent, function.

Function is an important consideration in the manufacture and use of cooking pottery, but the emergence and persistence of a given style cannot be explained solely on that basis. Shape is related to function, as are ears or handles for lifting the pottery. The presence or absence of a separate rim is likewise related; so too is the glazing of pottery. I wish to stress, however, that the elaboration and repeated choice of some variables—shape, multiplicity of types of ears, decoration of rims, and pots in general (color, designs, etc.)—are not based primarily on function but on tradition and style.

3 MAKING POTTERY

Pottery making in the Puebla barrios is essentially a male occupation, which is passed on from father to son; but the male offspring of either a sister or a daughter may also be taught to make pots. In this way, potters form a group that is linked together through kinship ties. A man may work with his father, if he is still living, or with one or more of his sons, nephews, grandsons, and brothers. In addition, he may employ nonrelatives or himself be an employee in a workshop.

There used to be many workshops (*talleres*) in the barrios in the past, but they have virtually disappeared since about 1930. The workshops were under the direction of a patron, usually himself a master potter. They employed workers who were paid in cash. Some of the workers were relatives, some were not. All of them, however, lived in the barrios.

It appears to have been the custom before 1930, and continues to be today, for potters to move from one workshop to another over a period of time in response to market supply and demand. The result of this movement is a pattern of circulating employment. This pattern means a potter's knowledge of his technique and specialty is reinforced and honed by different patrons. Because potters span three age categories, young (*joven*), adult (*adulto*), and elder (*grande*), from 20 to 60 or more years of age, the transmission of style from one generation to another is effected as they circulate among the workshops, and innovations in one workshop are carried into the larger pottery-making community.

The visiting that goes on between potters in the course of a workday contributes to commonality of and continuity in style. This pattern is related to the pattern of circulation described in the preceding paragraph, as well as to a condition of partial employment. A potter may work in one establishment in the morning, then another in the afternoon. Before lunch, he may seek out the company of a friend who is working elsewhere in the barrios for a visit to a favorite bar (*pulquería*). If he is unemployed during one or another of the work periods, he may seek work during that time segment or relay messages between establishments. Sometimes he simply gathers with other unemployed men in a doorway to gossip, or he may watch a kiln that is being fired. Many potters are also linked in *compadrazgo* relationships with each other. They are, in addition, now actively solicited for participation in city- and state-sponsored cooperative programs. These activities, too, generate a need for discussion and stimulate visiting.

While some potters fire their own products, some sell their crude pottery to others to be finished; still others rent space in a kiln for firing and sell their pottery themselves afterwards. This pattern of interdependence among potters in the buying, firing, and selling of pottery necessitates visits between them.

Learning to Make Pottery

Learning to make pottery begins early and informally in a potter's family. Toddlers and young children explore their surroundings as they walk or are carried about by older female children. They wander in and out of the workshops and near the kiln of the *vecindad* (neighborhood). They play amid pottery stacked around the inner courtyard and along house walls. They eat and go to sleep in rooms where pots, ready for sale, are stored in neat rows near the dining table and under the beds. And they are fed, as well as toilet trained, with this same pottery. Thus, most of their

early childhood experiences and associations take place in the context of pottery making and involve the use of pottery.

Until a child takes his first communion, usually at seven years of age, he is not considered a true person. He is a little angel (*angelito*), still innocent and pure, and no real work is expected of him. If a child should die, he or she is always buried in white clothes in a white coffin to symbolize innocence. At such a death, grief is repressed by the parents, siblings, and relatives because they believe the child will go directly to heaven and live among the angels forever.

After the first communion, a child truly becomes a *person* in the full religious and social sense. Work and responsibility are now expected of him or her by adults. Only boys train to become potters. Between the ages of 7 and 14 or 15, a boy is known as a *niño* (child) or as a *jovencito* (young person). It is during this latter age category that real work and formal learning begin.

Young people are first given the tasks of breaking up the dry clay with sticks and of "dancing" on the wet clay with bare feet to remove any stones and to achieve the desired consistency (see Plate 4). Techniques of manufacture are also taught at this time to young people from 10 to 15 years of age. Those learning to use molds begin earlier than those learning to use the wheel. The slow acquisition of skill continues into the next age category, *joven* (young man), from 15 to 30 years of age. As he nears the end of this age category, between 25 and 30, achievement of full competence as a potter often coincides with a decision to marry. Thus, social and professional coming-of-age frequently occur together.

As an *adulto*, 30 to 50 years, a potter reaches his peak of development as a craftsman. During this period, he may acquire additional skills in selecting raw materials, firing a kiln, and buying and selling pottery, all of which give him recognition among his peers as a master potter. Not all potters acquire these skills, however; some remain producers all of their lives. As a *grande* (an elder), 50 to 70 or more years of age, a potter is in complete control of his craft, although he experiences some loss in dexterity and endurance. He will continue to work as long as he is physically able. Only the elder and the adult potters teach others.

The method used by a master potter to teach an apprentice is imitation. I use the term *apprentice* to mean a beginning potter who learns his craft from an experienced master, although there are no formal stages for an apprentice, journeyman, and master as defined by a guild (Russell 1968:311). I am not certain if the production of traditional black-on-red ware

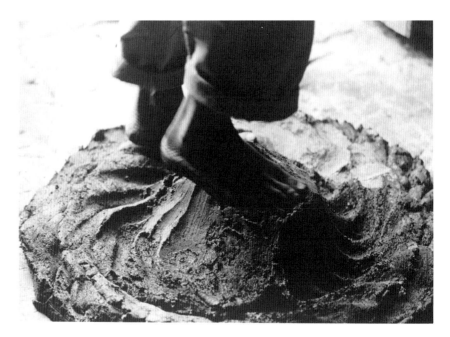

Plate 4. Potters, but especially young boys, "dance" on the clay to mix it thoroughly before using it on the wheel or in molds.

was ever under the jurisdiction of a guild, but it appears to me that the general outlines of a former workshop organization, as I was able to reconstruct from informants and early records, and the terminology still used by potters resembled those of guilds—though unchartered and informal.

In being permitted to work the wheel or to use molds, the apprentice tries to imitate the movements and forms created by the master potter, who serves as his model. The apprentice continually repeats his efforts with almost no verbal instruction. His early efforts are not rewarded. The term used by the master to describe these efforts as worthless is *porquerías*. *Porquería* literally means a mess. And to make a mess is humiliating. Success in learning is measured by somehow attaining conformity with the model. I believe it is these efforts to copy an existing and tangible model that, especially in the absence of explicit verbal direction, contribute to the persistence of style in black-on-red ware.

The emphasis on imitation in learning, however, does not rule out the possibility of innovation once the techniques have been mastered; and older and experienced potters do experiment. The limits imposed on their innovations come from considerations of time, consumer acceptance, and their own ideas of what is proper. These proprietary notions are shaped by their own early learning experiences and by cultural values.

Other factors reinforce the method of teaching. When the efforts of an apprentice are finally accepted by the master potter, the tendency is to repeat what has been achieved rather than to deviate and face rejection and humiliation again. This tendency is further reinforced by acceptance bringing material rewards. Effort alone is never rewarded—only the final product is judged. An apprentice knows he has learned well only when his pots are included for sale along with those of experienced potters and he is paid for his product. Thus, he is encouraged to repeat the efforts that brought his success rather than to risk the loss of hard-won income.

An apprentice is not paid to learn, and a master is not paid to teach. I believe that this practice too encourages conformity because, to learn, an apprentice must first convince someone that he is worth teaching. He must be obedient and willing to perform the least-desirable tasks in assisting the potter without complaint. These tasks include breaking up the crude clay with a stick, kneading the clay, fetching and carrying raw materials and pottery. In the course of his work, the apprentice tries to observe all that is going on and to learn the qualities of the raw materials, as well as the names of the finished pottery. For example, he may be asked to bring an *olla de a doce* (a jar of medium size). He learns by trial and error. He tries to select the size requested from the wide array of pottery in the courtyard or workshop. If he chooses incorrectly, the pot is rejected with some annoyance by the potter, who simply repeats the request. If he chooses correctly, the pot is accepted without a word or a gesture of praise. Again, it is only the final product that meets with approval.

Responsibility for learning rests with the apprentice, who must try to figure out what has to be done and then do it. At no point in the learning process does the master provide an overview of the techniques and shapes of pottery to be produced by the apprentice. Verbal communication between master and pupil is minimal. Each step is learned separately by imitation and proceeds by trial and error, with rewards for the final product alone. I suggest that the relative absence of verbal instruction and description and the reliance on a tangible model contribute to the development of covert categories, rather than overt categories, in the learning of style.

The Effects of Specialization

Specialization in black-on-red ware is based on the techniques of manufacture. Potters distinguish themselves as follows: *torneros*, those who use the wheel; *maneros*, those who use molds; and *olleros*, those who make only mold-made jars. Potters specialize in only one technique: wheel or molds, rarely both. I know of only two cases wherein the potter learned one technique and then later switched to another.

At the outset, a boy either continues his family's tradition, if they are potters, or, if they are not, finds acceptance as an apprentice by a master potter who will serve as his model. Fate, or acceptance as an apprentice, thus determines what pottery shapes and related stylistic features will be learned as the shapes and stylistic features are associated with given techniques of manufacture. Later, knowledge of other shapes and features will be increased if and when the potter learns to fire pottery. Wheel-made and mold-made pieces are usually fired together, and a master of the kiln must be able to distribute all the pottery to be fired. A master potter, by definition, must similarly be able to distribute pottery within a kiln. Both the master potter and the master of the kiln, therefore, have the most complete command of the universe of pottery. Figure 2-2 shows that universe of utilitarian pottery, as it was constructed, based on the points of view of the masters of the kiln and pottery. The diagram is my representation of their schema, and the methods by which it was obtained are described in chapter 5.

Each potter's specialty requires knowledge of a separate set of types and sizes. Within each specialty, there is further specialization. For example, potters who make the large *cazuelas* (cooking pots) do not make the medium and small sizes; the latter are made by other specialists. As a result, each potter learns and transmits only a limited portion of the total universe of black-on-red ware.

An apprentice first learns to make miniatures (i.e., small but complete pieces in the technique and style he eventually will master). On the wheel, he begins with toy cooking pots and jars; in molds, he first makes toy cooking pots and small eating bowls (see Plate 5). Only those who specialize in mold-made jars alone do not begin with miniatures but make small eating bowls instead in mushroom-type molds.

As an apprentice matures physically, the size of the pieces he makes gradually increases until the upper limits of his specialty are reached. The greatest prestige among potters is accorded to those who make the largest

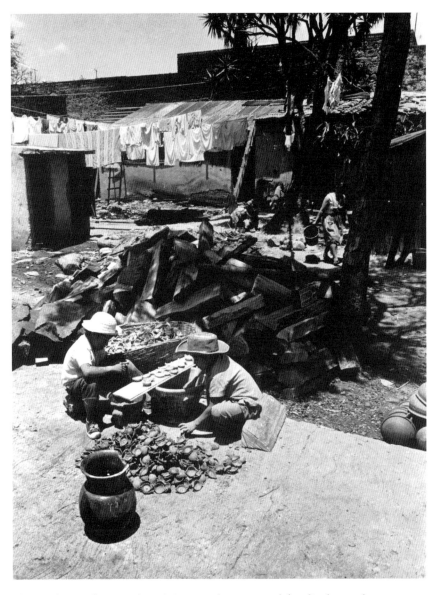

Plate 5. Young boys make miniatures that are used for display and as toys. Here, they are making *cazuelas*. The boys work in the courtyard of an urban complex of workshops and rooms where they live. Household activities go on around them. Nearby stand a load of wood for a kiln and stacks of drying pottery made by their fathers, older brothers, and other male relatives.

mold-made cooking pots and jars. These pieces reach a full meter in diameter and in height for cooking pots and jars, respectively. Wheel-made pieces never attain great size, but it is generally conceded that this technique is more difficult to learn than the mold technique.

The wheel technique itself is not conservative: each piece must be produced anew. The proliferation of types and sizes (Figure 2-2) is proof of the inherent flexibility of the technique. However, learning by imitation, reinforced by economic considerations, social attitudes, and values act to conserve style.

The mold technique itself *is* conservative and tends to preserve style. New molds are always made from existing pieces of pottery by the potter himself. And old molds continue to be used for 50 or more years in some cases. How long a mold is used depends on the frequency of use and the care it receives. Others are kept as models or mementos, having been handed down from father to son.

The mold gives form and size to the cooking pot. A flattened circle of prepared clay, called a *tortilla* by potters, is shaped over the mold. Since the tortilla has already been stomped and patted to the desired size on the floor of the workshop, there is practically no excess clay to be trimmed when it is stretched over the mold. I never observed potters measuring the tortilla; they accurately judged the size for any given mold by eye (see Plate 6).

Medium and small molds are placed on a wheel, where a thin ribbon of clay is trimmed from the rim. Large molds are trimmed on the floor of the workshop as they are usually too heavy to be lifted onto the wheel. After a few minutes outdoors, the mold is removed and the piece is moved indoors, where it continues to dry to a leather-hard stage. This indoor period will vary from a few minutes to several days, depending on the size of the piece and on weather conditions. Again, during the rainy season, the drying period is considerably lengthened.

Once the pot is leather-hard, it is smoothed on both inner and outer surfaces, first with a flattened stone, next with water and a piece of leather (see Plate 7). The base is then patted with a stone to modify its roundness. A rolled fillet of clay is attached to form the rim and a second fillet, of equal length, is divided in half to form the two handles, which are attached to either side of the rim (see Plate 8).

A potter sometimes decorates the rim using his thumbnail and fingers to create a design called *repulgada* (translated here as pinched). Sometimes he leaves the rim plain (undecorated). Potters decide to make plain rims or designed rims in response to what they perceive to be consumer preference.

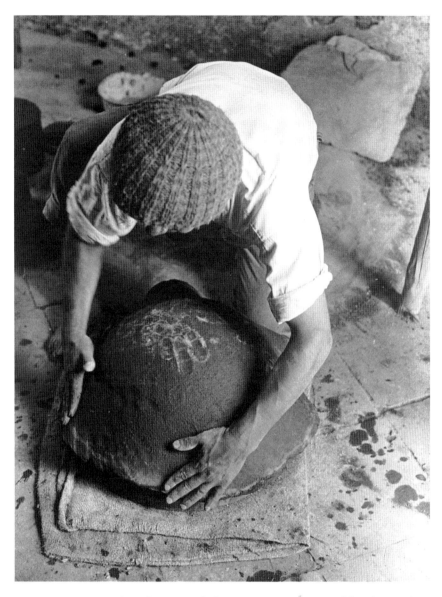

Plate 6. A clay tortilla is first pounded into exact size by a mold maker and then stretched over a mold. The pot shown here will be used daily by families and by small groups.

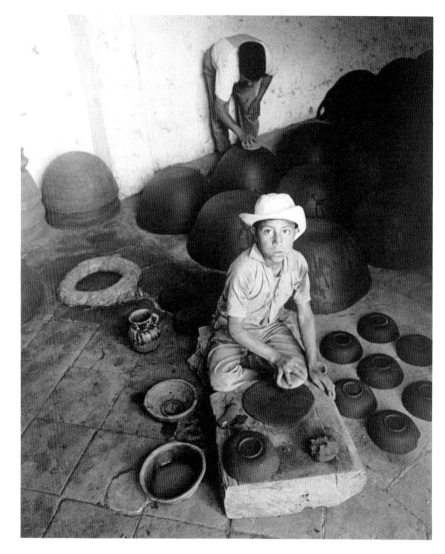

Plate 7. A master potter of large mold-made *cazuelas* (rear) smooths the leather-hard (part of the drying process) pots, while his young son (front) pounds the clay into a tortilla of correct size before pressing it into the small mold at hand to make eating bowls, *cajetes*.

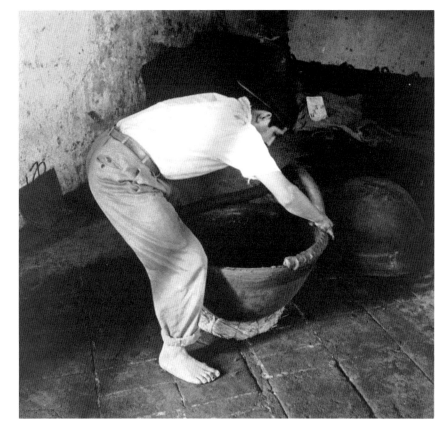

Plate 8. A large clay coil is added to one of the largest mold-made *cazuelas* to form the rim and the handles. The pot rests on a twisted straw ring, which steadies the rounded base. This type of *cazuela* is used for feasts and holds up to two, three, or more turkeys and chickens for *mole poblano* and other prized dishes.

They make two kinds of rims, they explain, because some women prefer the decorated rim while other women prefer it plain. It is clear from their comments that the potters themselves prefer the decorated rim as being prettier. They imply that women who prefer the plain rim are lazy—plain rims are easier to clean. As with other features of form and design, I found the potters to be concerned with aesthetics. They often commented on the appearance of the pots and expressed their preference for some aspect as being more pleasing to the eye. Women, the consumers, were less concerned with the aesthetic aspects and more concerned with the practical considerations of the pottery, such as size, price, and absence of physical flaws, including cracks, chips, rough surfaces, and so on. The exception to this dichotomy is the glaze or finish. It, too, has a decidedly practical consideration: poor glazing causes food to stick to the inner surface during cooking. A shiny, mirrorlike glaze is highly prized for its appearance by both the women and the potters.

Cooking-Pot Production

The three stages of cooking-pot production are the same for both wheel-made and mold-made ware throughout the community: the form, the border, and the ears.

Jars are made in two-part molds: the bottom is called the *asiento* (seat) and the top, the *cuello o gollete* (neck or collar). Each half is first covered with a clay tortilla which is stretched and shaped over the mold (see Plate 9). Joining is accomplished for medium to small sizes on the wheel (see Plate 10). Large jars are joined and finished by hand on the floor of the workshop. The surface is smoothed with a stone and a piece of leather. No rim is added to the jar, and handles are attached later, when the piece is partially dry. *Olleros* who make these jars use the same techniques throughout the community of potters.

The wheel-made vessel is formed by throwing a prepared clay cone onto a revolving pottery wheel. There is no mechanization. All power is supplied by the potter himself on the kick wheel. After the cone is centered, it is opened (*lacra*), then widened to the desired size (*tamaño*), before the sides are drawn up to give the vessel its final shape (*figura*). Potters consider cooking pots "open," while jars and other containers of liquids are "closed." The finished vessel is separated from the clay cone with a thin wire or string, which is drawn across the base. The vessel is then allowed to dry indoors until it is leather-hard. At this stage, it is put back on the wheel. The surface is smoothed and excess clay removed from the base in thin ribbonlike strips with a sharp metal tool (see Plate 11). The vessel is allowed to dry completely before being fired.

The firing crew plays an important role in the circulation of information and the preservation of style of Puebla black-on-red ware. A crew consists

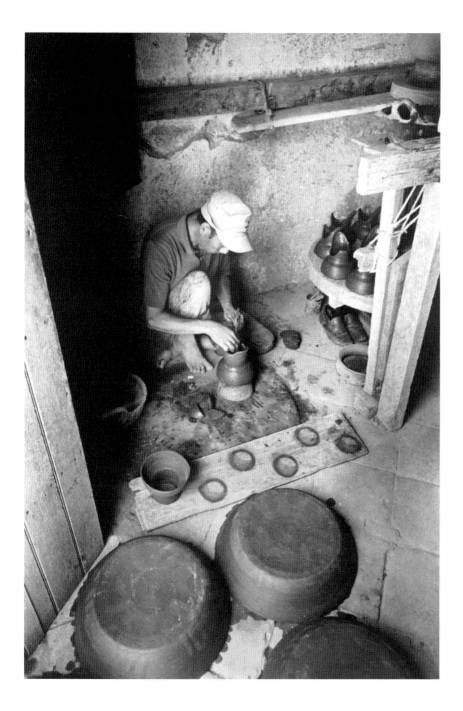

of a master of the kiln and his four assistants. The assistants are hired for each job by the master. Each master tends to have his own crew whom he hires and rehires each time. None of them knows how to make pottery, but it is the master and his assistants who do all the painting and glazing of the pottery, in addition to loading and unloading the kiln. The potter who hires the crew may take part in this stage of production, but it is primarily the crew's function to finish and fire all of the pottery. The crews circulate among the workshops as needed. Each crew decorates the work of the different potters with the same traditional designs. This practice of delegating the decoration to a small group of men hired for this purpose acts to preserve and distribute the style throughout the pottery-making community.

Firing the Pottery

The pottery vessels produced in the barrios are first fired red in an oxidizing atmosphere, painted with black designs and glazed, then fired a second time. The kiln is circular, open on the top, and semisubterranean (Figure 3-1). Wood fuel is used to fire the kiln. Temperatures reach 600 to 750 degrees centigrade in the first firing and 850 to 950 degrees in the second (and final) firing.

The kilns vary in size, as each is built to the specifications of the individual potter, but they are all alike in design and use (Figure 3-1). There were 11 kilns used to fire utilitarian pottery in the early 1970s. They ranged in size from 1.8 m to 3.4 m in diameter and, according to ceramicists and anthropologists with the Dirección General de Arte Popular, Secretaría de Educación Pública, México D.F., they are probably among the largest kilns, if not the largest, in use in Mexico (personal communication 1973). Because many sizes and shapes are fired together, potters are uncertain about how many pieces are fired at one time in a given kiln. However, I made two

Plate 9. When using a two-part mold to make the base of a pitcher, a basic bowl (*cajete*) is made first. The top half of the pitcher is formed over another mold and pinched to form the spout. In the foreground are mold-made, flat-bottomed, open *casos*, which are used to cook and serve rice, stews, and other dishes. Like other *loza colorada*, *casos* are sold in the city and in the far north and south of Mexico.

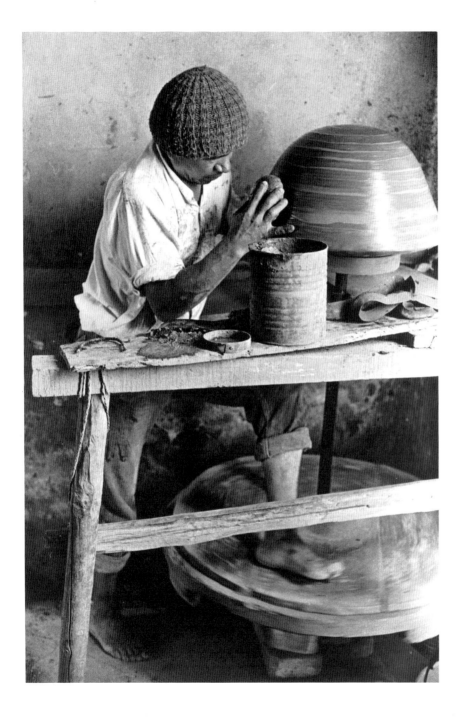

counts on two separate occasions: 1,000 pieces were fired in a medium-sized kiln, nearly 3,000 in one of the largest.

The firing of a kiln is done by a crew working in a team of five men. Each team consists of a master of the kiln and his four assistants. They are responsible for stacking the pottery and firing the kiln and also for glazing and painting all pottery prior to the second firing. There are at present five such teams in the barrios. Each team is hired at a prearranged fee for the three days needed to complete the cycle of work, and the team circulates among potters as needed.

To fire the ware, smoothed, dried pottery is stacked in circular rows, beginning on the open-work grill-like brick floor of the kiln, below ground level, and ending in a circular mound, which rises above the exterior wall of the kiln aboveground. It is not uncommon to have five or six rows of unfired pottery thus stacked and delicately balanced against each other. It is important that the sides be even and the rows secure, which can be tested by pushing the stacked pottery to see if it will move. One potter, who wished to demonstrate his skill in loading a kiln to me (he was acting as his own kiln master on this occasion), pushed heavily with his hands against the outer walls formed by the rows of stacked pottery to show that they would not move out of place. I was apprehensive, but his confidence was well founded; the pottery remained securely in place.

The stacking and loading of a kiln takes from three and one-half to four hours, and it is done by the master of the kiln. He stands on a clay cylinder, made especially for this purpose, in the center of the kiln floor. From this location, he may call out to his helpers to fetch certain pieces, and he places them as they are received. While the stacking proceeds, gray smoke seeps through the brick grillwork of the floor on which the kiln master stands. (The first firing is begun slowly with the start of the stacking process.) When the rows reach the edge of the kiln wall, the master, usually up to his waist in pottery by now, is lifted out of the kiln by his assistants with the aid of a long pole (see Plate 12). He is drenched in perspiration and darkened by the smoke, which is now bellowing up from the kiln. The center space is then filled by lowering pieces of pottery into it on the end

Plate 10. Finishing, smoothing, and final shaping of a mold-made pot is done on the wheel by the mold maker, here, Pedro Ramirez—if the pot is not too large or too heavy to be lifted safely.

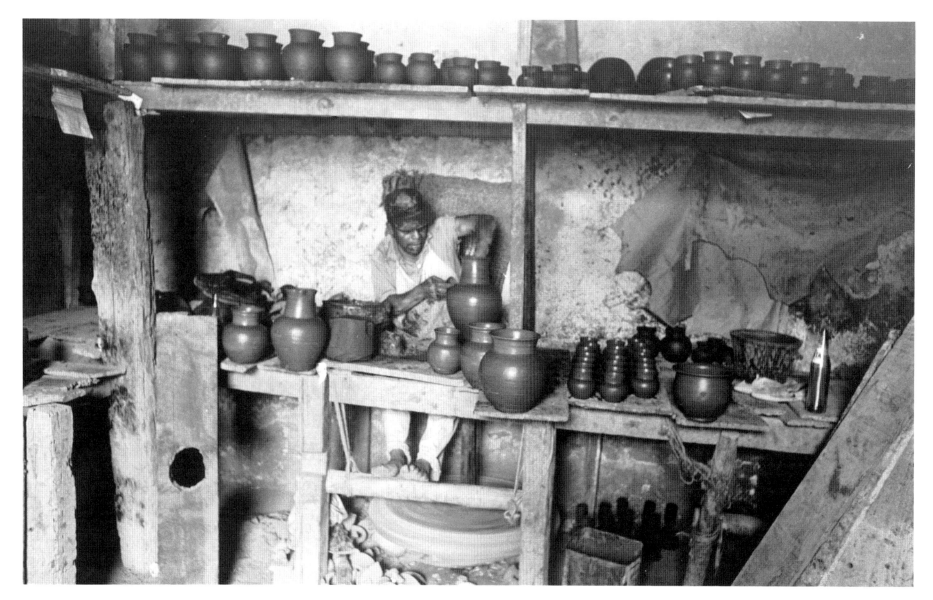

Plate 11. A large *olla* is scraped and smoothed into final shape on the wheel by a wheel potter in his workshop. The master potter shown here, Pedro Rodríguez, is surrounded by smaller jars and cooking pots in the range of types and sizes.

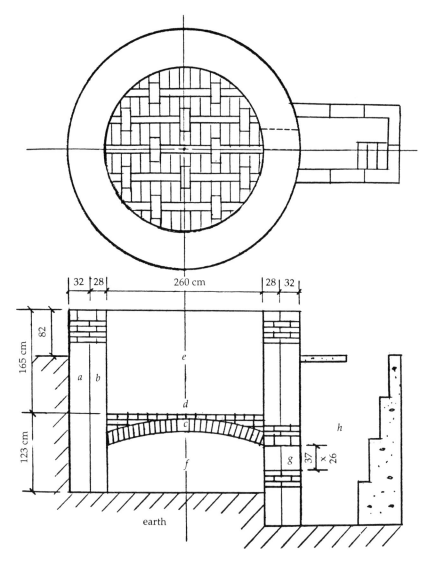

Figure 3-1. Schematic diagram of kiln, Puebla, Mexico, by George L. Kaplan.

a. facing (*forro*)
b. brick (*ladrillo*)
c. arch (*arco*)
d. table (*mesa*)

e. oven (*horno*)
f. ring (*anillo*)
g. firebox (*caldera*)
h. stairs (*escalera*)

of a long stick. The remaining rows that rise above the kiln's edge are now stacked at the master's direction. Then large jars reserved for this purpose are placed around the edge of the kiln, one upon the other in descending size to the top. Between the jars, pieces of wood are inserted all around to aid the fire. Finally, sheets of newspaper are tucked between the columns of jars.

Upon completion of this stacking phase, clouds of black smoke swirl from the top of the kiln. Within the hour, the newspaper ignites into flames that lick out from between the rows of stacked pottery as the hottest phase in the firing process is reached. This phase is judged by the master of the kiln by sight alone. The fire peaks when the pottery itself glows bright orange-red. Until this stage is reached, the master directs his assistants to bring and place wood into the kiln as changing conditions dictate. The kiln is also constantly fed with wood in the firebox belowground (see Plate 13). Then the assistants begin to toss dried cornstalks and corn husks on top of the kiln, along with the sticks they remove from the sides of the kiln. After an hour, this phase comes to an end, and the fire is allowed to subside. The pottery cools slowly overnight. The following morning, it is removed for glazing and painting. The whole procedure, from the start of the fire to the stacking, firing, cooling, and removal of the pottery takes 24 hours.

The first firing is started slowly and is not as hot as the second firing, which takes place after the pottery has been decorated and glazed. The second firing takes longer, up to three hours at its hottest phase, and the heat is more intense, from 850 to 950 degrees centigrade. The second firing also lasts 24 hours from start to finish.

According to potters and members of the firing teams, accidents, or losses of pottery, are not uncommon during the firing process. "Cold" pottery, pottery that is not sufficiently dry, will "pop" during the first firing, and sometimes stacked pottery will slide. I witnessed such an accident in which 30 pieces were broken. The potter and firing crew reacted quickly to stop the slide and appeared to regard the accident with fatalism. No one shouted orders or made accusations of blame for the slide. They all simply moved quickly and quietly to prevent further loss. Each person seemed to know what to do without being told. However, the next day, in separate discussions, the master of the kiln and a potter who had been visiting when the kiln was being fired told me that the accident had occurred because the pottery had been stacked too high. They each noted that the potter firing his products had insisted on stacking to that height, ignoring the objections of the master of the kiln. From these remarks and from those made later by

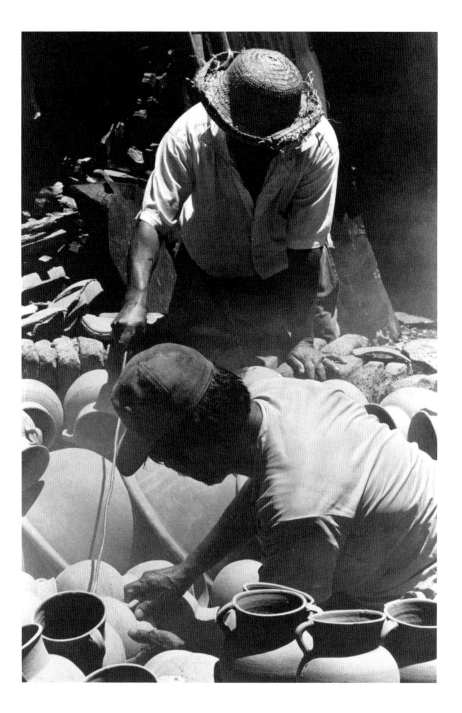

others concerning this same event, it was apparent that there was a consensus in the community that the potter had been unwise to have persisted over the objections of the kiln master. The potter himself never spoke of this accident to me. Although potters and crewmen report that it is not uncommon for some 12 to 15 pieces to be lost in a firing as a result of various causes, a slide such as I witnessed appears to be rare.

Painting the Pottery

The designs, done in a black solution, used to decorate utilitarian pottery are painted (or perhaps "run" is a more accurate description) over the surface of prefired pottery on top of the dried and powdery yellow glaze mixture. The glaze is applied by dipping the pieces into vats of a liquid mixture (*grieta*), which is made from sacks of powdered lead and other chemicals from northern factories combined with water. The painted pieces are then fired for the second and final time. Only the interior surface, rim, and handles of cooking pots are painted. Jars are painted only on the upper half of the exterior surface. Because the lower half of a jar, as well as the exterior surface of a cooking pot, is exposed directly to the flames and charcoal in cooking, these surfaces are left undecorated.

Mold-made cooking pots are traditionally decorated with a single slash across the handles, a swirl on the bottom, and a radiating design of crisscrossed or latticed black lines on the interior surface. The line design is called *cocol* by the potters, and it takes its name from the diamond shape formed by the intersecting black lines. It resembles a popular roll made by bakers, which has the same name and shape. The design is used, too, for jars with two handles.

Sometimes very large cooking pots are left undecorated. Several examples of all-red-glazed cooking pots, between 40 and 50 years old, can still be seen in the kitchen of an old Puebla convent.

The largest mold-made jars are decorated with black spots, which are

Plate 12. The master of the kiln crew stands waist deep in pottery on the smoking, open latticework brick floor of the adobe circular kiln used to fire *loza poblana*. Another crewman uses a metal rod to give the master the last of the pots needed to complete the inner loading. The master is then lifted out of the kiln with the aid of a wooden pole by other members of the crew. The loading continues aboveground from the ledges of the kiln.

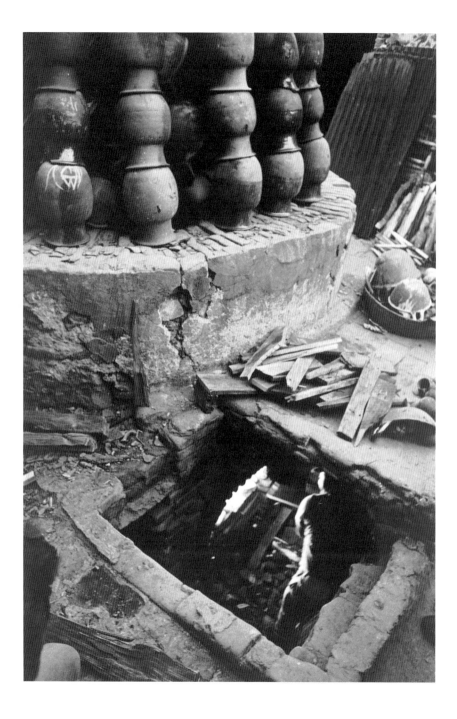

splashed on the neck of each vessel. The spots are called *manchas* and are also known to the potters as black birds of prey (*gavilanes*) and half-moons (*media lunas*). Large jars are occasionally decorated with the *cocol* (see Figure 3-2).

Wheel-made cooking pots of small to medium size are usually decorated with a slash across the handles, a swirl on the bottom, and a radiating design of black stripes on the interior surface. Single-handled jars of medium to small size made on the wheel are decorated with a series of evenly spaced oblique black lines on the upper half of the external surface of the vessel body. The line design on both the cooking pots and the jars is called stripes or rays (*rayas*).

Decorative Ware

The traditional painted designs that appear on utilitarian pottery also appear on decorative ware. The latter, made exclusively for gift giving, is always mold-made and generally resembles the types used for cooking, but it has more elaborate rims, modeled handles, and elements added to basic and special forms. For example, flat-bottomed cooking pots are made in the more usual round and in special oval forms. These pots are of small size and have numerous elements in the shape of stars, flowers, crescents, and others, the results of old buttons being pressed into the exterior surface of the mold used in manufacture. In addition, a small separate mold may be made in the shape of a fish or of an eagle with a serpent in its mouth standing on a cactus. These motifs are sometimes combined with sayings, which are pressed into the mold to create designs in relief on the finished pottery vessel. All the elements appear on the interior surface of cooking pots and on the exterior surface of mold-made jars.

Hand-modeled figures of cowboys (*charros*), young ladies (*catarinas o chinas poblanas*), and roses are among the decorative elements sometimes added to the neck and body of a large jar. Mold-made leaves, flowers, and sayings are among the more usual elements. Effigy jars are also made: a fat man, the head of an Indian, a fashionable turn-of-the-century lady, a high-

Plate 13. A crewman below loads wood into the firebox of the semisubterranean circular kiln when firing *loza poblana*. Above, wasted pots ring the loaded kiln, holding thousands of pieces of pottery, carefully balanced, in place.

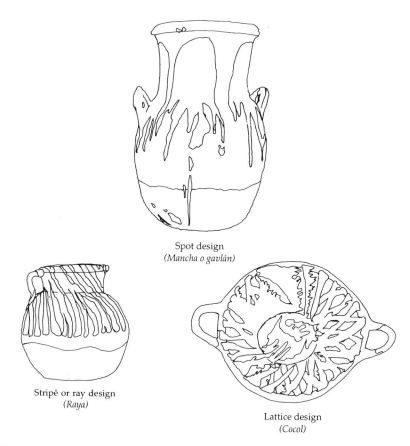

Spot design
(*Mancha o gavlán*)

Stripê or ray design
(*Raya*)

Lattice design
(*Cocol*)

Figure 3-2. Design types, black-on-red ware, Puebla, Mexico, by Elizabeth R. Kaplan.

button shoe, and so on. These jars, like the decorative cooking pots, are never used for cooking; they are therefore given an all-over glaze—inside and outside. At present, there are three potter families engaged in the manufacture of decorative ware in the same style.

The design conventions of the pottery-making community are very strong, as the following incident illustrates. A master potter, who had undertaken to teach me the details of his craft, decided to execute a complete series of jar types on the wheel. He wished to show me the full range that used to be made (many of which are no longer produced) and, not incidentally, demonstrate his own mastery of form. Later, after the series had been decorated, he was quite angry and apologized for the series' not being perfect because a member of the firing crew had painted the "wrong design," as he put it, on one of the pieces. The piece, a jar, a wine carafe, should have had *gavilanes* instead of the *cocol*. Whenever we discussed the series afterwards, he recalled this error. He remained annoyed about it for some time. Except for this incident, I can remember no other time when he openly expressed anger.

4 THE EMERGENCE OF A POTTERY STYLE

I **analyze** the traditional style of black-on-red glazed cooking pottery here in terms of contemporary use and thought and in terms of several broad themes having considerable time depth in the Central Highlands of Mexico. In my analysis, I examine the continuity between the themes manifested earlier in Precolumbian religious beliefs and practices, myths and symbols, and those expressed later in contemporary secular folk pottery. I do not view the themes simply as Precolumbian survivals, nor do I see the style solely as a unique and recent phenomenon. Syncretism and profound changes were wrought by the Spanish Conquest, colonialism, revolution, and independence in Puebla; old themes were embedded in new forms, causing them to be rephrased over time. Nonetheless, many of the indigenous ideas and values that had organized observable behavior and given meaning to life have shown remarkable persistence to the present. While such continuities may be surprising, other ethnographers have made similar observations elsewhere (Furst 1978:6, 132–136, 143). The strength of old beliefs among the Indians was still a cause of great concern to the Spanish priests, a century after the Conquest; and it continued to be so for a long time to come (Coe and Whittaker 1982:vii, 70, 91, 94–95). An analysis of style—in terms of usage, distribution, and reemergent themes—serves to deepen our understanding of the meaning and symbolism presently employed and to sharpen our historical perspective.

Present Pottery Distribution

The city of Puebla is the center of production and distribution of black-on-red glazed pottery. Most of the pottery is sold either in the city itself or in the surrounding countryside. Figure 4-1 illustrates the areas of distribution in Puebla and in other parts of Mexico and Central America. Black-on-red cooking pottery is sold to the north and to the south and east, as far away as Guatemala. The shaded area on the map represents the area of densest distribution and includes the city and surrounding countryside of Puebla, as well as the neighboring states of México, Veracruz, and Oaxaca. Within the shaded area, pottery distribution is most dense 25 to 50 km from

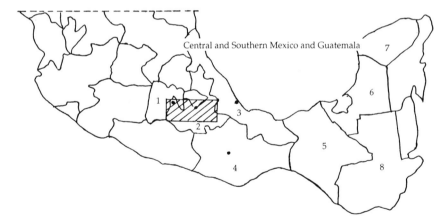

Figure 4-1. Present distribution of Puebla black-on-red glazed pottery in central and southern Mexico and Guatemala. *1*, Federal District; *2*, State of Puebla; *3*, State of Veracruz; *4*, State of Oaxaca; *5*, State of Chiapas; *6*, State of Campeche; *7*, State of Yucatan; *8*, Guatemala; *screened area*, area of intensive pottery distribution.

the city where it originates. Figure 4-2 shows the location of the main markets where pottery is sold in the city of Puebla itself.

The pottery is distributed in several ways. It is sold in retail shops owned by merchants and potters along the main street of the barrio of La Luz. It is bought by consumers, merchants, traders, and vendors directly from potters in their workshops (i.e., in any of the units of production). And it is sold in city markets (Figure 4-2) and outside on the streets. I use the term *merchant* to mean those who buy pottery for cash but who also accept payment in kind. The term *vendor* is used to designate those who have no fixed place of business or capital investment. They neither own property and equipment nor pay rent as merchants and traders must. They deal in cash, generally, in small-scale transactions on an individual basis. Vendors may be seen in or near the markets. They kneel outside on the sidewalks, perhaps a dozen medium to small pieces of pottery neatly stacked in front of them. Most local vendors are women. Some of them are the wives or relatives of potters, others are simply self-employed. Inside the markets, they have no fixed selling place but wander about offering their wares. They pay a small fee to the city each day that they make a sale. One such vendor I know is an elderly woman of 75 years. As a young child, her mother taught her to tie the knots of the fringe of the traditional shawl (*rebozo*) as a trade. Later, after she was married, she began to purchase pieces of pottery directly from potters for resale, a practice she has continued for more than 40 years.

Potters and male vendors sometimes sell in city markets, particularly those in or near the barrios. But they are more commonly found in the regional weekly markets (e.g., the Tuesday market in San Martín Texmelucán; the Friday market in Tepeaca; and the Saturday market in Izúcar de Matamoros, all in the State of Puebla). At these and other markets, potters and vendors sell directly to the people who walk or travel by bus from nearby towns and villages. Merchants who purchase pottery in the city may resell it to vendors or to those with fixed market stalls at these weekly markets.

Merchants may act as wholesalers; and they may own retail shops and fixed stalls in the markets. They are usually men, but women may also be owners. It is not unusual for a widow to continue the family business after her husband's death, especially with the assistance of a son, brother, or son-in-law. The customers are almost always women.

Traders from outside the city of Puebla make periodic trips to the workshops in the barrios to purchase pottery. They do not have a regular schedule. They may come once every three or four days or once in three or four weeks. When they do come, they make the rounds, going from potter to potter, selecting the types and sizes they want from what is then available. Potters do not know in advance when these traders will come or even if they will come.

The traders collect the pottery and, with the aid of their helpers, truck it to a further point, usually a town or village that serves as their base of operations. Some sell the pottery there, but others prefer to sell it in the more remote settlements, where they expect to turn a greater profit. A trader will drive his truck to a point beyond the town, then he and his helpers will leave the road and continue on foot to reach their destination. Often they have taken orders for particular pieces on previous trips, especially for very large cooking pots and jars. When they deliver the pot ordered or make a sale in the hinterlands, they receive payment in the form of seeds, eggs, or chickens, a turkey, or a goat. Both parties to the transaction arrive at the balance by the process of haggling (*regateando*). The products obtained by the trader may be sold in the town at the market for cash, or they may be transported all the way back to the city, where they can be sold for a higher price. Some money from the sale is used to purchase more pottery in the barrios, and the cycle begins again.

There is yet another kind of distribution of pottery in rural areas and distant towns and cities, by a special group of traders known as travelers (*viajeros*). They are traditionally associated with certain towns just outside the city of Puebla and with certain families living in certain barrios in those towns. Magdalena and Amozóc, both within 20 km of the city of Puebla, are known as traditional centers for families of travelers. In the past, they used carts and oxen to transport pottery and accepted payment in kind. Today, they use buses and trains to reach their destinations, which include rural areas and cities, such as Oaxaca, and they accept payment in cash, as well as in kind. They usually do not own trucks but will walk about the town or city, after arriving by train or bus, offering their wares. They remain away from home for up to 20 days' time. They do not hire helpers as traders do, but they may be accompanied by a brother or a son. During the time they are traveling, they stay at guest houses, paying for their room and food. They do not have relatives or compadres with whom they stay, nor do they seem to make any effort to form such relationships.

Each pattern of distribution, whether based on cash or kind, on a daily, weekly, or monthly basis, may vary at any point in the transfer of pottery, produce, or cash. Therefore, the potters cannot fully anticipate the demand,

and the sellers can foresee neither what the supply will be nor the amount of cash or the kinds of products they will receive in exchange from consumers. All of the patterns operate simultaneously: potters, merchants, vendors, traders, and travelers distribute the pottery in the Mexican states of Puebla, México, Veracruz, Oaxaca, Guerrero, Morelos, Chiapas, Campeche, and Yucatán; and in Guatemala.

Past Pottery Distribution

In Preconquest times, interregional trade routes supplied the Valleys of Mexico and Teotihuacán and the Aztec capital of Tenochititlán with bulk imports, and manufactured goods were exported out. The Puebla area provided trade goods to Texcoco, 24 km east of Tenochtitlán; the Valley of Toluca provided goods to the Azcapotzalco-Tlacopan area, to Morelos, and to the Chalco region (Hassig 1985:61).

Lakeborne commerce was active, and canoe traffic linked the entire lake system of the Valley of Mexico (Hassig 1985:60). Overland trade was based on a labor-intensive system of human carriers (*tlamemes*). Later, in the colonial period, following the drastic decline in the native population from 1540 to 1630, the necessary human power was lacking to expand the trade. Mule drivers (*arrieros*) and wagon drivers (*carreteros*), part of the Spanish-introduced system of transport, became essential for trade. Human carriers continued to operate on a limited scale, both apart from and together with the Spanish drivers (1985:170–171). The indigenous picture of trade and tribute was a complex one that is only beginning to be understood (Hodge 1984:142, 150; Spores 1984:57, 62, 83–84).

In the colonial period, it was the introduction of new goods either for Europeans or made by Europeans that led to the expansion of long-distance trade. Indian and European traders went south and north to and from the Mixteca Alta; to and from Guatemala, Tabasco, Chiapas, Yucatán, Oaxaca, Mixteca de la Costa, Mixteca Baja, La Cañada; to Tehuacán, Veracruz, Puebla (Ciudad de los Ángeles), and México. They went with maize, beans, rice, wheat, flour, *cochineal* (dye stuffs), silk, wool, and animal hides from the Mixteca Alta and returned with European textiles, metalware, jewelry, firearms, finished leather goods, candle wax, wines, and olive oils from Spain via Veracruz, Jalapa, Puebla, and Tehuacán. European and East Asian ceramics from the Philippines and Spain were traded by way of Huatulco, Acapulco, and Veracruz or were manufactured in Puebla (Spores 1984:135). In the sixteenth and seventeenth centuries, foreign goods were tightly controlled and taxed by the crown. Some of these goods included European and Asian pottery, wine, olives, and spices. But Indian products and resources moved relatively freely through the colonial economic network (1984:138–139).

Distribution of black-on-red glazed pottery underwent a marked change in the nineteenth century with the introduction of capitalism and railroads. Puebla pottery was then shipped more widely than before, when only human transport, carts, and oxen or horses were used. Pottery was issued to workers on plantations at lower altitudes, who used it to cook their meals. Later, trucks and buses carried the pottery from the trains for a fee. Unlike the Staffordshire pottery in England, which declined with the industrial revolution, the industrial revolution in Mexico, which began in Puebla and was heralded by the establishment of the textile factory La Constancia in 1835, led to increased demand for cookware. From 1876 until the Mexican Revolution of 1910, capitalism expanded rapidly, and Puebla pottery reached its peak of production and boasted its maximum number of workshops (13).

The fighting that ensued after 1910 lasted until the 1920s. The eventual calm that preceded World War II and the many political, economic, and social changes since then have greatly affected the production of black-on-red ware. These changes have resulted in a decline in the number of workshops and potters and in the adoption of other vessels entirely (e.g., china, enamel, and plastic, as well as glass substitutes). Nonetheless, traditional pottery continued to be made in the same styles as before, although a smaller range of types was produced. Consequently, its role as regional and national cultural markers continued to be strong.

The preceding discussion compresses a great deal of history, and it calls attention to those events that have, for the most part, created change, as well as maintained continuity, in the pottery-making community. In an ethnohistoric context, there is an opportunity to examine known events against the material record. In an archaeological context, such opportunities are generally unavailable and, therefore, seldom pursued. Some recent efforts to correlate sociopolitical events and artifacts, however, especially events emanating from major centers of power, indicate that change may lag behind in locally differentiated patterns (Flannery and Marcus 1983; Hodge 1984; Spores 1984). Thomas H. Charlton's pioneering studies of Late Classic Aztec ceramics, in the more remote areas of the Valley of Teotihuacán, verified that the Spanish Conquest of 1519–1521 was not readily reflected in rural ceramic production (Charlton 1969:176–177;

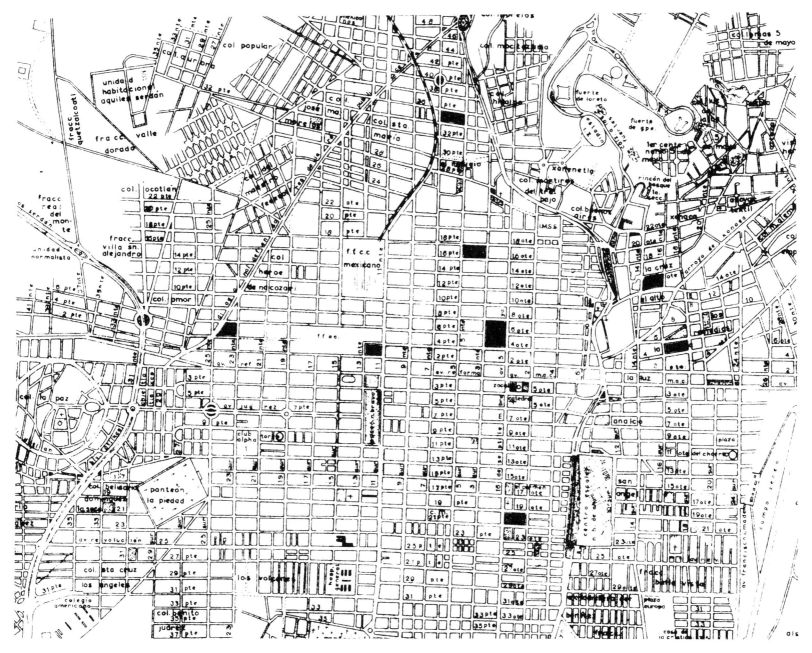

Figure 4-2. Distribution of Puebla black-on-red glazed pottery in the markets of the city of Puebla.

1976:28). And Aztec pottery production continued into the sixteenth and seventeenth centuries elsewhere as well (Müller and Hopkins 1977:36, 53). In Morelos, archaeological investigations have also demonstrated that important political and economic changes in relations with the Valley of Mexico were not monitored in classes of artifacts (Smith 1983:49). Other findings show that change could also be abrupt under favorable market and local conditions (Neff and Bishop 1988:518–519). Thus, it appears, each region and site and its production variables need to be examined in the specific contexts of time and place.

Pottery Usage, Present and Past

Present-day usage of black-on-red glazed ware takes place in varied settings. Some are festive, requiring special types and sizes; others are part of everyday life at its most ordinary. On fiesta days, the crowded churches are alive with fresh flowers—pink, red, and white gladioli, roses, and carnations—massed in tall dark vases beneath the pitying gaze of gilded patron saints. Inside, votive candles light women's faces bent in prayer while their babies, tightly wrapped in shawls (rebozos), sway rhythmically against their chests. Outside, the plaza is ringed with booths where food and drink are cooked and sold in traditional pottery, and games of chance are played. The cantinas are filled with men, drinking and laughing. Children beg for a ride on the Ferris wheel and watch the puppet shows set up in the street. By nightfall, strings of lights across the plaza and outside the church set the stage for the blaze of rockets and fireworks that sputter and streak across the darkened sky. The night is filled with band music and punctuated by the sound of pistols fired in exuberance.

The balance, so precariously maintained in daily life, explodes during the fiesta. "Life and death, joy and sorrow, music and mere noise are united, not to re-create or recognize themselves, but to swallow each other up. There is nothing so joyous as a Mexican fiesta, but there is also nothing so sorrowful. Fiesta night is also a night of mourning" (Paz 1961:53). It is, as D. H. Lawrence observed, as if the "instant moment is forever keen with a razor-edge of oblivion, like the knife of sacrifice" (1950:50).

Feasting accompanies all ceremonial occasions: baptism, confirmation, communion, and marriage; Christmas and Easter celebrations; a festival of any local patron saint, a saint's birthday, or a saint's day; the dedication of a new house, a workshop, or even a car. No occasion is properly observed in Puebla without mole, the prized turkey or chicken in chili sauce, prepared in the traditional black-on-red cooking pot. Drinking such beverages as pulque, chocolate, atole, various herb teas, as well as coffee and punch, is associated with the use of small pottery jars (jarros), and special jars (velorios) are made for use during the deathwatch preceding a burial. Pottery is associated with the most important and the most joyful occasions of life, in which family and friends, worship and excess, are joined together for the moment.

At noontime, young boys and girls are seen in the streets carrying pitchers and ollas filled with foaming pulque for the daily meal. As the sign says at the local pulquería, "soldiers, dogs, women, and children" are not allowed inside. But a separate window at the side entrance is provided for dispensing pulque into the waiting ollas of those who cannot enter. On their way to and from their school, the market, and their errands in the barrios, children pass pottery drying on wooden boards placed across the sidewalk and curb; they see it being carried in nylon bags to market for sale, and being loaded on hand trucks and larger trucks for transport out of the city. Pottery is used in the bars, restaurants, and homes on a daily basis and is, therefore, readily visible to all members of the community.

Other regional pottery styles are sold in the markets. They are distinct in color, form, and decoration, each being identifiable and identified with particular regions and towns. These wares serve as group markers in their own regions because they too are associated with their own social classes and events in the life cycle. Such pottery has strong emotional appeal; it is closely tied to food and family.

The importance of food, and of the pottery associated with it, is evident even in the humblest Puebla kitchen. Black-on-red storage jars may be found unused, stacked in descending size order, mouth down, in kitchen corners. A large water jar, more than 60 cm high, usually stands nearby, the drops of moisture clinging to the outside of the jar proof of the coolness of the water inside. Food is simmered in a cooking pot on a clay charcoal brazier, as it was in centuries past. Cooking pots of different sizes, not in use, rest upside down on their ears, one inside the other. Today, a tin brazier, a two-ring gas burner, or even a gas stove may be found in a humble kitchen.

The renowned kitchens of the wealthy and of the religious orders of Puebla once boasted long counters of brick, gaily faced with blue-, yellow-, and white-glazed Talavera tiles, into which charcoal braziers were set. The counters were usually found along an entire wall and were sometimes freestanding, like an island, near the center of the high-ceilinged kitchen.

All four walls were hung with pottery, interspersed with copper pots and pans, according to the taste of the master or mistress of the house. The pottery, stacked in the corners or hanging in cascades of sizes and shapes on the walls above the counter with its numerous braziers, testified to the size of the family or order, the numerous guests entertained, and the generosity and status of those who lived within.

The daily preparation of traditional Mexican food is tedious and time-consuming. Many ingredients and condiments must be ground and blended, and the cooking process itself is slow, especially in pottery vessels. Stews are made of meat, innards, and fowl; soups, vegetables, and sauces are prepared with seemingly endless varieties of fresh and dried chilies and eaten with tortillas at the main meal. This meal is usually served in middle- and upper-class homes between two and four o'clock and in lower-class homes around noon.

All food is prepared and freshly cooked each day. Men and women of all classes are quite sensitive to the aroma, taste, and contents of each dish. It is not unusual for someone to notice whether a cooked chicken had been refrigerated before being placed in the pot. This is a fine distinction, indeed, considering that all chickens are freshly killed and invariably eaten the same day in Puebla. People claim that refrigeration, even for a few hours prior to cooking, changes the taste and can be discerned. Their sensitivity to, and preoccupation with, food was striking to me. Questions concerning the uses of pottery vessels brought forth lengthy, enthusiastic recitals of the dishes and pottery types associated with them. These recitations were always accompanied by lip smacking and other sounds that indicated the vividness of their gustatory memories. A list of the necessary ingredients, the seasons when they could be expected to ripen, and the appropriate occasions for serving various dishes were readily supplied by those questioned, men and women alike.

At mealtime, in middle- and upper-class homes, the mother stands at the head of the table as she serves each course. She serves herself first, then her husband, then her children. In all other situations, she is generally modest and submissive. At home, at the dinner table, she reigns. Young brides are well aware of the importance of food. Several girls told me, "If you do not cook well, he will continue to eat at his mother's house." And several young men, when questioned, listed "being a good cook" first among the qualities they looked for in a wife.

In lower-class homes, the men are served first. They eat separately, before the rest of the family is fed. A daughter or wife will see to it that there is a continual supply of hot tortillas accompanying the beans, chilies, and perhaps the egg or stew that is served at the main daily meal. If a man is unable to return home to eat, the food is taken to him by his mother, wife, or daughter. In the city, where there has been rapid industrialization on the outskirts, it is still common for a wife to deliver her husband's meal to him at the factory in black-on-red pottery. For ceremonial occasions, the traditional mole that will be prepared is eagerly awaited and talked about for days in advance. Invited guests are assured that mole will be served, although they surely know it already. Thus, women are the source of food and satisfaction on a daily basis and the source of family pride on ceremonial occasions.

Before 1930, Puebla pottery was widely used for cooking by the rich and the poor in the city, town, and countryside of the region. Since then, gas stoves, refrigerators, and metal cabinets have begun to replace the charcoal braziers and wall hooks of the traditional Puebla kitchen. Wealthy women were the first to modernize their kitchens as they were already familiar with European and American cooking styles and menus. The "servant problem" now beginning to emerge has simply accelerated this change. In addition, many of the newly rich, created by rapid industrialization in Puebla in the last two decades, are Europeans (mostly Spanish and German) and Arabs, whose food habits are not rooted in the Mexican past.

Today, many middle-class women are working away from home. They and their daughters are becoming secretaries, clerical workers, saleswomen, teachers, and so on. The gas stove, the blender, and the pressure cooker have become necessary to their new way of life. Poor women, the wives and daughters of farmers, factory workers, craftsmen, and laborers, continue to use the old laborious methods of food preparation: brazier, hot plate, or gas burner; stone grinder and pottery mortar and pestle. They still depend, too, on pottery vessels for daily cooking.

The prospering middle class and upper class now often purchase mole, ready-made, in the markets for their own consumption on special occasions. But they see to it that mole is freshly prepared and served, along with other traditional dishes, in clay pottery vessels at fiestas for their workers, at political gatherings and dinners, when they entertain foreign guests, and on weekends in the country, where a rustic life-style is adopted. On these occasions, when Mexican and foreign-born owners of industry, business, and land, when politicians and members of government interact with other classes in society or with outsiders (non-Mexicans), they seek to express a common "Mexican" identity through the medium of pottery vessels and the food and drink intimately associated with them.

The expressed preference of President Álvarez Echeverría and his wife for Mexican handicrafts was felt in the Puebla region (1970–1976). The wealthy, sometimes called *malinchistas* because of their distaste for Mexican things, followed his initial lead in some ways. It became fashionable to have the husband's morning eggs cooked and served in a pottery casserole; and in the 1970s, the prestigious Flower Club in the city of Puebla included a number of arrangements in black-on-red ware. When Sra. Echeverría visited Puebla in 1973, this same ware was used to prepare and serve the food for the reception. In elevating folk arts to the national level, the president and his wife called for pride in heritage and Mexican solidarity among the various social classes by using secular symbols imbued with the traditional values of home and family, individual and nation, life and death, which have persisted for generations.

Symbolism, Present

People acquire their pottery for use in "the struggle" (*la batalla*), which is to say, daily life. This trenchant phrase, widely used in Puebla and the Central Highlands, exposes their view of life as a battle for existence against the forces of death. An encounter between friends often begins with the question, "What are you doing?" ("*¿Qué haces?*"). The expected answer may be translated, "the usual" or "getting along," but translated literally it means "here [on earth], fighting for life" ("*Aquí, luchando por la vida*"). I prefer the latter translation, though awkward in English, because it captures the feeling of the exchange in Spanish.

The sense of struggle pervades pottery making. Potters do not speak of making pots, they speak of *conquering* the clay. Crewmen call to each other as they work to fire a kiln using the terminology of the bullring. They refer to the sticks of wood they plunge into the stacked hump of pottery rising above the edge of the kiln as *banderillas*. The men who deliver the pottery to the city markets on wheeled carts or hand trucks refer to these as *the devil* (*el diablo*), which conveys the torturous labor of transporting their earthen loads. These and other terms are expressive and dramatic ways of describing and thinking about the activities surrounding pottery manufacture and distribution as they are seen in terms of *la batalla*.

At the same time, life is seen as a dream, a conception that contains an element of resignation because the dream must end with waking, as life with death. Perhaps, then, death is the only reality, and this sense of its palpable existence, its closeness, may at least partially account for its

acceptance by the people of this region. They express no fear of the dead. The most frequent reply to my question on the subject was essentially the same among all strata of society: "We are more afraid of the living than [of] the dead" ("*Tenemos más miedo de los vivos que los muertos*"). It was usually said with a smile and a knowing glance at those standing by who were quick to affirm the statement.

When a death does occur, it is the custom for friends and family to visit and stay with the corpse through the night until burial the following day. Coffee spiked with liquor, *aguardiente*, is served in a distinct type of pottery jar, called *velorio*, made specially for the vigil.

The dead are remembered and welcomed each year with flowers, food, and drink on All Saints Day (*Todos Santos*) and The Day of the Dead (*El Día de los Muertos*), a period of observance in Puebla from October 27 to November 2 (see Plate 14). In addition to the market displays, a home altar is arranged with all-black-glazed candlesticks, incense burners, and jars for holy water and pulque (see Plate 15). These all-black pieces, as well as the *velorios*, are made by the same potters who make black-on-red glazed utilitarian pottery, but the black ware is made and sold only for the Festival of the Dead (see Plate 16) (Kaplan 1990).

Each year during *Todos Santos*, the entire family, including children, visit the grave sites of relatives. They weed, wash the headstones, and make necessary repairs. Flowers are lavishly arranged, incense is burned, and candles are lit. Until recently in Puebla, the family spent the whole night in the cemetery praying, talking, and eating the food they had brought with them in black-on-red pottery. This custom of staying through the night has now been forbidden by the city authorities; but it is still permitted in nearby towns and villages. Potters and others explained that, since the spirits returned once a year to be with their families, they would go to the cemetery to make them happy and keep them company. As they repeatedly pointed out, "Why should we be afraid when we must all die and, after all, that is life!"

Acceptance and resignation in the face of death are given an ironic twist in the figures and toys made for *Todos Santos*. Skeletons are modeled in a fine show of life—as musicians, cowboys, newsboys, demure young girls, ladies, gentlemen, and others. It is as if people are aware of the great joke life is playing on them. All paraphernalia of the living are hung on skeletons. One toy I purchased in the marketplace is a small black wooden coffin with a string at one end. When the string is pulled, the lid opens and a grinning white skeleton suddenly sits up. This toy and others like it are given to

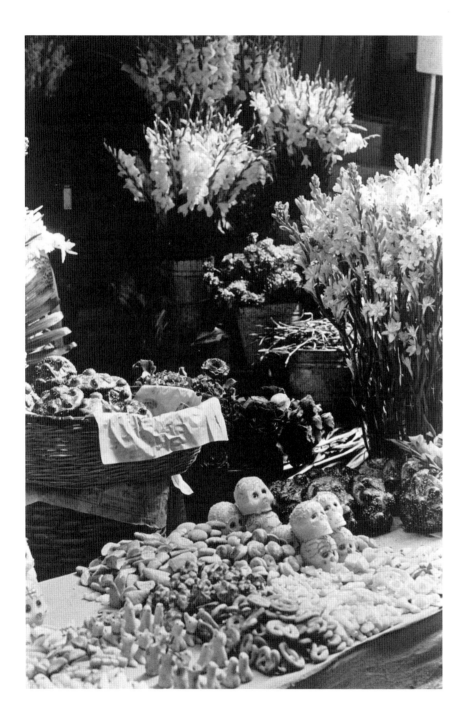

children. I was told of a visiting Frenchman who, invited to dinner in an elegant Mexican home during the Festival of the Dead, was horrified to discover his favor at the dinner table was a spun-sugar skull with his name on it. To the Poblanos there is nothing macabre in this practice. This attitude toward death is widespread; as Octavio Paz observes, unlike the European, "The Mexican . . . is familiar with death, jokes about it, caresses it, sleeps with it, celebrates it; it is one of his favorite toys and his most steadfast love" (Paz 1961:57).

Life and death are opposite parts of the whole, and one may quickly change to the other: "Whenever a Mexican cries Viva! he ends up with Muera! When he says Viva! he really means Death for Somebody or Other!" (D. H. Lawrence 1955:40). It may be, as some ethnographers have suggested, the threatening nature of the environment, with its frequent earthquakes, floods, sudden storms, and bolts of lightning, along with the unpredictability of human social relations, combining here to create a threatening atmosphere. Certainly, violence and sudden death, frequent illness, lack of resources and viable alternatives are ever present. They create a disturbing backdrop against which we struggle for life.

Humans are fragile; we are made of clay as we learn in Genesis 2:7. Jeremiah, patron of the potters, likens humanity to clay and pottery in the Bible (18:2, 4, 5; 19:2, 3, 4, 10, 11, 12; 51:34). Potters extend the analogy. They say jars are like men, closed and erect, while cooking pots are like women, open and yielding. An aberrant vessel, which combines the two forms, jar and cooking pot, is sometimes made as a joke for a prospective bridegroom; it is called a *joto*, which is slang for homosexual. There are many popular sayings in Puebla that compare men who are quick to anger with jars, since jars, having round bottoms, are easily upset.

That clay is associated with life is evident in practices related to pregnancy. Eating clay is common. Pregnant women select clay that has a certain strong, warm aroma. The importance of the aroma may be related to the idea expressed by potters that clay is not just earth but "the flower of the

Plate 14. At a market display of goods for Festival of the Dead, flowers for offering tables and church altars, bread for the dead, and many kinds of miniatures and sweets are offered. Items for sale in Puebla before the festival begins include spun-sugar skulls, *calaveras*. The symbolism of skulls and flowers recall Precolumbian beliefs and practices; the breads and sweets are additions of the Spanish colonial past.

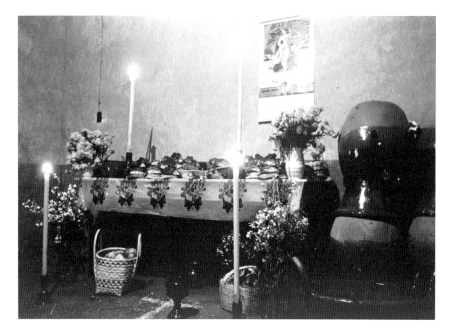

Plate 15. Dishes of food, breads, candies, cigarettes, liquor, fruits, and other things once enjoyed by departed loved ones are set forth on and under home-offering tables, *ofrendas*, for the Festival of the Dead. Black ware—candlesticks, incense burners, and pitchers to hold holy water—is set out; *loza colorada*, made by the same potters, is used for mole and for fruit-flavored waters.

earth" (*la flor de la tierra*). The clay from Puebla is aromatic and considered very good for eating, as is the clay from Guadalajara. The desire of pregnant women to eat clay is expressed in terms of "nature" or "the natural order of things" (*la naturaleza*): they feel that the life growing inside the woman desires to partake of the earth. Thus, the act of eating is a kind of communion, with the new life being nourished by the clay.

Conversely, clay is also identified with death. Death and dangerous things are "cold" (*frío*), and clay, too, is cold. A potter who takes part in firing a kiln will not enter his workshop for two or three days afterwards. The harm that would result from mixing hot fire with cold clay is the reason given by potters for the existing division of labor between those who make pottery, the potters, and those who fire it, the crewmen.

A woman who wishes to abort or prevent conception will drink the water of the clay (i.e., the water off the top of the glaze solution) if she can

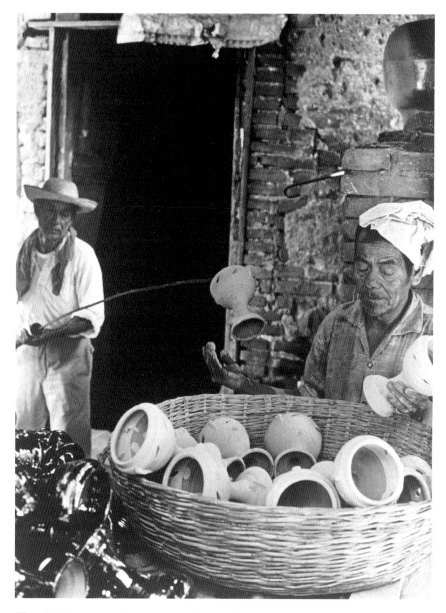

Plate 16. Long metal rods are used to load all-black-glazed incense burners into the aboveground, rectangular brick kiln reserved for black ware. The mirrorlike ware is made all year but is fired only in the weeks preceding observance of *Todos Santos* and *El Día de los Muertos*. Intense heat marks the firing. Already-glazed candlesticks of the shiny black ware are seen in the left foreground.

persuade a potter to sell her a glassful. The practice is known to be dangerous: women have become sick, and some are said to have died from it. Because it is also known to cause sterility, farmers who want to fatten their animals will give them this water to drink.

Life and death have also been associated with colors. Black is the color of death and night, but it is also regarded as beautiful. For this reason, the Aztec were apparently fascinated by black and gleaming things. Black Obsidian Butterfly, their goddess of fate, wore symbols of death on her face; nonetheless, she was considered the ultimate in beauty (Burland 1968:ix, 90). Black Obsidian Sacrificial Knife (Iztlacoliuhqui) was another form of the night god, Tezcatlipoca, Smoking Mirror (Caso 1953:44); and the black vulture also symbolized riches (Burland 1968:90).

The black designs on contemporary pottery are highly admired, especially for their reflections; and all-black pottery, used for *Todos Santos*, with its mirrorlike surface is most appreciated by potters and considered beautiful. In the context of daily life, the luster of the black designs deepens with the grease of rich foods and conveys a feeling of satisfaction and well-being to the users of the pottery. Black, the color of night and the underworld, is sensual, evoking thoughts of the riches hidden in the earth, of the danger and sin hidden in the night, of dark places and the underworld as the source of life. Poblanos are fascinated with death, as the Aztec were long ago. It is perhaps as Octavio Paz says, "We are seduced by death" (1961:58).

Red is the color of life; it is the color of blood, of the heart, and of love. A man who is passionately in love sends his sweetheart red roses. A mother protects her infant from the evil eye by tying a red string or ribbon around his or her neck or clothing. It is "red" rice that is served at fiestas. The curer at work always includes a red string, a red flower, and "red" eggs in his fight against envy and bad spirits seeking to inflict harm.

The colors of Puebla pottery, as they are conceived today, are the colors of life and death counterbalanced in design. Lines, spots, and swirls of black encircle the red pots, a representation of the cyclical view of the universe held and verbalized by potters and users, a representation of the desired balance between the forces of life (red) and the forces of death (black). For the Aztec, red and black were symbolic of an eternal celestial battle fought each morning: by day, Quetzalcoatl, the Plumed Serpent, against the black god of night, Tezcatlipoca, Smoking Mirror. The balance, when struck, though temporary, ensured the continuity of life, but it was not won without a struggle. This is how the Aztec saw their ancient world and how the Mexicans see their world today.

The themes expressed in the ancient Precolumbian "pulque complex" persist today, although the modes of expression and the contexts in which they may be found have changed. An analysis of the motifs shows the present style of black-on-red pottery to be related to the themes contained in the ancient complex. The native religion that provided the conceptual framework for Precolumbian life is no more. Pulque is no longer integral to worship, and drunkenness is no longer the prerogative of old men and warriors. The context now is secular: working men and women drink pulque with daily meals at home, in the workplace, and in bars, at fiestas and celebrations. Yet, the ancient association of pulque with visions and flowers remains. If pulque's effects are no longer celebrated in murals on sacred pyramids, they are still written on the walls of popular bars in the barrios: "The Happy Dream" (*El Sueño Felíz*); "Dreams of Bacchus" (*Sueños de Baco*); "The Monkeys" (*Los Monos*); "The Great Ones" or "The Big Ones" (*Los Grandes Buenos*); "The Great Flights" (*Los Grandes Vuelos*); "The Camellia" (*La Camelia*); and so on. It is not uncommon for a man drunk on pulque to refer to himself as "the king of the flowers" (*soy el rey de Xochitl*).

Similarly, the idea that pulque is nourishing finds expression in a popular saying: "Pulque is only a little less nutritious than meat" (*"Pulque sólo falta un grado para ser carne"*); and for poor people today, pulque is far more obtainable. In the not too distant past, people of all social classes in Puebla and elsewhere in Mexico drank pulque. Madame Calderón de la Barca, wife of the first Spanish ambassador to the newly independent country of Mexico, noted in her journal in 1840 that pulque was then the universal beverage outside of Mexico City. It was served at formal dinners, as well as at other meals (1970:228, 352, 353). Indian men and women drank theirs from little earthen jars, she noted, frequently becoming drunk (1970:183, 428, 450).

In fact, the maguey cactus used to make pulque, the *Agave atrovirens* and the *Agave americana*, provides calories, as well as vitamin C (48%), thiamin (10%), niacin (23%), calcium (12%), and iron (12%). Pulque has traditionally been an integral part of the diet in the Central Highlands, at least since the Conquest. Pulque, the fermented juice of the cactus, contains between 5% and 8% alcohol. Its consumption was concentrated in the areas where the cactus grew naturally, in parts of the states of Puebla, Michoacán, Querétaro, and especially throughout the states of Tlaxcala, Hidalgo, and México up to the Federal District. This area and the Central Mexican Plateau area roughly correspond and is where the Aztec dominated prior to the Spanish Conquest. The piercing of the "heart" of the maguey to extract the

Figure 4-3. Detail from *The Pulque Drinkers*, a mural, Cholula, Puebla, Mexico, by Elizabeth R. Kaplan.

honey water (*aguamiel*), as it is called, and the "emasculating" of the plant in the process gives expression to the intense relationship between human and plant in the collection, preparation, fermentation, and consumption of pulque—in ancient times, in the historic period, and in the present (Fournier 1979:6, 9–10, 11). The fermentation process was a closely guarded secret throughout the colonial period; and women were not allowed into the places where it was fermented because the spume, or scum, was seen as the male effusion (Fournier 1979:15–19).*

Bars called *pulquerías* specialize in selling pulque, and they serve it both in small individual pottery jars and in larger ones that are shared by friends and acquaintances. In such bars, glasses of special shapes and names and gourds (*xícaras or xomas*) are also traditional and may be used. In Puebla, there was also a flourishing glass industry, which produced the variously

* It is customary to give black-on-red ware sauce bowls as wedding gifts. Sometimes, when the bowl is presented to the groom by his friends, it is filled with pulque, with bananas floating in it as a joke. The references to fertility and sexuality are evident. The same potters make erotic drinking vessels in the form of male genitals. Pulque pours from a spout in the shape of a penis when the jar is raised for drinking. These practices leave little doubt that pulque is identified with semen as well as with mother's milk.

named shapes and types of glasses for pulque. These glasses were exported to nearby places where pulque was drunk and displayed in local bars up to the twentieth century (Guerrero 1980:160). The gourds are identical to those depicted on the mural *The Pulque Drinkers* at Cholula (see Figure 4-3). It is customary not to drink the last drops of pulque but to fling them from the vessel onto the barroom floor and interpret the resulting design. Men may also wipe the remaining foam of the pulque from their mustaches and fling the drops away with a quick motion of the hand. These designs, too, are interpreted with the assistance of bystanders, usually friends. Those that form a tail (*cola*), either a swirl or an S-shaped design, are called a scorpion (*alacrán*) and are considered a very lucky sign, which was a surprise to me because scorpions are feared and even cause a number of deaths in Puebla each year. Several of my informants had lost a young brother or sister in that way. However, I recalled that the scorpion was also associated with Quetzalcoatl, pulque, and the Milky Way (Caso 1953:41). A similar tail, a swirl design, is always made on the bottom of black-on-red cooking pots, and it is surrounded by radiating lines used to represent the heavens. The whole pot, then, may be seen as a reenactment of a daily and ancient celestial battle, captured for the moment, and affirming the continuity of life.

Throughout the Central Highlands, bars have picturesque names like "The Sultan" or "The King" (*El Sultán*), "The Butterfly" (*La Mariposa*), and "The Aviator" or "The Flyer" (*El Aviadór*), which capture the sense of the ancient associations of pulque in modern guises. The associations are carried further by the wreaths of flowers that encircle the names of the bars and the sayings, poems, and songs that often accompany them (Guerrero 1980:32, 162, 168–196, 209–210). References to *xochitl*, or flower, and the Aztec goddess of flowers, *Xochiquetzal*, punctuate these rhymes and songs as they do in Puebla. The notions of poems, speech, and songs are rooted in the words *xochitl* (flower) and *cuicatl* (song), which were called down from heaven in ancient times to worship and to express birth and rebirth (Bierhorst 1985:17–18, 21). Likewise, as in Puebla, a sense of national pride and identity are given spirited expression: "*Champaña, tinto, y jerez, escondanse avergonzados, o marchen precipitados, para su tierra otra vez*" ("Champagne, wine, sherry, hide your pride and go quickly, to your land once again").

A design of crisscrossing lines is used on the interior of cooking pots, and it appears on the exterior of medium to large jars. The design, called *cocol* by the potters, as does the shape of each jar, bears a striking resem-

blance to the pulque jars in the codices (Guerrero 1980:36, 53), where these large storage jars are shown encased in knotted ropes to facilitate their transport (see Figure 4-4) (Gonçalves de Lima 1956:132, 153, 154, 169, 204).

Spot designs, also called hawk and half-moon by the potters (*mancha*, *gavilán*, and *media luna*), are other forms of decoration used on large jars. These designs, too, have a long association with pulque, the night sky, and the moon. The jaguar skin worn by Tezcatlipoca was spotted (*manchada*) to represent the many stars that always accompanied him; and the moon itself was spotted (Caso 1953:25; Gonçalves de Lima 1956:134). A schematic representation of the semilunar nose ornament of the pulque gods some-times appears on large jars in the Precolumbian codices (see Figure 4-5) (Gonçalves de Lima 1956:136). Inverted, the ornament may be seen to resemble the present-day spot design or black birds and hawks (1956:209, 211).

The oblique lines on medium to small jars, the bands or stripes (*rayas*), represent lightning and the heavens and storms controlled by the black god of the night and the north, Tezcatlipoca (1956:149). These jars are frequently used for pulque.

The earlier associations of designs with pulque are not unrelated to present usage. The large jars are used to store pulque and to make the more potent mescal; medium to small jars, to serve and drink pulque. Consumption, however, is increasingly associated with the poor and with rural life; it no longer provides a central focus for ideas and values for people of the region. The themes that coalesced in the Precolumbian pulque complex are not immediately evident in a restructured and complex contem-porary society, but they can still be detected through the medium of the common black-on-red ware.

Symbolism, Past

One traditional, centralizing theme concerns an ongoing worldview of the universe—a universe constantly threatened with destruction yet continually renewed by struggle and sacrifice. This worldview has been well established for the Precolumbian Central Highlands as the result of extensive archaeological excavation and historical documentation (Nichol-son 1976; Nicholson and Sullivan 1988). Periodic destruction and recon-struction of pyramids and associated buildings and sculptures, as well as household goods, was widespread in connection with coinciding calendar cycles; and a cosmic view of a series of worlds or "suns" that ensued in a

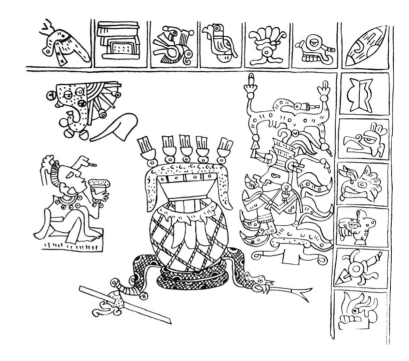

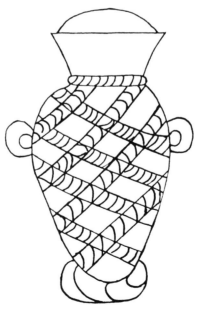

Figure 4-4. (*Above*) The goddess of pulque, Mayauel, Vaticanus B 56 (after Gonçalves de Lima 1956:204); and (*left*) the juice of the maguey cactus, pulque, Mendoza 29:77 (after Gonçalves de Lima 1956:169).

Figure 4-5. (*Top*) Rabbit mantle with lunar nose ornament design, Magliabecchi XII 3.4 (after Gonçalves de Lima 1956:136); and (*bottom*) pulque in jar and bowl with schematic lunar nose ornament design, Mendoza 62 (after Gonçalves de Lima 1956:136).

succession of destruction finds its clearest expression, perhaps, in the ancient manuscript *Anales de Cuauhtitlan* (Leon-Portilla 1975:33–37, 46). The daily renewal of life, too, was enacted on a cosmic stage. Night, personified by the black god Tezcatlipoca (Smoking Mirror), accompanied by myriad stars, was vanquished each day in a heroic battle fought by Day, in the person of the god Quetzalcoatl (Plumed Serpent), the great culture bringer.

The Toltec path of art and spirituality needed to survive the threatened end of the present "sun," or world, to make the journey (as must every man) to the region of wisdom, *Tlillan-Tlapallan*, "Land of Black and Red Color," as Quetzalcoatl had done (Leon-Portilla 1975:58). In a related myth, said to explain simultaneously the end of the Toltec culture in the Central Highlands about A.D. 900 and the death of the planet Venus, Quetzalcoatl leaves the city of Tula to go to the mythical Tlillan-Tlapallan, Land of Black and Red Color. He disappears there into the west, where the black and the red are joined, to where night and day meet, only to return again in the east, transformed into a morning star and preceding the sun (Caso 1953:39). Thus, red and black are associated with Quetzalcoatl.

On pottery and in murals, Quetzalcoatl was traditionally portrayed with a black pointed beard, an uncommon feature among the relatively beardless Indians. His promise to return to earth in the east during the year of his name (*Ce Acatl*) coincided with Cortés's arrival on the east coast of Mexico in the vicinity of the mythical Tlillan-Tlapallan. It was one of those remarkable instances in which life imitated art. Montezuma's initial reluctance to crush the black-bearded Spanish invader who so resembled the "great culture bringer" contributed to the destruction of the Aztec civilization.

A second traditional theme affirms a view of life as nourished by death. It encompasses a series of oppositions—life and death, day and night, dream and reality, sleeping and waking—inexorably linked in a cycle of renewal. There is a creation myth in which Quetzalcoatl returns to the underworld to recover the bones of those who have died, so that he may create a new race of men (Krickeberg 1976:129; Leon-Portilla 1975:29–30, 37–39). In his haste to leave he drops the bones, breaking them, but manages to gather them up and make his escape from the underworld. For his clumsiness, Quetzalcoatl is sacrificed by the other gods, and his blood gives life to the old bones (Caso 1953:38; Leon-Portilla 1975:39). Thereafter, the blood of this new race of men is needed to nourish the gods and to sustain the Sun in his fight to defeat the Moon and the night stars (Bierhorst 1984:32–35, 77–82; Caso 1953:24; Krickeberg 1976:156–157, 161). Human

sacrifice, as a means of perpetuating life, reached its apogee under the Aztec. The extent of their obsession with blood and death shocked and repelled even the battle-hardened Spanish conquistadors (Díaz del Castillo 1968:213, 219–220, 223–224).

Not only life but love and beauty originated in death and returned to death inevitably. Xochiquetzal, Most Precious Flower, a symbol of life and growth as shown by the beauty of flowers, belonged to the underworld (Burland 1968:91). It was she, the goddess of love and beauty, who seduced Quetzalcoatl in his form as Yappan, the virtuous, and caused the other gods to change him into a scorpion as a punishment (Caso 1953:41; Krickeberg 1976:31, 293–300).

A third theme concerns the need to attain a balance, even though it is only temporary and precarious. It is this balance that ensures the continuity of the world, of life, and of human life especially. Day and night, growth and decay, control and excess recur in a perpetual cycle precisely because they balance each other. This third theme is the one that is manifest in the ancient and widespread pulque complex in the Central Highlands and in the Puebla-Tlaxcala region in particular.

Pulque had Preconquest ritual significance. In addition to its consumption by warriors and old men and women (ancianos) who were not punished for drunkenness, it was widely used on ceremonial occasions among the Aztec. In the myth cited earlier, Quetzalcoatl was changed into a scorpion after he was seduced by Xochiquetzal. But he was seduced by her at the instigation of his archenemy, the night god Tezcatlipoca, only after she made him drunk with pulque, that is, only after he had lost control of himself (Caso 1953:41). The ancient lesson is clear: a loss of control threatens the balance of life itself.

A remarkable mural was discovered in 1969 at the archaeological site of Cholula, 13 km from Puebla. It predates by many centuries the Aztec culture that dominated the Central Highlands at the time the Spanish arrived in 1519. Named *The Pulque Drinkers* (*Los Bebedores*) by the archaeologists who uncovered it, the mural depicts a series of male figures, seated within horizontal bands, being served and drinking a liquid presumed to be pulque (see Figure 4-3) (Marquina 1971:5, 25, 28, 32–33; Müller 1971:41, 42, 50). The bowls from which they drink resemble those used by pulque drinkers today. The surrealistic position of their heads suggests that they are in an unusual state, perhaps experiencing visions. The size and artful execution of the mural, its extent (it is one of the largest murals thus far discovered, measuring 70.0 m in length by 2.1 m in height, and it is not yet fully uncovered),

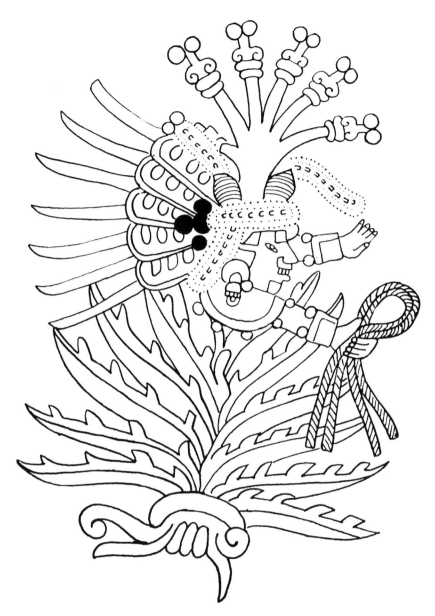

Figure 4-6. The goddess of pulque, Mayauel, Borbonicus 9 (after Gonçalves de Lima 1956:210).

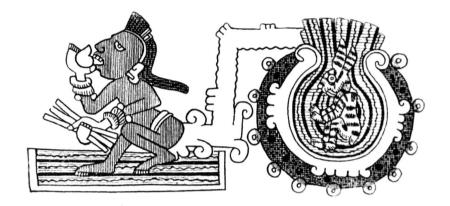

and its location on an early construction of the main pyramid at this major ceremonial site indicate the age and importance of the pulque cult, known to have been centered in this region.

Bands or stripes were frequently used to represent the heavens in Precolombian art. At Cholula, there are later murals that are composed of bands or stripes in combination with stars, further evidence of the association between bands and stripes and the heavens. The gods of pulque were identified in the Aztec pantheon by their striped black and red face paint and a semilunar nose ornament. The red and the black, as noted earlier, were identified with day and night. The god of night, Tezcatlipoca, was black and wore a spotted (*manchada*) jaguar skin about his shoulders.* The black spots were said to resemble the clusters of night stars associated with him, and he carried an obsidian or sacrificial knife (Caso 1953:25, 44). His idol, worshipped in the main temple of the Aztec capital Tenochtitlán, was

* See also Patricia Rieff Anawalt's recent discussion of the importance and social and political contexts in which spotted cloaks were worn, made, and acquired (1990:291–292, 296, 304, 306).

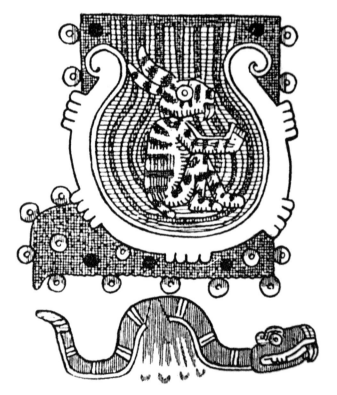

Figure 4-7. (*Left, top*) The goddess Tlazolteotl, the filth eater, and the Moon, Vaticanus B 29 (after Gonçalves de Lima 1956:133); and (*left, bottom*) the Moon with the rabbit and (*below*) Sacrificial Knife, Borgia 55, 50 (after Seler 1904–1909).

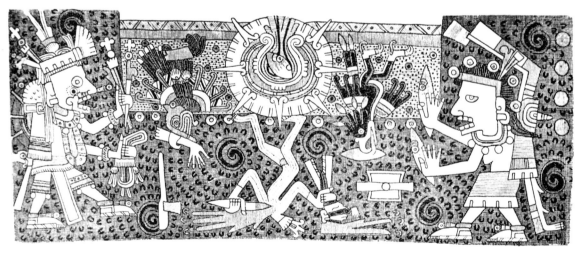

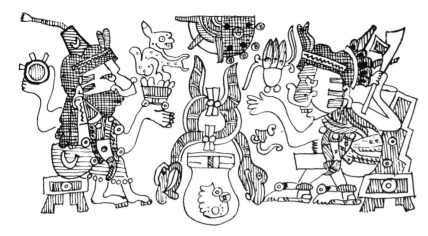

Figure 4-8. (*Above*) The pulque goddess with Tlazolteotl as pulque goddess, Borgia 57 (after Gonçalves de Lima 1956:156); and (*right*) Dead Sun, Borgia 57 (after Caso 1953:36).

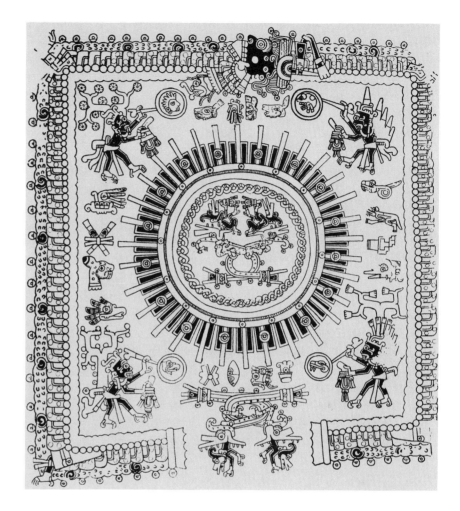

stained with reflective metallic paint and was called "Smoking Mirror" by the Indians (1953:43). The moon, or the "dead sun," was likewise associated with him (1953:42, 53). Not only the moon but the symbolic spots, stripes, and swirls connected with the night sky and Tezcatlipoca are also connected with day and Quetzalcoatl. These, in turn, are connected with the gods of pulque and with the present symbolism of cooking pottery, as will be shown.

The eighth day of the month in the Aztec calendar was represented by a rabbit, Tochtli, and it was dedicated to the goddess of pulque, Mayauel (see Figure 4-6) (Burland 1968:89). Not unexpectedly, the rabbit was a symbol of fecundity, as was the goddess herself. She was conceived as an all-nourishing mother, and the whitish cloudy pulque was seen as her milk. She was said to have 400 breasts with which to feed her 400 children, the *Centzon Totochtin*, the innumerable gods of drunkenness. They wear black-and-red-striped face paint and the semilunar nose ornaments mentioned earlier.

This nose ornament was white and was probably made of bone; its shape resembles the outline of a jar. Sometimes this nose ornament appears in the center of a representation of the moon, and sometimes a rabbit appears in its stead (Caso 1953:53). Pulque cups from Cholula and the Puebla-Tlaxcala and Mixteca-Puebla areas show these symbols in the Late

Classic period (Müller 1978:205–206; Müller and Hopkins 1977:38). On bowls of this period, too, similar design elements and arrangements in ancient pottery resemble those on black-on-red glazed ware in Puebla (Müller 1978:187, 196–197; Müller and Hopkins 1977:36). In two representations of the moon from the Puebla-Tlaxcala region, in the *Codex Borgia*, jars filled with water are plainly depicted encircled by the nose ornament; and in the same codex, a rabbit and a sacrificial knife are also contained within the jars (Figure 4-7) (Caso 1953:50). Blue is the color of water in Precolumbian art, and the Borgia jars in the moon are decorated with blue and black stripes. Perhaps there was some recognition of the relationship between the

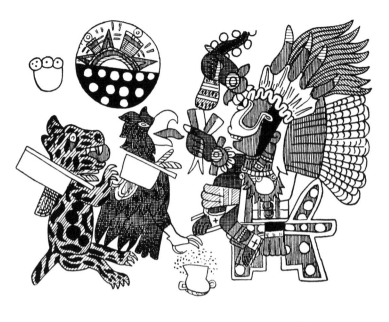

moon and the tides, here represented as water, by the priest-astronomers on the Central Plateau. Perhaps the blue and black striped jars in the moon are just symbolic of the rains that fall from the heavens. In any case, symbolism associated with the moon is also linked to the gods of pulque (Figures 4-8 and 4-9).

Here in the pulque complex of the Puebla-Tlaxcala region in the Central Highlands, the major themes I have outlined coalesced: a cyclical worldview of the universe—life through death and human sacrifice; and human beings, heaven, and earth interlocked in delicate balance. Human sacrifice nourished the gods who made life possible. The heart and blood of the sacrificed victim fed the Sun in his fight against darkness, and the Night,

Figure 4-9. (*Left, top*) The goddess of pulque, Mayauel, Tonalamatl de Aubin, II (after Gonçalves de Lima 1956:203); (*left, bottom*) the god of medicine, husband of Mayauel, Patecatl, Borbonicus 11 (after Gonçalves de Lima 1956:211); and (*below*) the goddess of pulque, Mayauel, Borgia 16 (after Gonçalves de Lima 1956:132).

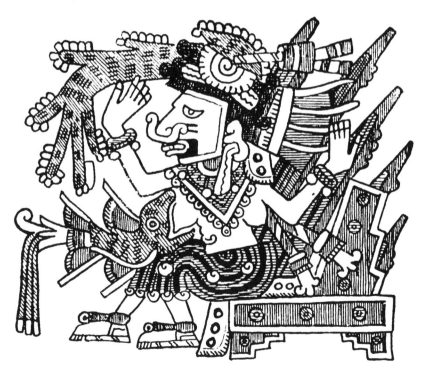

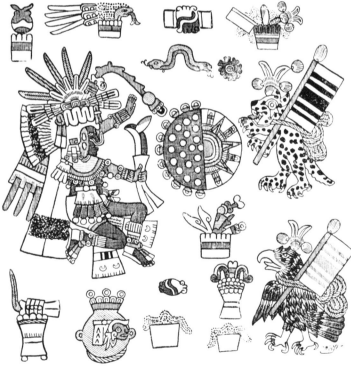

beaten, vanished into the underworld only to reemerge and fight again. Human sacrifice also brought the rains, which in turn brought new life from the underworld in the form of growing things. These growing things, symbolized by the maguey, were sacrificed, as was man himself, to ensure the continuity of the universe. Man's heart and blood were offered to the gods; so too was the "blood" taken from the "heart" of the maguey (i.e., pulque was offered to them). I suggest, then, that the cloudy, whitish pulque was symbolic not only of mother's milk but of father's semen, both life-giving substances that renewed the cycle: hence, the importance of the cult and the reverence accorded pulque in the highlands.

5 ANALYZING A FOLK STYLE

The foregoing description of a folk pottery—Puebla black-on-red glazed utilitarian ware, its history, production, and distribution—suggests that the pottery is imbued with the identity and, in some ways, the ethos and worldview of a group of people. On the one hand, its emergence following the Spanish Conquest may be seen in terms of colonialism and crown policy, which through separatism and exploitation heightened the Indians' consciousness, inducing them to draw upon earlier cultural elements and incorporate these elements into a new pottery style. On the other hand, the florescence of the style in the nineteenth century, following independence from Spain, may be seen in terms of a new sense of national identity, which led to the fusion of formerly separate Indian and Spanish pottery traditions. Through spatial distribution, the pottery extended that sense of identity and in both periods served to define social relationships between realigned groups in the region and in the nation.

The question that has guided this research project concerns the nature of style in art, group style in particular, rather than individual variation. The purpose is to develop a framework for a more rigorous concept of style and, in addition, to help better understand the human creative and cognitive processes. My underlying assumption is that style—the distinctive and recognizable way that something is done or ought to be done—is more than the historical product of creativity and circumstance and more than the reflection of some underlying universal mind. The former may account for the diversity of styles but not its continuity; the latter may account for the continuity of style but not its diversity. I assume that style in visual art is the realization of a system of nonverbal and affective communication, a system of symbols whose form and meaning are con-joined by those who use it. It is made up of units that, comparable to phonemes, exist in a system of contrasts, which are related to each other in specifiable ways according to rules that govern their combination. In my view, the performance of those who use the system is essential to the analysis, as well as to the identification of meaningful units (i.e., the distinctive features). Thus, the term *emic* is used here in two ways: in the usual linguistic sense of synchronic and structural analyses, as a construct, a simplification of a description of observable behavior (Langacker 1967:6, 29–32, 153–154, 157); and in the cultural sense that Harris and others use the term: to mean the conscious and native point of view (Harris 1968:568–604). For me, however, style is realized as the result of social interaction, plus economic, political, and technological factors.

Art style is seen here as analogous to language, in that both form significant patterns through the manipulation of symbols by their users, who remain essentially unconscious of the system itself. Style in visual art, then, is a system held in the mind and shared and transferred through learning and interaction in time and space. Some of the ways this takes place are discussed elsewhere (Kaplan 1976b). It is not so much the structure of the mind that is sought here, although it is assumed that the system analyzed has a certain psychological and cognitive reality for those who participate in the culture, rather, the aim is to account for certain observable phenomena, as Burling has suggested (1964), and to employ a method that can be replicated by others (Douglas 1967; Shankman 1969; Yalman 1967). To these ends, I apply the emic model as a heuristic device, as one means of determining the structure of a regional style of folk pottery from the Valley of Puebla, Mexico. Though the structure obtained using the emic

model may be "surface" and even "spurious" in the transformational sense, it can nevertheless serve as an important demonstration on an available level in material culture (Keesing 1971:20).

Folk pottery is especially important for cognitive studies. It is characterized by commonality—the quality of being shared in space—and by continuity—the quality of being persistent in time. Like folk art, folk pottery may be defined as traditional in its origin and method of production within the context of a complex society or state. It differs both from the prestige-laden art of the elite and from the faddish and fleeting art of the popular. It preserves a direct relationship between craftsman and medium through techniques of hand manufacture. It is not concerned with microstyles of individuals, families, and workshops; instead it is concerned with group and even regional style, making it most relevant for testing several notions: style, cognition and creativity, communication, and group identity and solidarity.

I look at art style as if units comparable to phonemes existed in a system of contrasts from which style is created. I consider the culture bearer's knowledge and sensibility, his definition and performance with regard to meaningful units (i.e., the distinctive features essential to an overall structural analysis). I see style as analogous to language, in that both form significant patterns through the active manipulation of symbols by their users, who remain essentially unconscious of the system itself.

Given the interest in linguistic models, this study offers an empirical test of the usefulness of such models for nonverbal behavior. In light of the emic-generative controversy in linguistics, the two models will be evaluated in chapter 6 (Keesing 1971; Lyons 1970a, 1970b; Muller 1966, 1971). The emic model is applied here to an analysis of black-on-red glazed utilitarian pottery. My aim is to determine the extent to which distinctive features and design motifs of the folk pottery may be grouped together into single units derived from the performance of the culture bearer. While I do not again address these issues, I suggest that such a single unit may be called a *tifeme*, derived from the word *motif* and pronounced 'tefem (tiyfiym); the constituent features may be called *allotifs*, based on the analogy with the phoneme-allophone, morpheme-allomorph distinction in linguistics. In my view, restrictions on allotifs, as well as the rules of combination for tifemes, produce style in material culture.

To obtain the system herein, standardized tests and open-ended interviews were conducted with a sample of 12 potters. The potters were chosen on the basis of their skill and experience, as acknowledged by their peers in the pottery-making community. It was assumed that skilled potters, specialists in both the use of the wheel and of molds, would have the greatest control of the system. This assumption has been supported by the results of the tests and interviews. Specialists were found to be in agreement with regard to the distinctive features and design motifs they identified, and their answers were treated as categorical responses. (Where they lacked a discrete label, one was supplied.)

The interview results are given in Table 5-1. In the series of tables that are discussed later in this chapter, 25 pottery types and 94 associated features were identified by the potters; size was not included. Size was included, however, in the potters' universe of black-on-red glazed utilitarian pottery; Figure 2-2 shows they made the types in a wide range of sizes. All-black ceremonial ware and decorative black-on-red ware mark the boundaries of the utilitarian ware, and it is this ware, as a system, that is being subjected to analysis. Several statistical techniques (cluster analysis, both hierarchical and nonhierarchical, and multidimensional-scaling techniques) were applied to the data contained in the series of tables that follow. Emic analyses based on these data are also presented in Figures 5-1 and 5-2. The method is then described in detail and the results discussed later in this chapter. A further discussion of methodology is to be found in chapter 6.

A second method used in this study was applied to determine the extent to which there was agreement among a representative sample of the city's population regarding style in utilitarian pottery. Based on the analogy with language and the emic model, there should have been substantial agreement, that is, a shared system; and there should have been variation as a result of class, sex, and age, that is, dialect differences. For example, it was expected that there would be imperfect learning manifested by children, since they have not yet mastered the system completely, yet they have also been exposed to new, nontraditional influences in their formative stages.

Intensive interviews, closed- and open-ended, were conducted with a sample of 125 persons in the city of Puebla in 1973. The sample was subdivided on the basis of class, sex, and age, according to native categories. These categories were first elicited from the 12 informants selected for open-ended interviews in 1972. Each informant was asked initially if there were any social "classes" in the city. Then each was asked to describe the ones he or she mentioned. In addition to providing the names of persons who were cited as members of a given class, the informant usually volunteered

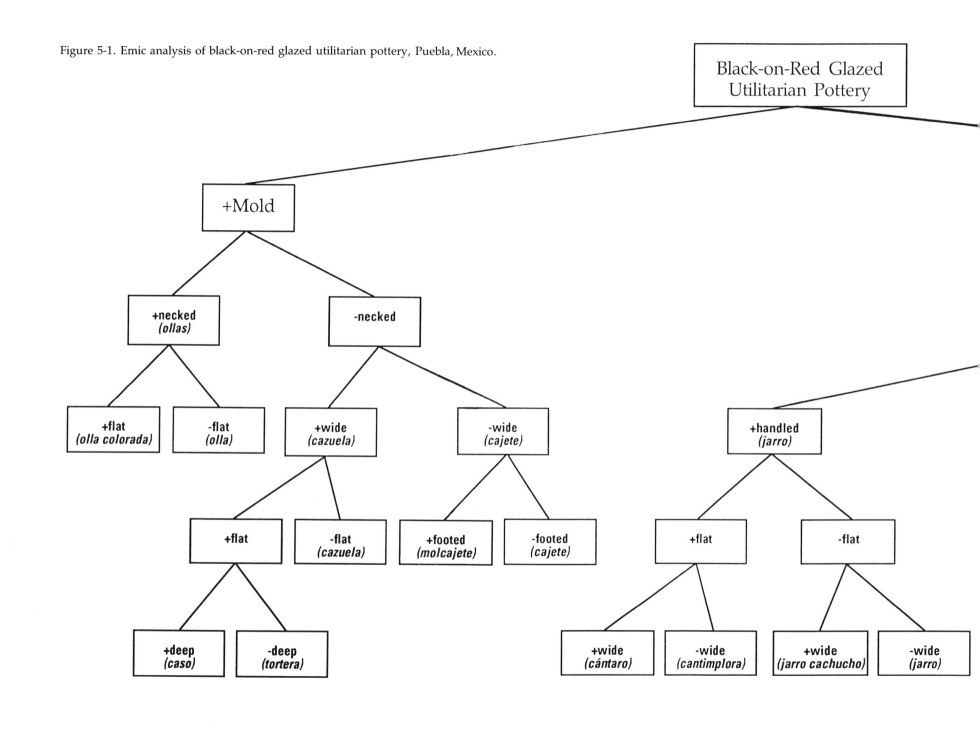

Figure 5-1. Emic analysis of black-on-red glazed utilitarian pottery, Puebla, Mexico.

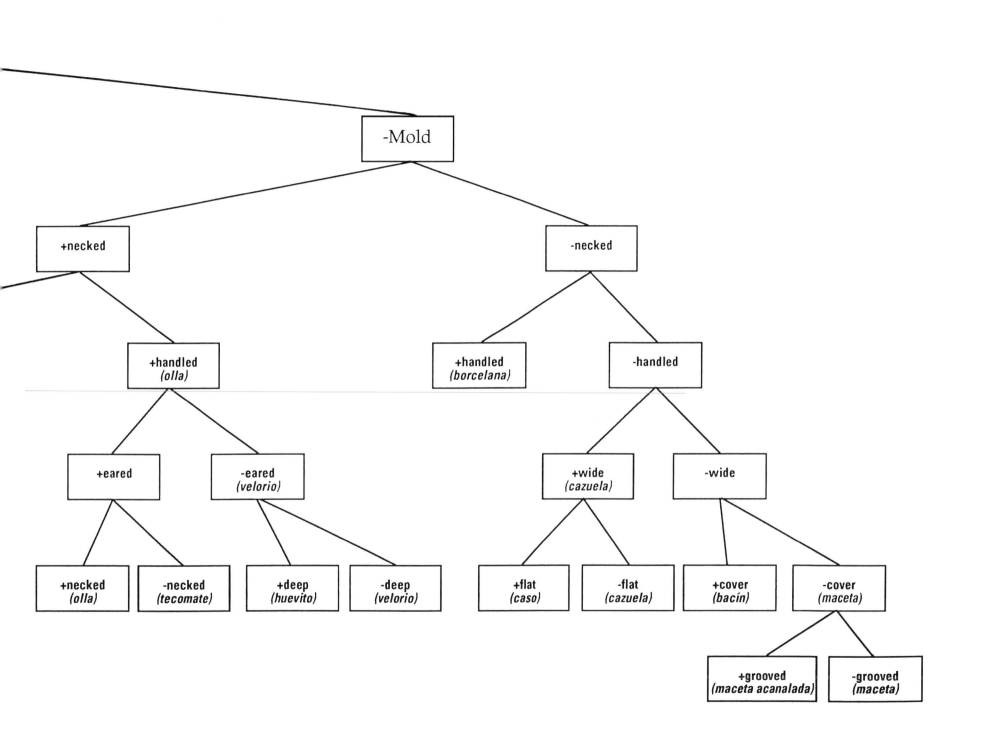

Emic Analysis

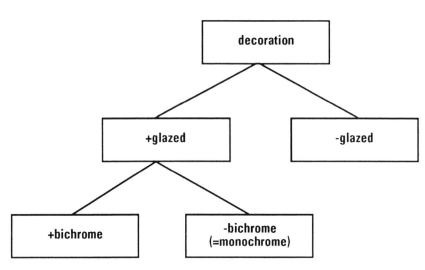

Figure 5-2. Emic analysis of decorations of black-on-red glazed utilitarian ware, Puebla, Mexico.

data on family background or origin, occupation, income, life-style, and education, in that general order. The names were noted for possible future inclusion in a sample to be tested, and a number of those originally cited in 1972 were interviewed in 1973.

Of the 12 informants (two men and two women from each of the three classes tested—upper, middle, and lower), those belonging to the upper and middle classes were in general agreement about the class structure in the city. The three-tiered division they made also agreed with my own observations. Of course, there were gradations within each division. For example, all informants made a distinction within the upper class between those who were Mexican of noble or known lineage (*los de abolengo*) and those who were merely wealthy (*los ricos*). The former included even those in reduced financial circumstances (*vinieron a menos*). The latter included the newly rich and those of foreign descent. Within the middle and lower classes there were gradations as well, but these were based mainly on occupation and income plus education and life-style. The boundary between them was not clearly marked, so that at the lower end, the middle class merged with the upper lower class; at the upper end, the middle

class merged with the lower upper class. The sharpest division, then, was between the upper and lower classes, since the middle class was identifiable, but it merged at either end with the two other classes.

I did not systematically pursue the investigation of gradations within class because to do so would have altered the aims and scope of this study. The three main class distinctions were sufficient for my purposes and for an initial study. Nonetheless, I did seek informants who and interviews that were representative of social-class gradations; and in chapter 6 I have taken these gradations into account in evaluating the results. For example, among the upper class, the sample included men and women of distinguished families (*abolengo*) and of wealth alone (*los ricos*). I created a fourth category of specialists, the potters and crewmen, so that the results would not be skewed with regard to class.

Potters and crewmen identified themselves and are identified by others as belonging to the lower class. They were primary informants, serving as a standard of knowledge about this pottery and style, as they were expected to have the largest fund of such knowledge. I was not successful in eliciting "class" categories from potters or other members of the lower class who served as informants, except for an expressed two-tiered division: rich and poor. Their basis for this division was simple: money and power. Power was defined in terms either of occupation (in government, big business, medicine, law, and the military) or of having money or both. They lumped all wealthy and powerful people together (*los ricos y los poderosos*) as distinct from themselves. They referred to themselves as the poor people (*los pobres*) and sometimes as the simple people (*la gente humilde*). They did not use the term *class* and did not respond to the initial question in its original form. It was rephrased to ask whether there were "differences" among the people in the city. Pursuit of this line of inquiry did produce the two-tiered division of rich and poor, with implicit recognition of a middle class.

The upper class responded to the term *class*, but they seldom used it in discussion. They usually referred instead to "the others" and to "themselves." These "others" were identified as the simple people (*la gente humilde*), the same term used by the lower class for itself, plus the people with some means and preparation (*la clase media*). When pressed for details, they supplied a description of three groups, distinguishing them as separate classes. I found the term *class* most commonly employed by those identified as being in the middle: teachers, intellectuals, and university students, in particular. They also spoke in terms of *los ricos* and *los pobres*, with themselves as an implied point of reference in the middle.

Table 5-1 Key to Responses to Pots 1 Through 28

Response Number	Response	Response Number	Response	Response Number	Response	Response Number	Response	Response Number	Response
1.	No answer given	39.	*Arrocero*	77.	*Jarro muñeco*	115.	*Loza de* Guanajuato	144.	*Platones, platos, vasijas* (no ware named)
2.	*Cántaro*	40.	*Cazón*	78.	*Jarro panzón*	116.	*Loza de La Luz*	145.	*Vajilla* (no ware named)
3.	*Jarro*	41.	*Cazuela arrocera*	79.	*Payaso*	117.	*Loza poblana*	146.	*Platones, platos* (no ware named), *no es de* Puebla
4.	*Jarrón*	42.	*Cazuela extendida*	80.	*Pichel*	118.	La Luz, Puebla	147.	*Platos, charolas* (no ware named)
5.	*Mescalera*	43.	*Cazuela tortera*	81.	*Vasija*	119.	*Caseros*	148.	*Platones, cajetes* (no ware named)
6.	*Nixtamal or nixcomal*	44.	*Olla extendida*	82.	*Pocillo*	120.	*Jarros de* La Luz, Puebla	149.	*Cajetes* (no ware named)
7.	*Olla*	45.	*Paellera*	83.	*Ánfora*	121.	*Jarros y ollas*	150.	*Charolas* (no ware named)
8.	*Olla de a medio*	46.	*Tortera*	84.	*Olla colorada de a diez*	122.	*Jarros y ollas de* La Luz, Puebla	151.	*Palanganas* (no ware named)
9.	*Ollón*	47.	*Tortera de a medio*	85.	*Olla de a tlaco*	123.	Each piece named separately, Puebla	152.	*Platones, plates de* Oaxaca
10.	*Tamalera*	48.	*Cazuela de a medio*	86.	*Botijo*	124.	*Ollas de* La Luz, Puebla	153.	*Cajetes,* Oaxaca
11.	*Tinaja*	49.	*Cazuela molera*	87.	*Jarro cántaro de a doce*	125.	Oaxaca	154.	*Platones, charolas,* Oaxaca
12.	*Jalapeña*	50.	*Cazuelón*	88.	*Olla cántaro*	126.	*Cazuelas* (no ware named)	155.	*Platones,* Monte Alban
13.	*Jalapeña tlaquito*	51.	*Casito*	89.	*Jarro cantimplora de a doce*	127.	*Cacerolas* (no ware named)	156.	*Platos,* Acatlán
14.	*Jarra*	52.	*Casito de a ochito*	90.	*Chimbule*	128.	*Cazones y cacerolas* (no ware named)	157.	*Palanganas,* Acatlán
15.	*Jarro sope*	53.	*Cazuela de a ochito*	91.	*Porrón*	129.	*Cazuelas,* La Luz, Puebla	158.	*Platones, platos,* Amozóc
16.	*Olla de a tlaquito*	54.	*Cazuela china*	92.	*Tibor*	130.	*Cacerolas,* Guanajuato	159.	*Platones,* Guadalajara
17.	*Tarro*	55.	*Cazuela ondeada*	93.	*Chasquito*	131.	*Cazuelas mexicanos*	160.	*Platos,* Tabasco
18.	*Jarro arrocero*	56.	*Olla ondulada*	94.	*Jarro cachucho de a doce*	132.	*Cazuelas del pueblo*	161.	*Platones, platos,* La Luz, Puebla
19.	*Jarro olla*	57.	*Cazuela dedal*	95.	*Jarro de a doce*	133.	*Cazuelas y torteras (arroceras)* (no ware named)	162.	*Platones y cajetes,* La Luz, Puebla
20.	*Olla jalapeña de a diez*	58.	*Cazuela coquito*	96.	*Olla de a doce*	134.	*Ollas* (no ware named)	163.	*Charolas,* La Luz, Puebla
21.	*Olla sope*	59.	*Cazuela juguete*	97.	*Olla jalapeña de a dos*	135.	*Loza negra,* Oaxaca	164.	*Comales,* Guerrero or Oaxaca
22.	*Sope*	60.	*Plato*	98.	*Barríl*	136.	*Loza negra,* Guadalajara	165.	*Ollas,* not Puebla, La Luz
23.	*Jarro cafterío*	61.	*Salsera*	99.	*Gallo*	137.	*Loza negra*	166.	*Jarros,* not Puebla, La Luz
24.	*Jarro medio tránsito*	62.	*Salero*	100.	*Olla panzóna*	138.	*Barro de* Cuetzalan	167.	*Cazuela,* San Jerónimo Ocotitlán
25.	*Tazón*	63.	*Cazuela larga*	101.	*Tecomate de a sope*	139.	Acatlán	168.	*Cazuela, no es de* Puebla
26.	*Cafterío*	64.	*Charola*	102.	*Cazuela china de a doce*	140.	Michoacán		
27.	*Capulixtle*	65.	*Comal*	103.	*Albañal*	141.	*No es de* La Luz, Puebla		
28.	*Jarro chocolatero*	66.	*Ensaladera*	104.	*Bacín*	142.	*Hehuites,* Acatlán		
29.	*Jarro dedal*	67.	*Frutera*	105.	*Bacín de a doce*	143.	*Cacerolas y platos* (no ware named)		
30.	*Taza*	68.	*Palangana*	106.	*Borcelana*				
31.	*Cacerola*	69.	*Pescadera*	107.	*Botes de tapadera*				
32.	*Cajete*	70.	*Platón*	108.	*Cubeta*				
33.	*Caso*	71.	*Tortera labrada*	109.	*Hervidor*				
34.	*Cazuela*	72.	*Botellón*	110.	*Maceta*				
35.	*Cazuela olla*	73.	*Cantimplora*	111.	*Macetón*				
36.	*Gallina*	74.	*Florero*	112.	*Maceta de a diez*				
37.	*Tecomate*	75.	*Garrafón*	113.	*Loza*				
38.	*Tecomate de a seis*	76.	*Garrafón labrada*	114.	*Loza colorada vidriada*				

Table 5-2 Pottery Types Identified by Potter Informants

Type Number	Pottery Type	Type Number	Pottery Type
1.	*Olla* (mold)	14.	*Tecomate*
2.	*Olla* (wheel)	15.	*Borcelana*
3.	*Olla colorada*	16.	*Bacín*
4.	*Jarro*	17.	*Maceta*
5.	*Jarro cachucho*	18.	*Molcajete*
6.	*Jarro cantimplora*	19.	*Cajete*
7.	*Velorio*	20.	*Cantimplora*
8.	*Velorio huevito*	21.	*Jarro labrado*
9.	*Cazuela* (wheel)	22.	*Olla labrada*
10.	*Caso* (wheel)	23.	*Tortera labrada*
11.	*Cazuela* (mold)	24.	*Jarro negro*
12.	*Caso* (mold)	25.	*Olla negra*
13.	*Tortera*		

The members of all three classes, as well as the specialists, were in agreement about age categories: elder, adult, young, child. Sex was categorized as either male or female. The tests and interviews were usually conducted in the potters' workshops and homes. They always took place in familiar surroundings, where a potter would feel at ease. In these surroundings, the behavior of other members of the pottery-making community—family and friends—could also be observed. They often lent support to the potter's responses and offered additional examples from their own experiences, which were noted separately. The results of each interview were checked against spontaneous comments and labels applied to the pottery in daily life. The extent to which potters isolated and manipulated distinctive features in the course of manufacture of a given pottery type was recorded; and references to features and pottery types, using discrete labels, were noted in casual conversations among potters and in discussions with me. All of these observations of actual behavior supported the system of classification and distinctive features used by potters to describe the "universe" of black-on-red ware (see Tables 5-2 and 5-3).

Table 5-2 lists the 25 pottery types of black-on-red ware identified by potter informants. Table 5-3 lists the 94 distinctive features they describe.

Table 5-4 records the presence of 94 features that are associated with the 25 pottery types distinguished by potters and includes all-black ceremonial ware and decorative black-on-red ware.

The methods used in this study may have relied on verbal data, but they were not based on a view of style solely as a mental phenomenon. They included observations of the overt behavior of informants and others in daily and ceremonial activities to supplement and support the data obtained in the interviews.

I had originally intended to participate in the production of pottery forms myself and to modify the distinctive features and design motifs to determine the limits of acceptance and substitution. But this plan had to be abandoned because pottery making in the barrios is a male occupation. Although informants said that women could make pottery, they did in fact rarely do so. Small mold-made eating bowls and toys were made by young boys and occasionally by women, although I never observed women potters at such work. I have seen unmarried daughters and wives sometimes take part in unloading a kiln, in breaking up raw clay with a stick, and in scraping leather-hard pots. In all of the preceding tasks, women are classed with young boys, 7 to 12 years of age, who regularly carry out this work. Whereas I observed dozens of children thus occupied, I only saw two women actually assist their husbands—and in both cases, the potter was extremely poor and worked alone. Evidently, few women could be considered potters in the city of Puebla. Most were involved only peripherally and, in case of need, in associated tasks.

Were a woman to make pottery, even a stranger such as myself, a loss of prestige would result. Several informants, while expressing a willingness to teach me pottery making, were reminded of funny stories, which still make them chuckle, of North American girls who had wanted to learn. One had donned trousers to sit at the wheel and apparently persisted for some days in learning. She was the star attraction in the barrio. And the potter, even though it was years later, still described with evident relish how people found excuses to pass by just to see this amazing and funny sight. I decided not to become equally ridiculous in their eyes.

There were other reasons, too, besides my sex, for abandoning my plan to learn pottery making. The potters were initially suspicious of my motives for wishing to learn about their craft; they openly expressed the idea that I had come to learn so that I could go back and teach my students to make pottery in the United States of America. They apparently had been visited at various times by male ceramicists, foreign and Mexican, who had wished to learn from them—and rarely succeeded. As I had no such idea, it seemed

Table 5-3 Distinctive Features Identified by Potter Informants

Feature Number	Feature	Feature Number	Feature	Feature Number	Feature	Feature Number	Feature
Technique (técnica)		*Seat* (asiento)		*Color* (color)		*Effigy* (labrada)	
1.	Wheel (*tornero*)	26.	Round (*redonda*)	52.	Red and black (*rojo y negro*)	69.	Lady (*catarina*), Fat man (*panzón*), Monkey (*mono*)
2.	Mold (*manero*)	*Foot* (pata)		53.	Red (*rojo*)		
3.	Mold (*ollero*)	27.	Base (*con pata*)	54.	Black (*negro*)	*Design location* (diseño appropriado)	
		28.	Three feet (*tripodo*)			70.	Inside, all-over (*adentro*)
Shape (forma)		29.	No feet (*sin patas*)	*Glaze* (grieta)		71.	None inside (*liso*)
4.	Round (*redonda*)			55.	Glaze inside, all-over (*grieta adentro*)	72.	None outside (*liso*)
5.	Deep (*hondo*)	*Ears* (orejas)				73.	On neck (*pescuezo*)
6.	Extended (*extendida*)	30.	Rolled type 1 (*volada*)	56.	Glaze outside, all-over (*grieta afuera*)	74.	On body (*cuerpo*)
7.	Oval (*ovalada*)	31.	Flat types 2, 3 (*oreja*)			75.	On neck and upper half of body (*arriba*)
8.	Egg shaped (*huevito*)	32.	Spider type (*adornada/araña*)	57.	Glaze outside, upper half (*grieta afuera arriba*)	76.	On bottom, inside (*adentro al fondo*)
9.	Very round (*panzón*)	33.	Rat type 5 (*ratón*)	58.	No glaze outside (*sin grieta*)	77.	On sides, inside (*adentro a los lados*)
10.	Straight walled (*pared va derecho*)	34.	Decorative type 6 (*adornada*)	59.	Shiny glaze (*brilla mucho*)		
11.	Flaring walled (*pared va tendido*)	35.	Decorative types 8, 9 (*adornada*)			*Uses* (usos)	
12.	Arc walled (*arqueada*)	36.	Flat type 10 (*oreja*)	*Decoration, painted* (pintado)		78.	To cook food (*cocer*)
		37.	No ears (*sin orejas*)	60.	Unpainted (*sin negro*)	79.	To boil liquid (*hervir*)
Mouth (boca)		38.	One ear (*un oreja*)	61.	Black stripes (*rayas negras*)	80.	To stew (*guisar*)
13.	Open (*abierta*)	39.	Two ears (*dos orejas*)	62.	Black stripes (*cocoles*)	81.	To fry (*freír*)
14.	Wide (*ancha*)	40.	Four and eight ears (*cuatro y ocho orejas*)	63.	Black spots (*manchas negros o gavilanes*)	82.	To grind (*moler*)
15.	Narrow (*angosta*)	41.	Ears horizontal			83.	To pour (*echar*)
		42.	Ears vertical	*Decoration, embossed* (moldeada)		84.	To drink (nonalcoholic) (*tomar*)
Neck (gollete/pescuezo)		43.	Ears on body of pot	64.	Flowers (*flores*)		
16.	No-neck (*sin gollete*)	44.	Ears on rim of pot	65.	Stars (*estrellas*), Leaves (*hojas*), Buttons (*botónes*), Birds (*pájaritos*), Fish (*pescaditos*), Eagle with snake (*Águilar con víbora*)	85.	To drink (alcohol) (*beber*)
17.	Tall neck (*pescuezo largo*)	45.	Ears on rim and body of pot			86.	To serve (*servir*)
18.	Short neck (*pescuezo corto*)					87.	To store food (*guardar*)
		Cover (tapa)				88.	To store water (*conservar*)
Rim (bordo)		46.	No cover (*sin tapa*)	*Decoration, modeled* (figuras)		89.	To adorn with, as a gift (*adornar*)
19.	No rim added (*sin bordo*)	47.	Corn cob cover (*elote*)	66.	Lady (*muñeca*)		
20.	Big rim (*bordo grande*)	48.	Rag cover (*trapo*)			90.	To play with, as a toy (*jugar*)
21.	Small rim (*bordo pequeño*)	49.	Wood cover (*madera*)	*Decoration, grooved* (diseño gravado)		91.	To hang up (*colgar*)
22.	Spout (*pico*)	50.	Pottery cover (*tapa*)	67.	Spur (*espuela*)	92.	To wash (*lavar*)
23.	Plain rim (*liso*)	51.	Leaf cover (*hoja*)	68.	Channeled (*acanalada*)	93.	To plant (*sembrar*)
24.	Pinched rim (*repulgado*)					94.	To carry (*llevar*)
25.	Wavy rim (*china*)						

Table 5-4 Presence and Absence of 94 Features Associated with 25 Pottery Types Distinguished by Potters

Features	1. Olla	2. Olla	3. Olla colorada	4. Jarro	5. Jarro cachucho	6. Jarro cántaro	7. Velorio	8. Velorio huevito	9. Cazuela	10. Caso	11. Cazuela	12. Caso	13. Tortera	14. Tecomate	15. Borcelana	16. Bacín	17. Maceta	18. Molcajete	19. Cajete	20. Cantimplora	21. Jarro labrada	22. Olla labrada	23. Tortera labrada	24. Jarro negro	25. Olla negra
Techniques/Técnica																									
1. Wheel/Tornero		•		•	•	•	•	•	•	•				•	•	•	•			•				•	•
2. Mold/Manero											•	•	•					•	•			•			
3. Mold/Ollero	•		•																			•			
Shape/Forma																									
4. Round/Redonda	•	•	•											•								•			•
5. Deep/Hondo									•		•				•			•	•						
6. Extended/Extendida										•		•	•										•		
7. Oval/Ovalada																							•		
8. Egg Shaped/Huevito								•																	
9. Very round/Panzón				•	•	•	•													•	•			•	
10. Straight walled/Pared va derecho										•		•	•			•	•						•		
11. Flaring walled/Pared va tendido									•		•														
12. Arc walled/arqueada	•	•	•	•	•	•	•	•						•				•	•	•	•			•	•
Mouth/Boca																									
13. Open/Abierta									•	•	•	•	•			•	•	•	•				•		
14. Wide/Ancha	•	•	•								•	•										•			•
15. Narrow/Angosta				•	•	•	•	•												•	•			•	
Neck/Gollete																									
16. No neck/Sin gollete o pesquezo o cuello									•	•	•	•	•	•	•	•	•	•	•				•		

continued

Table 5-4 (*continued*)

Features	POTTERY TYPES																								
	1. Olla	2. Olla	3. Olla colorada	4. Jarro	5. Jarro cachucho	6. Jarro cántaro	7. Velorio	8. Velorio huevito	9. Cazuela	10. Caso	11. Cazuela	12. Caso	13. Tortera	14. Tecomate	15. Borcelana	16. Bacín	17. Maceta	18. Molcajete	19. Cajete	20. Cantimplora	21. Jarro labrada	22. Olla labrada	23. Tortera labrada	24. Jarro negro	25. Olla negra
17. Tall necked/*Pesquezo largo*	•	•	•			•														•		•			•
18. Short necked/*Pesquezo corto*				•	•		•	•													•			•	
Rim/*Bordo*																									
19. No rim added/*Sin bordo*	•	•	•	•	•	•	•	•						•	•	•	•	•	•	•	•	•		•	•
20. Big rim/*Bordo grande*									•	•	•	•	•										•		
21. Small rim/*Bordo pequeño*	•	•	•	•	•	•	•	•						•	•	•				•	•	•		•	•
22. Spout/*Pico*				•		•														•	•				
23. Plain rim/*Liso*									•	•	•	•	•	•	•	•									
24. Incised rim/*Repulgado*									•	•	•	•	•										•		
25. Wavy rim/*China*	•								•														•		
Seat/*Asiento*																									
26. Round/*Redonda*	•	•		•	•		•	•	•		•			•				•	•			•		•	•
Foot/*Pata*																									
27. Base/*Con pata*																					•				
28. 3-footed/*Tripado*																		•							
29. No feet/*Sin patas*	•	•	•	•	•	•	•	•	•	•	•	•	•	•			•	•		•	•			•	•
Ears/*Orejas*																									
30. Rolled type 1/*Volada*											•	•	•										•		
31. Flat type 2, 3/*Oreja*	•	•							•	•				•	•	•					•	•			•
32. Spider type 4/*Adornada/araña*																					•	•			
33. Rat type 5/*Ratón*		•		•	•	•														•				•	•

continued

Table 5-4 (*continued*)

Features	POTTERY TYPES																								
	1. *Olla*	2. *Olla*	3. *Olla colorada*	4. *Jarro*	5. *Jarro cachucho*	6. *Jarro cántaro*	7. *Velorio*	8. *Velorio huevito*	9. *Cazuela*	10. *Caso*	11. *Cazuela*	12. *Caso*	13. *Tortera*	14. *Tecomate*	15. *Borcelana*	16. *Bacín*	17. *Maceta*	18. *Molcajete*	19. *Cajete*	20. *Cantimplora*	21. *Jarro labrada*	22. *Olla labrada*	23. *Tortera labrada*	24. *Jarro negro*	25. *Olla negra*
34. Decorative 6/*Adornada*																						•			
35. Decorative 8, 9/*Adornada*																							•		
36. Flat type 10/*Oreja*	•	•		•	•	•									•	•				•	•	•		•	•
37. No ears/*Sin orejas*			•				•	•									•	•	•						
38. 1 ear/*Una oreja*				•	•	•										•				•	•			•	
39. 2 ears/*Dos orejas*	•	•							•	•	•	•	•	•		•						•	•		•
40. 4 & 8 ears/*Cuatro & ocho orejas*																							•		
41. Ears horizontal	•								•	•	•	•	•	•									•		
42. Ears vertical	•	•		•	•	•									•	•	•			•	•	•		•	•
43. Ears on body of pot	•																								
44. Ears on rim of pot									•	•	•	•	•	•									•		
45. Ears on rim and body	•	•		•	•	•									•	•	•			•	•	•		•	•
Cover/*Tapa*																									
46. No cover/*Sin tapa*	•	•	•		•	•	•	•		•	•	•					•	•	•	•			•	•	•
47. Corn cob/*Elote*						•																			
48. Rag/*Trapo*		•		•																					
49. Wood/*Madera*	•	•	•						•	•					•										
50. Pottery/*Tapa*															•	•				•	•				
51. Leaf/*Hoja*		•		•																					
Color/*Color*																									
52. Red and black/*Rojo y negro*	•	•		•	•	•	•	•	•	•	•	•	•	•	•	•	•		•	•	•	•	•		
53. Red/*Rojo*			•						•	•	•		•				•		•						
54. Black/*Negro*				•		•	•	•												•	•			•	•

continued

Table 5-4 (*continued*)

Features	POTTERY TYPES																								
	1. Olla	2. Olla	3. Olla colorada	4. Jarro	5. Jarro cachucho	6. Jarro cántaro	7. Velorio	8. Velorio huevito	9. Cazuela	10. Caso	11. Cazuela	12. Caso	13. Tortera	14. Tecomate	15. Borcelana	16. Bacín	17. Maceta	18. Molcajete	19. Cajete	20. Cantimplora	21. Jarro labrada	22. Olla labrada	23. Tortera labrada	24. Jarro negro	25. Olla negra
Glaze/*Grieta*																									
55. Glaze inside, all-over/*Grieta adentro*	•	•	•	•	•	•	•	•	•	•	•	•	•	•	•	•		•	•	•	•	•	•	•	•
56. Glaze outside, all-over/*Grieta afuera*	•			•			•	•							•	•					•	•	•	•	•
57. Glaze outside, upper half/*Grieta afuera arriba*	•	•	•	•	•	•	•	•						•						•					
58. No glaze outside/*Sin grieta*									•	•	•	•	•					•	•						
59. Shiny glaze/*Brilla mucho*	•	•	•	•	•	•	•	•	•	•	•	•	•	•				•	•	•	•	•	•	•	•
Decoration, Painted/*Pintado*																									
60. Unpainted/*Sin negro*			•							•		•					•	•	•	•				•	•
61. Black stripes/*Rayas negras*				•																	•				
62. Black crisscross/*Cocoles*	•	•			•	•			•	•	•	•	•			•						•	•		
63. Black spots/*Manchas negras o gavilanes*	•						•	•							•				•						
Decoration, Embossed/*Moldeada*																									
64. Flowers/*Flores*																					•	•	•		
65. Stars/*Estrellas* Leaves/*Hojas* Buttons/*Botónes* Birds/*Pájaritos* Fish/*Pescaditos* Eagle with snake/*Aguila con vívora*																							•		

continued

Table 5-4 (*continued*)

Features	1. Olla	2. Olla	3. Olla colorada	4. Jarro	5. Jarro cachucho	6. Jarro cántaro	7. Velorio	8. Velorio huevito	9. Cazuela	10. Caso	11. Cazuela	12. Caso	13. Tortera	14. Tecomate	15. Borcelana	16. Bacín	17. Maceta	18. Molcajete	19. Cajete	20. Cantimplora	21. Jarro labrada	22. Olla labrada	23. Tortera labrada	24. Jarro negro	25. Olla negra
Decoration, Modeled/*Figuras*																									
66. Lady/*Muñeca*																						•	•		
Grooved/*Diseño gravado*																									
67. Spur/*Espuela*					•	•									•	•	•			•					
68. Channeled/*Acanalada*																	•								
Effigy/*Labrada*																									
69. Lady/*Catarina* Fat man/*Panzón* Monkey/*Mono*																				•					
Design Location/*Diseño apropriado*																									
70. Inside, all-over/*Adentro*									•	•	•	•	•										•		
71. None inside/*Liso*	•	•	•	•	•	•	•	•							•	•	•		•	•	•	•		•	•
72. None outside/*Liso*									•	•	•	•	•			•	•	•							
73. On neck/*Pesquezo*	•																					•	•		
74. On body/*Cuerpo*	•											•										•	•		
75. On neck & upper half of body/*Arriba*	•	•		•	•	•		•						•			•				•	•	•		
76. On bottom, side/*Adentro al fondo*									•	•	•	•	•					•	•				•		
77. On sides, inside/*Adentro a los lados*									•	•	•	•	•						•				•		

continued

Table 5-4 (*continued*)

Features	POTTERY TYPES																								
	1. Olla	2. Olla	3. Olla colorada	4. Jarro	5. Jarro cachucho	6. Jarro cántaro	7. Velorio	8. Velorio huevito	9. Cazuela	10. Caso	11. Cazuela	12. Caso	13. Tortera	14. Tecomate	15. Borcelana	16. Bacín	17. Maceta	18. Molcajete	19. Cajete	20. Cantimplora	21. Jarro labrada	22. Olla labrada	23. Tortera labrada	24. Jarro negro	25. Olla negra
Uses/*Usos*																									
78. To cook food/*Cocer*										•		•		•											
79. To boil liquid/*Hervir*	•	•	•	•										•											
80. To stew/*Guisar*									•	•				•											
81. To fry/*Freír*													•	•											
82. To grind/*Moler*																		•							
83. To pour/*Echar*					•	•														•	•			•	
84. To drink (nonalcoholic)/*Tomar*				•			•	•																	
85. To drink (alcoholic)/*Beber*				•																					
86. To serve/*Servir*					•	•													•	•	•	•	•	•	•
87. To store food/*Guardar*		•	•						•	•				•											
88. To store water/*Conservar*	•																			•					
89. To adorn with, as a gift/*Adornar*	•			•					•	•		•			•	•	•				•	•	•	•	•
90. To play with, as a toy/*Jugar*				•					•	•															
91. To hang up/*Colgar*				•					•	•											•	•	•		
92. To wash/*Lavar*																•									
93. To plant/*Sembrar*																	•								
94. To carry/*Llevar*		•		•	•	•													•						

unwise to confirm their suspicions by actually making pots myself. But there was yet a third reason: it would take quite a long time before I could become proficient enough to vary existing pottery features and generate new forms. It seemed to me that my time would be best spent in establishing rapport, asking questions, and observing intensely.

My husband became a reluctant apprentice during my second field season in 1973. He had previously studied ceramic sculpting and modeling with some success. It took several days of negotiations, several false starts, and a great deal of patience (on both sides) before his lessons were arranged with one potter-informant. As each potter's seat and wheel is made by a carpenter to fit the individual, my husband was none too comfortable in his borrowed potter's "cage" (*jaula*). I translated the potter's sparse instructions (my husband speaks very little Spanish) while my husband struggled with the resisting clay. Since potters are usually at work seven days a week, the "teacher" was often called away to negotiate a sale, prepare the glaze, or solve a problem. In fact, reluctance to disturb their normal routine and interfere with their livelihood had been among my other reasons for not becoming an apprentice myself. I did gain some insight into the learning experience from the gap between the potter's minimal directions and my husband's expectations in terms of instruction. And I did certainly gather additional information about how style is broken up in the learning process. But the experiment, in terms of manipulating style, was a failure. I made an ethnographic description (in the usual sense) of how style is learned by children in pottery-making families and noted the spontaneous use of clay and other related materials. The children were photographed at work and at play. My purpose was to analyze how style is broken up in the actual teaching-learning experience of children.

Although I was unable to observe the process of learning through time in the same children, I did find children of different ages and sexes involved in pottery making. Based on interviews and observations of children (and adults) I was able to establish a learning sequence (see chapter 3). The information collected contributes to the data on children's expressions in the visual arts before they are fully enculturated. The following information was collected for each child observed and interviewed: name, sex, age, and order of birth in the family. Additional information was collected about the tasks assigned to children in pottery making, the ages at which they are assigned, and the order in which they are assigned. I observed how a task is learned and corrected, whether by adult potters or others, by instruction, imitation, trial and error, and so on. I questioned adults and children to learn what differences, if any, exist on the basis of age and sex, teachers, and methods of teaching children.

Style was analyzed as follows: what potters say they do, would do, or should do to create folk pottery in appropriate style (to them); what they actually do, as can be observed by an outsider (me or anyone else), in the process of manufacture; and what is observable in the objects themselves. Nonpotters were asked about what is done or should be done to produce the same folk pottery. I wished to learn how nonpotters in the culture accepted the objects produced, the extent to which variations and substitutions were accepted and judged appropriate.

A record was kept of each potter: his name, address, age, place of birth, and other occupations, if any. His wife, children, parents, siblings, and compadres were recorded as well. Dates, places, and summaries of interviews and visits were included on the file card. A similar file was kept for nonpotters.

In the first field season, the labels for the pottery itself and types were elicited by asking questions.

Q. What are these? (pointing to a group of objects)
A. These are . . .
Q. Are these all the same?
A. No, this is a . . . this is a . . . and that is a . . .
Q. How do you know this is a . . . ?
A. Because . . . (features given)
Q. Is this a . . . ? (each object offered)
A. Yes, this is a . . . (No, this is not a . . .)

The same procedure was repeated with unfinished (undecorated) ceramics. As a result, information about distinctive features and design motifs was obtained. Informants (potters and nonpotters) were queried to determine whether these features contrast, whether they are in free variation or in complementary distribution.

Q. Can I do this?
A. Yes . . . (No, that does not belong there . . .)
Q. Would you do this?
A. No, I would not. I would put it here . . .
Q. Would anyone do this?
A. Yes . . . (No, it is never done . . .)

In the second field season, having analyzed the data previously elicited, I compiled lists and arranged them in the form of a tree diagram represent-

ing the potters' universe of black-on-red ware on large foldout sheets. These sheets were presented to four master potters and to four of their employees in two separate workshops. Some additions and deletions were made until all agreed that the tree diagram was correct and complete.

At first I was surprised at their ready acceptance of the diagram and labels. I could not repress a feeling of exasperation; if they had known this all along, why did they let me struggle so long to figure it out myself? The answer was that they had earlier assumed the role of teacher. Now they seemed pleased with both their pupil and their own ability to teach. "Yes, you have really learned well. This is the way it is." "You have done well." "Yes, that is right." It seemed to me, that they were also pleased with the sheer size of the sheets, which I had opened out accordion fashion to a length of nearly 2 m and which we then went over together. All of the terminology in the diagram was written in Spanish. Since they are literate, they could check the sheets themselves.

The potters' universe of pottery was first determined through the interview techniques described; then a limited number of samples from that universe were selected as being representative of type and size; I then photographed the samples with color film. The photographs were numbered and mounted in an album (purchased in Puebla) along with some photographs I had taken of pottery from other regions and from nearby towns in Puebla. The purpose was to test what was known about the ware from the city of Puebla in contrast to knowledge of both similar and distinct wares. The same album of color photographs was presented to a sample of specialists, potters and crewmen, and to members of the lower, middle, and upper classes in the city of Puebla. This sample was further subdivided on the basis of sex and age. Class, sex, and age were based on native categories. The persons interviewed were selected according to the criteria for each category, their willingness to participate, and their availability for follow-up testing. In all, 125 interviews were conducted with a minimum of three persons in each category of each subdivision, a total of 32 categories. The tests included open-ended interviews, as well as a standardized color test, which was devised for this study.

The color test consisted of a book of 15 colors, selected according to my best judgment from potters' samples of unfired, fired, and finished clays collected in the course of fieldwork in 1972, as well as from clays found in other parts of the world. The colors corresponded to the Munsell Soil Color Charts. The 15 color cards were selected and mounted, two to a page. The book was presented to 81 of the 125 persons in the sample tested in 1973.

Each person was first asked to name the colors in the book. Then each was asked if any of the colors resembled the clays or the utilitarian pottery of Puebla. Finally, each was asked if any substitutions for the colors associated with Puebla pottery were possible. I also noted any additional comments and information they volunteered.

I seldom proceeded beyond the second question because the test seemed to generate boredom and resistance to further questioning. They seemed, however, willing enough to name the colors in response to the first question, that is, to name the colors in the book. Fifty persons responding to the second question identified red and black as the colors of ordinary cooking pottery in Puebla. However, they were all confused and annoyed by the question about substitutions. As far as they were concerned, they had already identified the "proper" colors for cooking pottery and saw no need to proceed further. To my surprise, the specialists, those who made and fired pottery, found it most difficult to judge clay and pottery color in the book format. One-quarter of the possible responses to the color cards went unanswered in each of the 26 interviews with specialists. Later, I tried giving potters pieces of broken pottery that I had picked up on the ground— sometimes from their own workshops—to compare with a color card. But they did not respond even then. It should be noted that clay color is usually judged by potters in the unfired state and that texture is also important (see chapter 2). Other possible criteria would be associated with stage of production and function. The works of Conklin and others, with regard to color categories, show that this is a complex subject for analysis and should be tackled as a separate study (1955:341–343). My judgments with regard to color were not accepted by the specialists entirely, and the test, in general, did not produce much useful information. Therefore, I discontinued it after 81 interviews had been completed.

The album of photographs devised as a test to elicit stylistic features, first from a sample of potters, second from a representative sample of people in the city, was composed in the following way. A selection of 39 pots was made from the potters' total universe of 133 sizes and 21 types of black-on-red glazed ware in Puebla (see Figure 2-2). Two-thirds of the pots selected were wheel-made (26), and one-third were mold-made (13). They were selected in proportion to the types produced; that is, twice as many of the wheel-made (14) as the mold-made (7) types were recognized by potters. Thirty-nine pots were selected to represent types, as well as the three techniques distinguished by potters themselves: jar makers who only used molds; those who used molds to make various cooking pots; and those

who used the wheel to make both jars and pots. Three other categories—large, medium, and small—were represented as specializations in size.

Because there were gradations within each of the three size categories, the examples were selected to show a distinct difference in size when photographed. All of the prints were of the same dimensions (9-by-13-cm color prints), but I realized that, without selecting for the medium, differences in pot size might easily be lost. The results of the first series of tests—using prints of all 39 pots plus those of 13 additional pieces of pottery, contrasting in time and place of manufacture with Puebla ware—showed that, even with care in selection, informants had difficulty perceiving relative size in the pottery. This difficulty undoubtedly stemmed from the use of photographs instead of the pots themselves, but also from the subtlety of size variations that actually exist within a given category. The advantages of using photographs, however, far outweighed the disadvantages. It would have been impractical to have attempted to carry such an extensive—not to mention cumbersome, breakable, and heavy—sample around for interviews to various sections of the city. The album (26 by 30 cm) with its mounted prints was portable, durable, and light; and the test was the same for all informants interviewed.

To enable informants to judge a vessel's size from photographs, I included a common household item, familiar to everyone in Puebla, as a point of reference. The item selected was a metal basket with eggs. It can be seen any day of the week being carried on the streets of the city to and from markets; it is used and known among all social classes. Human hands were included in the photographs as further indication of relative size; a man's hands were used in some photographs and a woman's in others. Also included was a metric ruler at the base of the vessels, along with an identifying number.

Table 5-5 lists the 28 pots used for all testing after some 40 interviews had been completed. I eliminated 24 prints from the album because many of those showing gradation in size within pottery types were yielding redundant information and because other information was being lost as the informant became fatigued. Table 5-6 lists the 24 examples of pottery eliminated. The 28 prints remaining in the album were those that had proved most productive. They had revealed contrasts in the pottery sample tested, and they generated much additional data on family life, former customs, and present-day changes in society.

I would like to note that, while I anticipated difficulty with the potters' perception of the pottery sizes shown in the photographs in the album

Table 5-5 Pottery Used in Testing

Example Number	Ware Type
1.	Large jar (*olla de a medio*, mold-made)[a]
2.	Large jar (*olla de a tlaquito*, mold-made)
3.	Medium jar (*jarro sope*, wheel-made)
4.	Small jar (*jarro medio tránsito*, wheel-made)
5.	Small jar (*jarro capulixtle*, wheel-made)
6.	Large pot (*tecomate de a seis*, wheel-made)
7.	Group of assorted jars
8.	Large pot (*tortera de a medio*, mold-made)
9.	Large pot (*cazuela de a medio*, mold-made)
10.	Small pot (*casito molerito*, mold-made)
11.	Toy pot (*cazuela dedal*, wheel-made)
12.	Group of assorted pots
13.	Large pot (*cazuela china*, wheel-made)
14.	Decorated pot (*tortera pescadera labrada*, mold-made)
15.	Effigy jar (*jarro panzón*, mold-made)
16.	Jar, town of Amozóc, Puebla (*olla colorada*, mold-made)
17.	Pot, town of Ocotitlán, Puebla (*cazuela*, mold-made)
18.	Plates and bowls, town of Tzintzuntzán, Michoacán (*platos y cajetes*, mold-made)
19.	Jar, town of Zautla, Puebla (*jarro*, mold-made)
20.	Jar, town of Zacapoaxtla, Puebla (*olla*, mold-made)
21.	Large jar, unfired (*cántaro de a doce*, wheel-made)
22.	Large jar, unfired (*cantimplora de a doce*, wheel-made)
23.	Large jar, unfired (*jarro cachucho de a doce*, wheel-made)
24.	Medium jar, unfired (*olla de a doce*, wheel-made)
25.	Large pot, unfired (*tecomate de a doce*, wheel-made)
26.	Large pot, unfired (*cazuela china de a doce*, wheel-made)
27.	Chamber pot, unfired (*bacín de a doce*, wheel-made)
28.	Flower pot, unfired (*maceta de a doce*, wheel-made)

[a]All examples are black-on-red glazed ware or are unfired from the city of Puebla, except where noted as being from other towns. The examples are listed in the order of appearance in photograph album.

Table 5-6 Pottery Originally Used in Testing but Eliminated

Example Number	Ware Type
1.	Medium jar (*jarro arrocero*, wheel-made)
2.	Small jar (*jarro tránsito*, wheel-made)
3.	Toy jar (*jarro dedal*, wheel-made)
4.	Large pot (*cazuela de a tlaco*, mold-made)
5.	Medium pot (*cazuela de a diez*, mold-made)
6.	Small pot (*cazuela de a ocho*, mold-made)
7.	Large pot (*tortera de a tlaco*, mold-made)
8.	Small pot (*cazuela medio tránsito* wheel-made)
9.	Small pot (*cazuela arrocero* wheel-made)
10.	Small pot (*cazuela capulixtle*, wheel-made)
11.	Large jar (*olla de a doce*, wheel-made)
12.	Large jar, unfired (*olla de a doce*, wheel-made)
13.	Large jar, unfired (*olla de a doce*, wheel-made)
14.	Large jar, unfired (*olla de a doce*, wheel-made)
15.	Large jar, unfired (*caso de a doce*, wheel-made)
16.	Effigy jar (*jarro apache*, mold-made)
17.	Flowered jar, town of Pátzcuaro, Michoacán (*jarro,* wheel-made)
18.	Effigy jars (2), Collection of the Museo del Artes y Industrias Populares, Mexico City (mold-made)
19.	Assorted jars, Collection of the Museo Casa del Alfeñique, Puebla (mold-made)
20.	Assorted partially finished jars, Talavera factory, Puebla (wheel-made)
21.	Eighteenth- and nineteenth-century Talavera plates, Collection of the Museo del Estado de Puebla, Puebla, (mold-made)
22.	Assorted jars, Oaxaca (hand modeled)
23.	Painted plates, town of Tzintzuntzán, Michoacán (mold-made)
24.	Polychrome plates, town of Capula, Michaocán (mold-made)

format (especially after the ill-fated color test described earlier), this did not prove to be the case. With few exceptions, they rarely made an "error" in size; and when they did, they were always within one size, either next largest or smallest, of the pot shown in the print. An error here refers to misjudging the size or the label assigned to the pot by its maker and agreed upon by other potters who judged the pot itself and not the print. There was near unanimity among adult and elder potters and crewmen with regard to pot type, size, and design, and with regard to the features distinguished. (For the detailed results of the testing, see the end of this chapter and see chapter 6.)

What I did not anticipate was the potters' enthusiastic response the prints themselves. They often called over some relatives, friends, or employees to exclaim over how well the pottery looked. They remarked that the photographs really did justice to their work. This was not the only occasion on which I found them to be very concerned with the aesthetics of their work. Remember, this is everyday cooking pottery, utilitarian ware, primarily functional; yet there was a deep and widespread feeling among the potters for its form, finish, and design. There is power in their tradition.

At that time, there were 70 potters and 25 crewmen engaged in the production, decoration, and firing of black-on-red glazed cooking pottery. Of these specialists, 12 potters, recognized by their peers as master potters, were initially my primary informants. Their system of classifying the pottery, their own view of the universe of black-on-red ware, was first obtained in a series of open-ended interviews in 1972 (Kaplan 1976a:138–140). Potters identified 20 pottery types with discrete labels, based on 94 features and 137 sizes. Finished pots of each type were then photographed in color, numbered, and mounted in an album, unlabeled, and used in standardized tests in 1973 (1976a:150–160). A sample of 125 persons was tested, representing 32 native categories of persons, distinguished on the basis of sex, age, and class. The open-ended interviews included no terms for pottery types, sizes, or features that were not first introduced by the informant; and, in a sense, each informant constructed his or her own interview.

The original test album of 52 photographs included 13 prints of pottery from nearby towns and from other regions of Mexico. The purpose was to test the accuracy of the responses and to compare knowledge of black-on-red pottery with other wares. Eight unfinished examples of black-on-red ware were included to isolate further the features being distinguished. Verbal responses to photographs and to actual pottery were combined with observations of existing behavior in the manufacture and use of pottery. The extent to which features distinguished verbally by potters were isolated, manipulated, and recognized in the process of the manufacture of pottery types was noted; and features and pottery types using discrete labels were noted in conversations with me and among potters, as well as with others. The observations tended to support the system of classification.

I expected potters to have the most detailed knowledge and the largest vocabulary concerning pottery and to exhibit the most consistency in their

responses. I also assumed that, based on the analogy with language, there would be differential participation and knowledge of style as a system, based on age, sex, and class—which did prove to be the case when responses were tabulated and correlated.

The emic model of structural linguistics, applied to the native taxonomy of pottery, proved capable of reducing the 94 features or variables to 12 distinctive features; and the 20 types (or 25 if the decorative types were included) and 137 sizes, to 14 major categories uniquely labeled. The 12 features were marked plus or minus (+/−) with regard to their presence or absence: they were mold, flat, wide, deep, covered, footed, necked, handled (one ear), eared (more than one ear), glazed, grooved, and bichrome. The vessels not marked for the mold technique were wheel-made (− mold), and vessels not marked for flat bases were round (− flat). *Wide* covered a variety of features; the realization of *wide* or *deep* depended on the class of object. For example, the feature *deep* distinguished the class of objects known as *caso* (+ deep) from the class *tortera* (− deep), and the class *velorio huevito* (+ deep), from the class *velorio* (− deep). In the latter case, the feature *deep* appeared to be of no great consequence because informants mentioned it only if pressed to explain why one pot is called *velorio huevito* and the other simply *velorio*. This double term, like *olla colorada* and *jarro cachucho*, was considered marginal because the distinctions among the three double terms were not especially significant to the informants.

The feature *neck* was defined as a very tall neck, and the absence of the feature (− necked) was defined either as a very short neck (like the *jarro* or *jarro cachucho*) or as no neck. Here, too, the realization of the feature depended on the class of the object. *Handled* was defined as having one ear; *eared*, as having more than one ear. A *covered* vessel was one normally made with a cover; and unless marked *footed*, all vessels were without feet (− footed). With regard to decoration, all vessels were either decorated and glazed or they were undecorated (− glazed). They were either painted black-on-red (+ bichrome), or they were monochrome (− bichrome).

Application of the generative model to the same data base further reduced the system to a single rule capable of producing 6 of the 14 major categories of pots. When the features were modified, the rule produced the other eight categories. But it is not possible to analyze "deep structure" in the Chomskyean sense.

Generative analysis as applied here does evoke the life history of the pottery. Based on this model, I note that the eating bowl, the *cajete*, a semicircle, is the basis for all other forms generated on the wheel and in molds. This conclusion was not only the result of the potters' observations concerning variations in type and size but also arose from my own observations based on their behavior and comments. In addition, it was consistent with the historical, archaeological, and other ethnographic evidence.

The eating bowl, or *cajete*, the semicircle, closely resembles the gourd bowl. Gourds were among the earliest plants used and domesticated in Mesoamerica; and they are still widely used in the dried state as eating bowls and drinking vessels. The traditional bowl for pulque is still a dried gourd, called *xoma* or *xícara*, in the rural areas of Puebla. These bowls are represented on the famous Precolumbian mural *The Pulque Drinkers* at Cholula. It is not certain whether the bowls represented are actually gourds or are made of clay; the form is the same in any case. Sahagún's sixteenth-century account of life-style in *The Merchants* noted that they drank chocolate from "gourds" (1959:33). The literal translation of the Spanish, however, is actually "gourds of clay" (*xícaras de barro*), or clay bowls. Clay bowls have a long and continuous history in this region; and their use was preceded, then paralleled, by the use of gourd bowls of the same shape. The generative rule reflects the history of a basic geometric shape, and it looks like this:

$$\text{Pot} \rightarrow \text{Bowl (Cajete)} \quad \left(\left\{ \begin{array}{l} \text{Necked (handle)} \\ \text{Footed} \\ \text{Eared} \end{array} \right\} \right)$$

(This rule, I note, is similar to Glassie's finding, that the square constitutes the basis of three classes and types of Middle Virginia folk housing [1975].) This rule is capable of producing 6 pots; the remaining 8 to 11 pots could be produced by modifying the feature. A computer program could be constructed to generate these pots, but the effort is unwarranted. A further evaluation of the usefulness of linguistic models and other methods applied here is made in chapter 6.

An apparent preference for the generative model by Glassie (1975) and by Muller (1966, 1980) in their studies of folk housing and of shell gorgets, respectively, has been due in part to an emphasis on historic and prehistoric material culture, wherein informants were unavailable. In addition, the large number of informants available for this kind of "structural" analysis— "from flow charts to grammar . . . to programlike statements" (Muller 1977:29)—make the generative model attractive. For Glassie and Muller, *structure* was seen as the rules that can be written to account for the types or microstyles. But the applicability of such generative concepts as *competence*, *deep structure*, and *transformational rules* to such studies is remote at

this time. The only sensibilities regarding competence and performance available are those of the investigators, who must rely on the abstractions they have made from the artifacts. The generative model is not well enough developed to analyze deep structure in material culture but depends heavily on verbal statements about the artifacts. These comments point to a fundamental problem in nearly all structural studies that make use of linguistic models: the need to distinguish clearly between the two viewpoints in doing research—the performer's and the investigator's—between those who have internalized the meaning and rules of the system and those who are attempting to abstract them.

The emic model has been operationalized, and as I have endeavored to demonstrate here briefly, it is capable of dealing with folk art at an available level. Unlike linguistics, in which the two competing models have led to much productive research, the study of folk art has been trammeled by a paucity of operational models. The emic model provides a useful heuristic device for analyzing structure in art style and may be preliminary to applications of the generative model to folk art or to other art forms.

A preference for the generative model is attributable, in part, to criticisms leveled at the emic model by the transformationalists, who consider the emic approach particularistic in the study of language and, presumably, culture. They see it as relying on a taxonomic model and focusing on a study of elements, rather than on the relational systems of which the elements are a part (Keesing 1971:3, 5, 11, 19). However, even its critics admit that these limitations are not so much a part of the emic model as they are of the use that has been made of it. My own interest in the emic model is both personal and epistemological, being more concerned with observable differences in styles than in being able to account for underlying similarities. While it is important, the search for such similarities, which occupies the transformationalists, is probably premature in folk art at this time.

One of the statistical methods applied to the emic analysis of a Mexican folk pottery style was the following: P-STAT Version 3.05, Revision 2, December 14, 1973, 270 k Overlay (Roald Buhler 1971); it was used to tabulate and correlate the variables of sex, age, status, specialty, and response to photographs of the pots (1–28), based on 125 interviews. The variables are categorical; they are based on the responses of the informants, with final determination by the investigator. (Table 5-7 illustrates the coding used for the computer program.)

Each of the 125 persons in the sample tested was assigned an identifying

Table 5-7 Code for P-STAT Version 3.05, Revision 2, December 14, 1973 270 K Overlay: Black-on-Red Glazed Ware, Puebla, Mexico

Line	Number Code	Code Key
Line 1[a]	1	Informant's designation (numbers 1–125)
	2	Informant's designation (numbers 1–125)
	3	Informant's designation (numbers 1–125)
	5	Card number: 1
	6	Sex 1. Male
		2. Female
	7	Specialty 1. Potter (Self-employed)
		2. Potter employee
		3. Member of painting and firing crew
	8	Age category 1. Elder (*grande*)
		2. Mature adult (*adulto*)
		3. Young (*joven*)
		4. Child (*niño*)
	9	Status 1. Specialist
		2. Lower class
		3. Middle class
		4. Upper class
	10	Response to pot
	11	Response to pot
	12	Response to pot
Line 2	1	Informant's designation (numbers 1–125)
	2	Informant's designation (numbers 1–125)
	3	Informant's designation (numbers 1–125)
	5	Card number: 2
	10	Response to pot
	11	Response to pot
	12	Response to pot

[a]Numbers refer to columns punched in coding.

number (1, 2, 3); and each categorical response was numbered (10, 11, 12). The responses were categorized as follows: first, all responses to each pot were collected according to the pot's number on separate sheets; second, each sheet was studied to subsume under one label those responses that, in my best judgment, varied only slightly from the others and conveyed essentially the same information (distinctions were preserved when they appeared to be subject to interpretation); third, each categorical response was assigned a number, and the number was entered in the appropriate columns.

Some photographs of pottery in the test album evoked more varied responses than others. For example, the two group photographs (7 and 12), which I had hoped would elicit a name for the ware, produced 50 responses. I was able to reduce the total to 10 for photograph 7 and 18 for photograph 12 by the method described in the preceding paragraph. Responses identifying the cooking pots as being from "here," "La Luz," "Puebla," or "La Luz, Puebla" were classified together as La Luz, Puebla (response 118 in Table 5–1); the responses *"loza de La Luz," "loza del barrio de La Luz," "loza corriente de La Luz, Puebla," "loza Puebla, barrio de La Luz"* were classified as *"loza de La Luz"* (116). One response (118) was simply geographical; the other (116) also included the type of pottery, a general label indicating an ordinary or common ware (*loza*). Both responses could have been combined, but the distinction between an implied (118) and an expressed (116) (albeit general) label for the ware was preserved. Both responses clearly show the extent to which this pottery is identified and even synonymous with Puebla and the barrio of La Luz. In all, 168 categorized responses to 28 pots were encoded on the computer cards (5 in Table 5-7). Again, the key to all of the responses is provided in Table 5-1.

As Table 5-7 outlines, specialty (7) was made a separate category of status (9) and was subdivided to indicate function: potter (self-employed); potter employee; or member of a painting and firing crew. All specialists are male (6). Age categories (8) are those distinguished by informants: child (*niño*); young person (*joven*); mature adult (*adulto*); or elder (*grande*). The age ranges are identified as follows: elder (*grande*), 50 to about 70 years; mature adult (*adulto*), 30 to 50; young (*joven*), 15 to 30; and child (*niño*), 7 to 14 years of age.

I do not translate *grande* as "old" because there are other terms for an old person that are used under certain circumstances. A person is not called *old* (*viejo, vieja*) unless he or she is too old or disabled to work. The term is seldom used because it is considered a mild insult. The term *venerable*

(*anciano*), like the term *old* (*viejo*), indicates that a person is unable to work, but there is a measure of respect attached to *venerable* because of the extreme age attained. A person is venerable or very old after about 80 years of age. This term, like the preceding one, is seldom used, though for a different reason: few people live to be very old, that is, much beyond the age of 70, particularly among specialists. I was able to locate only one potter older than 80. He would have resented being called either old or venerable because he, too, still worked every day, though he was hampered by poor eyesight and hand tremors. I did not attempt to include a very old age category in the sample tested because it was apparent that the problems of obtaining an adequate sample exceeded the possible benefits. Although the results are not presented here, some very old people were in fact interviewed. They were found to be in general agreement with elders of the same class and sex.

The Appendix, containing Tables A-1 through A-28, summarizes the results of the tests based on pots 1 through 28; the key to the responses is listed in Table 5-1. Specialists, members of the lower class, and women were found to have the most detailed knowledge of this pottery as expressed by specific labels for types and sizes. Some labels refer to monetary units that have been in existence in Mexico since the sixteenth century; others refer to weights and measures that have comparable time depth; and still others probably refer to size series established by the Spanish guild (e.g., *de a seis, de a diez, de a doce*—six, ten, and twelve, respectively). As early as 1524, only three years after the Conquest of Mexico was completed, a series of ordinances by Cortés established the usage of standard weights and measures after those in Spain (Carrera Estampa 1949:3). Many persisted through the colonial period and into the present (1949:7, 9, 10, 14). For example, *de a cuartilla* and *de a medio* are traditional units of measure applied to sizes of black-on-red utilitarian pottery. Likewise, *de a real* and *de a tlaco* are colonial monetary units applied to pottery sizes. And these units of money, weight, and measure, have been intertwined in an even more complex size series of pottery types. (See Figure 2-2 for the potters' taxonomy.)

Children and members of the upper class were frequently unable to distinguish between variants (response 1, Table 5-1), or they responded using the most inclusive labels (*olla*, response 7; *jarro*, response 3; *cazuela*, response 34). For example, pot 8 (*tortera de a medio*, Table 5-1) is identified by the general label *cazuela* (response 34, Table 5-1) by most children, young people, members of the middle and upper classes, and by men; a more

specific label, *tortera* (response 46, Table 5-1), was used for the same pot by most adults, elders, lower-class persons, and women. Specialists used *tortera*, too, but they also used the even more specific label, *tortera de a medio* (response 47, Table 5-1).

Differences in knowledge or terminology were more marked when less familiar types and groups of pottery, from Puebla and elsewhere, served as stimuli (pots 6, 8, 14, 15, 21, 22, 23, 25, 27; 7, 12, and 18). These pots actually yielded much information about the distinctive features used to define types and wares. Their features are listed in Table 5-4. For example, pot 6 (*tecomate de a seis*, Table 5-5), was, according to potters, a cross between an *olla* (response 7) and a *cazuela* (response 34). The *tecomate* was made on the wheel. It was round (features 4 and 12), had a relatively closed mouth (features 13 and 14), and had ears (features 31 and 39), just like the wheel-made *olla*. But it was neckless (feature 16), and its ears were placed horizontally (feature 41) on the rim (feature 44), like the *cazuela*, and it was used in much the same way (features 78 and 80). This mixture of features was reflected in the varied responses recorded for pot 6.

The results of the tests indicated that differences in responses to pots 1 through 28 were related to variables of age, class, and sex. Specialists, as anticipated, commanded the most detailed knowledge of the pottery, had the largest vocabulary of labels, and exhibited the most consistent agreement in responses based on such knowledge. My assumption that style is a system analogous to language was supported by the results. An overall similarity in responses to a pot, as shown in the summary, was consistent with this assumption. If style does indeed resemble language and functions as a kind of system of affective communication, then there should be substantial agreement among those who know about and use it. And differences in responses based on age, class, and sex, likewise, were consistent with this assumption: they reflected imperfect learning and evidence of change among children; they reflected imperfect learning based on limited participation in the system among members of the upper class. "Dialect" differences were reflected in greater class and sex differences.

Quantitative methods were used to reveal the nature of structure from a matrix of data elicited from the potters. The data consisted of information that indicated the presence or absence of 94 features on a set of 25 different kinds of pots (for features present see Table 5-4). The presence or absence of these features was determined by sampling the 12 specialists. It was assumed that specialists would have the greatest command and knowledge of pottery making and the preceding tests supported that assumption.

On 25 pottery types (see Table 5-2), potters distinguished the presence or absence of 94 features (see Table 5-4). These pottery types and features were cross-classified, with a plus sign (+) indicating the presence of a particular feature on a specific pottery type. A measure of similarity or distance can be computed by analyzing the cross-classifications of the pottery types with these features. The analysis assumes only that the pottery types are in some way determined by the feature analyzed.

A variety of techniques can be used to measure the similarity of the different features identified by the potters. For example, D'Andrade and his coworkers (1972) have utilized the phi (ϕ) coefficient to measure the similarity between Mexican and American disease terms. However, Goodman and Kruskal (1954, 1959, 1963, 1972), who have developed a set of measures of association, note that, although the chi-square statistic is useful as a test of hypothesis, its accuracy as a measure of association is questionable. In particular, there is serious doubt about whether two different phi (ϕ) coefficients can be compared, as is necessary in developing a measure of distance between all pairs of objects.

Among the alternative measures of association developed, there are various matching coefficients. For example, the simplest measure of association involves counting the number of features on which two pottery types agree, either counting or ignoring absence-absence matches. However, as Whallon (1972) has noted, these similarity measures are inherently deficient because each feature is weighted equally in its derivation.

A measure that differentially weights each feature has been developed by Goodman and Kruskal (1954). It indicates the power of one feature as a predictor of a second feature and is based upon Guttman's (1941) lambda (λ) coefficient of predictability. It allows for differential weighting of features in measuring the similarity of the pottery types. The more alike the feature is to other features the smaller will be the weight of the feature. These weights are computed as follows:

$$wt = 1/\Sigma j\lambda ij \qquad \Sigma \lambda ij > 0$$

$$\text{where: } \lambda ij = \frac{\Sigma fr - \Sigma fc - (Fr + Fc)}{2n - (Fr + Fc)}$$

where: fr = maximum frequency for each within class row
fc = maximum frequency for each within class column
Fr = maximum frequency of marginal totals for rows
Fc = maximum frequency of marginal totals for columns
n = total frequency (number of pots)

The computational aspects of this formula can be illustrated by computing λ_{ij} for a particular pair of features. The cross-classification for feature 1 (wheel technique) and feature 13 (open mouth), for example, is shown in Table 5-4, with regard to the presence or absence of these two features.

To compute the weight for feature 1 (wheel technique), the λ_{ij} can be computed for all cross-classifications of feature 1 with each other feature. The λ (lambda) values are summed up, and the weight for each feature is computed. The distance between the two pottery types is computed by adding the weights for the features in which the two types have a mutual presence or a mutual absence. Thus, the various features are being assessed differentially in determining the similarity of pottery types.

Based upon the computations used here, those features that are somewhat redundant receive less importance in measuring the similarity of the pottery types, while those features that are more discriminating in differentiating between types receive greater importance. Features that are completely redundant are combined for the purpose of analysis. A computer program was used to compute the weights of each feature and the proximity of each pair of pottery types because of the large number of pottery types (25) and features (94) involved in this study (Carmone and Robinson 1968). The following is an example of cross-classification of feature 1 (wheel technique) with feature 13 (open mouth).

Feature 13	+ (Presence)	− (Absence)	Total
(Open mouth) +	4	6	10
−	11	4	15
	15	10	25

In this case, we have:

$$\lambda_1(13) = \frac{(6+11)+(11+6)-(15+15)}{2(25)-(15+15)}$$

$$\lambda_1(13) = \frac{17+17-30}{50-30}$$

$$\lambda_1(13) = \frac{4}{20} \qquad \lambda_1(13) = 0.20$$

A computer program was written by David M. Levine (1975a) in the FORTRAN IV language to compute the matrix of distances between pots. PASCAL would be the preferred programming language today.

Two multivariate statistical procedures were applied to analyze the data: cluster analysis and multidimensional scaling. The objective of my cluster analysis was to find similar groups of objects (pots). Cluster analysis attempts to group the objects (pots) by stylistic similarities. The objects (pots) are separated such that each is more similar to the others in its group than to those outside its group. The type of cluster analysis used here was hierarchical clustering as developed by Johnson (1967). A hierarchy, or treelike structure, is developed to join objects together in groups. Once any two objects are joined together in a group, these two objects cannot later be separated. My basis for linking pots into clusters was the diameter method. The linkage was based on the maximum distance between pots allowed into the cluster, and attempts were made to develop compact clusters.

My results from the connectedness method of cluster analysis proved unsatisfactory: the method neither simplified nor ordered the data in a meaningful fashion. Sometimes, connectedness results in long chains of objects linked together only by the two most similar points (see Table 5-8). The diameter method of cluster analysis, however, yielded a hierarchy of the 25 pots for which a measure of similarity had been obtained. The results are shown in a taxonomy of the pottery (Figure 5-3). Of the 25 possibilities, I was able to interpret 12 compact clusters. These compact clusters are, in general order of their appearance in the hierarchy, as follows: 7 and 8, *velorio* and *velorio huevito*; 18 and 19, *molcajete* and *cajete*; 9 and 10, wheel-made *cazuela* and *caso*; 11, 12, and 13, mold-made *cazuela*, *caso*, and *tortera*; 5 and 6, *jarro cachucho* and *jarro cántaro*; 17 and 23, *maceta* and *tortera labrada*; 3 and 16, *olla colorada* and *bacín*; 15 and 24, *borcelana* and *jarro negro*; 1 and 2, mold-made *olla* and wheel-made *olla*; 4 and 20, *jarro* and *jarro cantimplora*; 21 and 22, *jarro labrada* and *olla labrada*; and two single clusters: 14, *tecomate*, and 25, *olla negra*.

I expected 18 and 19 to be the first cluster to emerge in the hierarchy. The grinding and eating bowls, called *molcajete* and *cajete*, respectively, are very simple in form, semicircular, open, and without ears. This simple form appeared to be the basis for almost all others generated on the wheel and in molds. The size of a given vessel is determined by the bowl, the *cajete*, on the wheel; and it is the base of all mold-made jars, as well as of cooking pots. However, the first cluster that emerged consisted of the two special drinking jars called *velorios*. They are more complex in form than the bowls, being closed, but except for a single trait variation (7 is round while 8 is egg shaped), the vessels are identical. The bowls, 18 and 19, varied in 7 of the 19 traits by which they are distinguished. The number and relative weight

Table 5-8 Cluster Analysis, Connectedness Method, of 25 Pottery Types Identified by Potter Informants

Connectedness Method	Pottery Types																								
	22	20	03	16	14	02	04	01	17	18	19	23	15	05	06	07	08	24	21	09	10	11	12	13	25
0.19998093E 02																X	X	X							
0.19837189E 02									X	X	X					X	X	X							
0.19366196E 02								X	X	X	X	X				X	X	X							
0.19317596E 02								X	X	X	X	X				X	X	X		X	X	X			
0.19277786E 02								X	X	X	X	X				X	X	X		X	X	X	X	X	X
0.19271896E 02								X	X	X	X	X	X	X	X	X	X	X		X	X	X	X	X	X
0.19159485E 02								X	X	X	X	X	X	X	X	X	X	X		X	X	X	X	X	X
0.19133789E 02								X	X	X	X	X	X	X	X	X	X	X	X	X	X	X	X	X	X
0.18560898E 02								X	X	X	X	X	X	X	X	X	X	X	X	X	X	X	X	X	X
0.18254089E 02								X	X	X	X	X	X	X	X	X	X	X	X	X	X	X	X	X	X
0.18183289E 02			X	X	X			X	X	X	X	X	X	X	X	X	X	X	X	X	X	X	X	X	X
0.18000397E 02			X	X	X			X	X	X	X	X	X	X	X	X	X	X	X	X	X	X	X	X	X
0.17964386E 02			X	X	X			X	X	X	X	X	X	X	X	X	X	X	X	X	X	X	X	X	X
0.17657089E 02			X	X	X			X	X	X	X	X	X	X	X	X	X	X	X	X	X	X	X	X	X
0.17638596E 02			X	X	X			X	X	X	X	X	X	X	X	X	X	X	X	X	X	X	X	X	X
0.17260300E 02			X	X	X			X	X	X	X	X	X	X	X	X	X	X	X	X	X	X	X	X	X
0.17196899E 02			X	X	X		X	X	X	X	X	X	X	X	X	X	X	X	X	X	X	X	X	X	X
0.17080994E 02			X	X	X		X	X	X	X	X	X	X	X	X	X	X	X	X	X	X	X	X	X	X
0.17054993E 02			X	X	X	X	X	X	X	X	X	X	X	X	X	X	X	X	X	X	X	X	X	X	X
0.16957794E 02			X	X	X	X	X	X	X	X	X	X	X	X	X	X	X	X	X	X	X	X	X	X	X
0.16933685E 02			X	X	X	X	X	X	X	X	X	X	X	X	X	X	X	X	X	X	X	X	X	X	X
0.16859894E 02			X	X	X	X	X	X	X	X	X	X	X	X	X	X	X	X	X	X	X	X	X	X	X
0.16566788E 02		X	X	X	X	X	X	X	X	X	X	X	X	X	X	X	X	X	X	X	X	X	X	X	X
0.16297989E 02	X	X	X	X	X	X	X	X	X	X	X	X	X	X	X	X	X	X	X	X	X	X	X	X	X

of such traits account for the emergent hierarchy of pots. That fewer than 12 clusters were unintelligible, in the cultural sense of what was known and categorized by the potters and myself, might perhaps result from other features that had not been defined either explicitly or implicitly by the potters and as a result of the method's resolution. In fact, as D'Andrade and his coworkers have pointed out, this method assumes little about the organization of a domain except that it is, at least in part, determined by relevant properties used to define it and that further analysis is required to group the objects and their properties in a meaningful way (1972:11).

The objective of my multidimensional scaling was to attempt to develop a configuration of objects (pots) that best fit the actual similarities between pairs of pots. Nonmetric multidimensional scaling as developed by Shepard (1962a, 1962b) utilizes only the rank order of the similarities to develop the configuration of objects. The configuration indicates the coordinates of each object (pot) scaled in up to six dimensions. A measure of goodness of fit (Kruskal's [1964a, 1962b] stress coefficient) is computed to determine how well the configuration fits the actual data. The researcher then attempts to interpret the dimensions that separate the various objects, allowing for

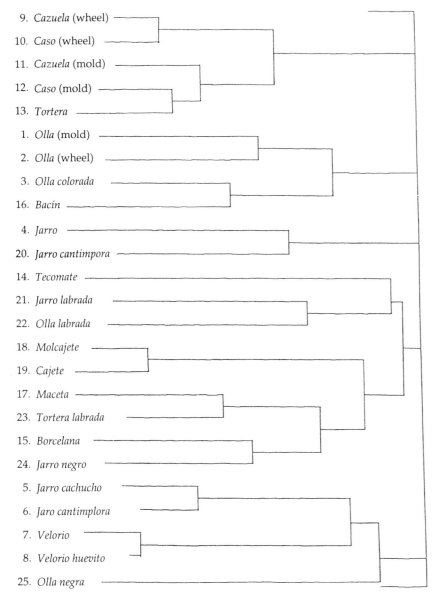

Figure 5-3. Taxonomy for pottery types based on hierarchical clustering technique.

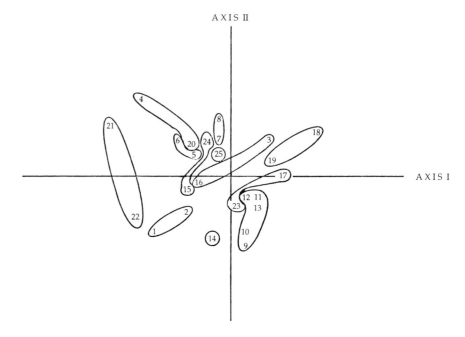

Figure 5-4. Multidimensional-scaling plot for pottery types, with major groupings from the hierarchical clustering technique encircled.

rotation, translation, reflection, and uniform stretching of the axes. A basic criterion for analysis is the interpretation of factors using the lowest number of possible dimensions, subject to the simultaneous desire to minimize the stress coefficient.

With multidimensional scaling, I attempted to set up the objects (pots) in a space of a given number of dimensions and to develop coordinates. It was not possible to interpret three or more dimensions. However, two clear dimensions were obtained, which were open and closed multiple and nonmultiple ears. Figure 5-4 illustrates the plotting along two axes for the pottery types with the major group from the hierarchical clustering technique encircled.

The stress coefficient was 0.5056 for the 25 pots scaled in two dimensions. Based on Levine (1975b), this value was significantly less than what would have been obtained had there been no structure inherent in the data. Therefore, these results clearly suggest that there are systematic factors being used in the perception of the similarity of the pots. This result is of

particular interest because no structure was imposed on the collection of the original data obtained from the potters. Open-ended interviews were relied upon, during which no types, sizes, features, or other categories were introduced or employed by me until they had first been used by each informant; so in a sense, each informant constructed his or her own interview. Furthermore, neither the clustering technique nor the multidimensional-scaling technique applied in this study inserted a preexisting outside structure into the data. Consequently, the structure that emerged from the data lent support to the view that was assumed by me, of style as a system held in the minds of the participants. The techniques so far described serve to make this system manifest.

Of added interest is the correspondence between the dimensions obtained from multidimensional scaling and the cultural categories employed by the potters and others. The distinction between open and closed, multiple and nonmultiple ears, which serves to separate the pottery types (see Figure 5-4), likewise, most frequently serves as the basis for separating types of pottery among the culture bearers, although 94 features are identified. The concept of open and closed is an important cultural distinction, representing as it does the dichotomy of male and female. This conception of the female as open, yielding, and submissive, the male as closed and aggressive, shapes the roles of men and women in that culture, generally, and it finds expression in their folk pottery. More detailed analyses of this and other cultural concepts are contained in the sections on symbolism in the preceding chapter.

It is also interesting to note in Figure 5-4 that vessel 17, which is on the horizontal axis that divides those vessels above with no ears or one from those below with two ears or more, truly occupies an intermediate position, since it usually has no ears, but at times two ears are added. This same vessel is linked to 23, a decorated, open vessel. Vessels 14, 15, and 16, which are located close to the vertical axis that divides closed vessels to the left and open vessels to the right, truly occupy a position closer to the open vessels. In fact, 14 is a particularly interesting type because it is ambiguous; it is a mixture of features associated with open and with closed, with the jar (*olla*) and with the cooking pot (*cazuela*). Its position along an axis, like that of 15 and 16 (and like that of 24 and 3, with which these last two pots cluster), indicates its marginality. Pots 7, 8, and 25, likewise, occupy a position along the vertical axis. They are relatively simple and uncommon closed types.

Another factor asserts itself to the right and left of the vertical axis dividing open and closed pots. All pots to the right may be undecorated or decorated either with black-on-red designs or with all-red glazing; all those to the left may be decorated either with black-on-red designs or with all-black glazing. This factor, too, corresponds to basic cultural distinctions that associate red with the life-force, day, and hot things and black with death, night, and cold things. Black—in conjunction with being closed and male—and red—being open and female—are in opposition to each other on the graph as they are in the culture. This division is also expressed in observable behavior, and it is verbalized. Black-on-red ware represents a balance of these opposing life-forces in the native cosmos. Consequently, the combined colors appear across the dividing line. Here, once again, important cultural distinctions find overt expression in a structure that emerges from that data.

A third method, emic analysis, was then applied to the data. The 94 features elicited from the potter-informants, subjected to the preceding analyses, and listed in Table 5-4, were analyzed with regard to the potters' universe of utilitarian pottery (see Figure 2-2). It was possible to reduce the 94 features to 12 distinctive features. These features account for the 14 unique terms and three marginal ones (*olla colorada*; *velorio huevito*; *jarro cachucho*) that make up the potters' universe of daily pottery.

Cluster analysis and nonmetric multidimensional scaling, applied to the raw data obtained from potters, served as a check for me and for the native taxonomy of pottery analyzed from the same data base. The cognitive imaging, or "map," that these techniques produced, isolated factors analogous to cultural categories that give shape to the way people think and behave in the society. Another and somewhat unexpected result was the historical dimension that manifested itself in the course of interpreting the dimensions of the multidimensional scaling (see Figure 5-4). Indian and traditional pottery types appeared separately and together in the discussion of the meaning of dimensions. Although up to six factors were investigated in the multidimensional-scaling analysis, the structure of the cognitive map could be attributed to the two factors of open-closed pottery types and multiple-nonmultiple ears. Significantly, these factors were consistent with other oppositions or cognitive categories within the folk culture: male-female, night-day, life-death, hot-cold, natural world–supernatural world, drink-food, and Indianism-nationalism. The goodness of fit of this cognitive map to the data obtained from pottery informants was significantly better than what could have occurred had there been no inherent structure to the data. It provided another way of looking at the same data, of getting at the

"native" viewpoint, and of seeing if a second statistical set of techniques would produce the same results.

The importance of ears as a factor in the folk classification of pottery types resembles Deetz's findings in his study of Arikara ceramics (1965:75–80). It is not simply a result of function, which could apply as well to other factors (only one other, already noted, proved statistically significant and amenable to useful interpretation). Ears are rarely considered distinctive features or variables in creating typologies and classifications of ceramics; more often, they are considered a random variable, if not omitted altogether. Deetz's results, as did mine, depended on statistical techniques, not on an investigator's assumptions in classifying ceramics; and they were not expected. Rims, on the other hand, were expected to be important to the potters' ethnotaxonomy and way of thinking. They proved not to have the importance Deetz and other archaeologists have assumed and have generally encountered in the archaeological record (which is most often sherds, however, not whole pots). Puebla potters actually vary rim form and decoration in response to consumer preference; and rim form, technique of manufacture, and function were also found to be correlated. For the most part, the folk potters themselves have used the same criteria as the archaeologists in classifying pottery: color, shape, design elements, and function. However, Puebla potters give ears and size differentiation within major pottery types (150 sizes of 25 types) considerably more attention than expected.

The quantitative techniques applied in this study classify a body of empirical ethnographic data, provide insights into the cognitive structure of a folk taxonomy of pottery, and prove consistent with major cultural categories that shape social behavior and inform worldview in Puebla. Ethnographic and ethnohistoric field research show that these data and the folk taxonomy they yield are more than arbitrary cultural behaviors. They reflect history, as well as inherent structure, in the data, which were discovered using a multivariate approach and ethnographic fieldwork.

Discussion

Since the advent of ethnoscience in the late 1950s, the study of meaning in culture and, more recently, in material culture has been marked by the search for systematic and demonstrable techniques with which to recover and represent classes of artifacts and behavior as the culture bearers conceive them. Some studies have ventured into the refinement of concepts and techniques associated with language and linguistics. At times, they have addressed problems of classification and typology, both of which are classic problems of historical concern to cultural anthropologists and archaeologists alike. (Some articles include Burgess et al. [1983]; Hays [1983]; Hunn [1982]; Kay and Kempton [1984]; Kintigh [1984]; and Shapiro [1984].) Archaeologists have sought to devise measurements of meaningful arrangements of data to interpret culture history and behavior, but they are not seeking cognition as such.

Other ethnographic studies give emphasis to symbolism and cognition. Some owe a debt to the structuralism of Lévi-Strauss, while other researchers developed their own approaches (Bucher 1981; Dougherty et al. 1982; Douglas 1982; Furbee and Benfer 1983; Kaplan 1976a, 1976b, 1977a, 1977b; Kaplan and Levine 1981; Wierzbicka 1984). Among them is a lexicosemantic approach to ceramic folk classification, using a model of the prototype and graded extension; and some researchers devised statistical techniques that have yielded mixed results (see Kaplan 1985:360; Kempton 1981). Consideration of all models relevant to classification, folk and otherwise, including the prototype and semantic-space models, must be seen in the broader context of earlier work on primitive classification. The works of Lévy-Bruhl (1926), Durkheim and Mauss (1963), Douglas (1973), and Wittgenstein (1953) are among the most important forerunners of a variety of studies, including this one, which take into account function and context in approaching "primitive" or indigenous and folk systems of thought. Representations of such indigenous systems by those outside the system, for example, etic descriptions, especially those without parallels to indigenous thinking, have been criticized and are in contrast to the emic model adopted here (Hallpike 1979).

6 CONCLUSION

How beautiful it was in the past. This black-on-red
pottery went to all parts of the world, and everyone
had a glimpse of what Mexico was like. Now, it is
ending with us.

— *Don Pedro Rodríguez, a master,*
elder potter of the barrio of La Luz, Puebla, 1974

This study is one of art style in material culture. It is an ethnography
and a kind of life history of a folk pottery tradition, based on a single
functioning style of cooking pot made in the barrio of La Luz, Puebla. In it,
I examine the conditions that underlie pottery production, distribution, and
usage in contemporary and historical contexts; and in it, I apply empirical
and quantitative methods to probe a posited relationship between a given
style of folk pottery and its users. Style, analyzable as a system of distinctive
features, is a ubiquitous phenomenon that evokes strong emotions in a
group or society. Its effect is potent because the emotions it stirs may either
unite or incite people to act. It emanates from a shared way of thinking,
from common values and experiences. Those who identify with a given
style find their sense of belonging reinforced by the "correctness" of things.
In seeking a more objective and replicable methodology with which to
analyze style, something is illuminated about the creative process and the
phenomenon of style itself.

Style as Identity

The potters of Puebla who produced black-on-red ware were found to
constitute a community within a spatially defined area of the city (popula-
tion 276,000:1970 Census). They identified themselves and were identified
by others as belonging to that area (La Luz), and they intermarried and
interacted for ritual purposes within it. The community of potters and the
history of black-on-red cookware, as it is presently reconstructed from
historical records and documents, were revealed to have had considerable
time depth in the city. Visible evidence of the present style's existence more
than a century ago was found in two still-life paintings from Puebla by
Agustín Arrieta (1809–1867). Earlier hard evidence of the style was recov-
ered from a 1797 document, which records a dispute between Indian and
Spanish potters with regard to rights over black designs on red cooking
pottery. For the period before the latter part of the eighteenth century,
evidence is scanty: city and parish records indicated some seventeenth-
century Indian manufacture of domestic pottery in Puebla, but the style or
styles could not be determined with certainty. To date, there has been no
historical archaeology in the city and its environs. Sixteenth-century pottery
manufacture in Puebla, apart from the domestic wares of Spanish work-
shops and the blue-and-white glazed majolica, called Talavera, remains
conjectural. However, research in the Valley of Mexico and the Valley of
Teotihuacán indicates that Preconquest Aztec pottery types continued to
be made into the seventeenth century (Charlton 1976).

In Mexico, there is a long tradition of craft specialization in urban
workshops, including ceramics (Cowgill et al. 1984:162, 166, 171; Millon
1976:232). Puebla offers an example that may serve to dispel the notion that
folk art and folk crafts are to be found only in rural areas, among family units
of production. For at least 200 years, the community studied comprised
folk potters and their ware—folk pottery—based on traditional techniques,
forms, and designs. This, despite urban production of black-on-red cook-
ware, for profit and wages, in a money economy, and despite much special-
ization and evidence of workshop organization, which discloses the pres-
ence of a kind of crude system of mass production.

Available evidence suggests that the Puebla style emerged and flour-
ished against the backdrop of Postconquest social, economic, and political

change in Puebla. Separation and exploitation of the Indians by the Spaniards during the colonial period served to heighten and perpetuate "Indian" consciousness. Pottery and the native foods traditionally associated with it became both a necessity and a subtle means of expressing an ancient heritage—consequently, an Indian identity. The pottery itself became widespread as colonists adopted native foods, ingredients, and techniques of preparation. With independence after 1821 and separation from Spain, a new awareness of common American identity contributed to the formation of Mexico as a nation. Economic and social change led to the fusion of the formerly separate manufacture of Indian and of Spanish domestic pottery. This union was followed by a florescence of the black-on-red pottery style in the mid to late nineteenth century, alongside capitalist expansion. The beginning of the industrial revolution in Mexico took place in Puebla and was marked by the growth of a new bourgeoisie. By 1930, the style went into a decline after the gradual restoration of order, following the Revolution of 1910. Since 1950 especially, enamel ware, aluminum pots, gas stoves, electric blenders, and plastic containers have steadily eroded the black-on-red pottery market.

Symbolic analysis of this pottery style demonstrated the continuity of several underlying and pervasive themes in the Central Highlands. These themes centered on the nature of the universe and human beings and on the existence of paired oppositions. Life and death, male and female, for example, opposed each other in an ongoing cycle, each menacing, bringing forth, and engulfing the other, starting the process anew, and exacting a divine and human toll. Overshadowing the conceptual pairs were impending catastrophes threatening to destroy the desired balance, so carefully acquired and so precariously maintained.

The present distribution and usage of black-on-red ware reflects profound political, economic, and social change in Puebla: a widening gap between the rich and poor, the urban and rural, the industrial and agricultural segments of the population. The pottery serves as a symbol of collective identity in relations between these segments and as a symbol of in-group solidarity within some of the segments of the region. President Echeverría and his wife first raised pottery and other folk arts to the level of national consciousness in the 1970s, as symbols of group identity, where it continues to mediate intergroup relations.

Cognition and Style

The methods of learning and teaching pottery making were important ways of sharing and transmitting style. In the community, conservative methods of imitation and trial and error in learning, the traditional techniques of manufacture, and the rewards for successful performance tended to perpetuate the existing folk style.

The emphasis on imitation and trial and error in learning is rooted in well-established and widely accepted traditions and in the value placed on conformity by members of this society. The contrast between my own expectations and reliance on verbal instruction and the potters' methods of teaching became evident in the aborted attempt to learn to make pottery. It made me realize how dependent we have become on instruction (verbal and written) in industrialized, capitalistic society. In such societies, unlike the community of folk potters, technology changes rapidly, and knowledge is impersonal and objectified. Instruction facilitates the ready and rapid transfer of information and techniques, especially when the tasks are subdivided into smaller units. The more comprehensive and traditional ways of doing things, in which a person controls an entire process, are neither valued nor useful, though they may be more personally satisfying. Instruction enables people to act and interact within systems devised for mass production; the value is on flexibility, not on conformity, with people and parts expected to be interchangeable. There is impatience with imitation and trial and error as methods that are wasteful of time and money. People are not expected to absorb and internalize information in the learning process, thereby gaining a sense of their own mastery in performance; they are not provided with concrete models, following the movements and examples of the master before them, as do the folk potters of Puebla. Indeed, they are, for the most part, expected to follow external and abstract models (instructions, diagrams, tapes, etc.) generated by unseen specialists and frequently changed.

Specialization was found to be another means of learning and transmitting style. The techniques of manufacture, on which much of specialization is based, were acquired gradually and perfected over a lifetime. Separation of potters and crewmen, those who produced the pottery and those who fired and decorated it, was in fact symbiotic. Continuity and cooperation among specialists acted to preserve style. These and other conditions were revealed to account for two universal characteristics of a folk style: commonality (being shared in space) and continuity (being persistent in time). The

social, economic, and political conditions previously described provided the stimuli for the style's production, distribution, and use.

In my search for more objective methodology, I assumed style to be a system that creates affect. To test this notion and to illuminate something of the nature of style itself in the process, I applied linguistic models and statistical models to the analysis of a folk pottery tradition. In particular, generative and emic models were made applicable to material culture. The emic analysis was structural, in the usual linguistic sense of a construct, based on a description of observable behavior (Langacker 1967:29–32, 153–154, 157), calling for the breakup of style into units, comparable to phonemes, and posited to exist in a system of contrasts, governed by rules for their combination. The performance of the culture bearers was central to this analysis because my observations, ideas, and analyses could be checked against their own; and the "rules" governing style could be tested by generating new behavior. Otherwise, it is the products of behavior that are available to archaeologists and utilized by most investigators.

The potters distinguished 94 features associated with 25 pottery types (see Table 5-4). Emic analysis made it possible to reduce the number of features to 12 distinctive features and to account for major pottery types distinguished by unique labels in the potters' universe of black-on-red ware. The following are the distinctive features; they were marked plus or minus (+/−) with regard to their presence or absence: mold, flat, wide, deep, covered, footed, necked, handled (one ear), eared (more than one ear), glazed, grooved, bichrome. The resultant system is represented in Figures 5-1 and 5-2.

Whereas the application of the emic model reduced a profusion of features from 94 to 12 and a complex native taxonomy from 21 types and 137 sizes to some 14 major categories uniquely labeled, the application of the generative model further reduced the system to a single rule:

$$\text{Pot} \rightarrow \text{Bowl (\textit{Cajete})} \left(\begin{cases} \text{Necked (handle)} \\ \text{Footed} \\ \text{Eared} \end{cases} \right)$$

It is capable of producing 6 of the 14 major categories of pots; and, if the features were modified, this rule could produce the other eight categories. There was no attempt, however, to analyze deep structure.

To test further the notion of style as a system, I proposed to subject a body of empirical data to statistical analysis by computer. The data were elicited from potters by the methods developed in this study and detailed in chapter 5. They are emic in the usual cultural sense of being known and recognized by the culture bearers (Harris 1968:568–604). The performance of the culture bearers engaged in making pottery was considered basic to the methods applied here. Their statements, as well as observed behavior in the process of manufacture, were essential to isolating distinctive features, apart from—and to compare with—the encapsulated behavior contained in the objects themselves. Living informants provided the opportunity to test etic systems and the emic model when new behavior was generated for them to judge.

I was fortunate in locating Dr. David M. Levine, Department of Statistics, Bernard M. Baruch College, City University of New York, to assist me with the problem of devising appropriate statistical measures. He became interested and undertook to write the programs. Two multivariate techniques were applied: cluster analysis (hierarchical and nonhierarchical) and nonmetric multidimensional scaling. Both are capable of revealing the structure inherent in an empirical body of data. The data are based on a determination of the presence or absence of 94 features on a set of 25 pots from the point of view of the culture bearers (Table 5-4). The method did not rely solely on verbal behavior; it employed material culture in a systematic way in interviews and tests and compared the results with actual behavior in the production and use of pottery.

The nonhierarchical or connectedness method of cluster analysis did not prove useful in ordering the data. But the hierarchical or diameter method did yield 12 interpretable compact clusters for which a measure of similarity had been obtained. These clusters are interpretable in terms of what is known and distinguished in the culture by the potters and by me. Features yet to be defined might render even fewer clusters than the 12 interpretable ones. (It may also be that the method's resolution might render fewer than 12 unintelligible.) The method itself assumes little about the way in which a domain (in this case, black-on-red pottery) is organized, except that the relevant properties used to define it are involved in the resultant organization and that, to meaningfully group the objects and their properties in the domain, further analysis is needed (D'Andrade et al. 1972:11).

Cluster analysis of the 94 features did provide a weight for each pottery feature distinguished by the culture bearers. The number and relative weight of such features or traits accounted for the emergent hierarchy of pots. Analyses that depend on the identification of traits or distinctive features by an outside investigator either must assign a weight to them (Narroll 1956:705) or must leave them unweighted (Carneiro 1969, 1970,

1974; Tolstoy 1963, 1966). In general, ethnoscientists engaged in discovering native taxonomies have not used statistical procedures.

The results of multidimensional scaling yielded two clearly interpretable dimensions: open and closed, multiple and nonmultiple ears. The stress coefficient was 0.5056 for the 25 pots scaled in two dimensions. The value was significant of the structure inherent in the data (Levine 1975a). It indicates that similarity between pots was being systematically perceived in the culture.

Discussion

Archaeological studies have always relied heavily on the classification of material objects and their attributes in establishing cultural sequences in time and space (Chang 1967; Deetz 1965; Rouse 1960; Willey 1962). The underlying assumption in archaeology (and in ethnology and art history, as well) is that classifications are not just useful devices but represent significant cultural categories. At least three marked trends in archaeology are related to this study. The first relies on detailed and quantitative analysis of observable and measurable traits and trait complexes to confirm or deny historical relationships between cultures (Deetz 1965; Read 1974; Tolstoy 1963, 1966). The second undertakes detailed ethnographic research to illuminate existing problems in archaeology (Arnold 1971; Friederich 1970; Hill and Gunn 1977; Kramer 1979; Thompson 1958). And the third applies quantitative techniques to surveyed sites and surface materials (LeBlanc 1975; Mueller 1974). The techniques are valuable tools but do not themselves ensure either the objectivity or the significance of the results attained. For example, the sophisticated usage of the computer by Deetz in his study of Arikara ceramics (1965) is enhanced by a delimited data base of available materials and prior knowledge of culture change. Because the data were sherds, the elaborate classification system coded for computer analysis relied heavily on the subtlety of rim variation and decoration (1965:38, 45). The results obtained were then related to historical changes known to have taken place in the culture. The problem of fit between archaeological and historical data is an ongoing one in interpreting material culture (Smith 1983:37–38, 44, 50).

When I went into the field, I took Deetz's Arikara ceramic study with me, along with certain expectations that I had derived from it. I soon discovered in discussions with the Puebla potters that rims did not have the same significance for them that I had expected. All the potters agreed that they varied rims to meet consumer preference and their own aesthetic tastes. The term they used to describe production captured the general sense of rim unpredictability in Puebla—rims were made according to "*capricho*" (whim). The classification of the pottery described in chapter 2 did reveal a relationship between kinds of rims and kinds of pots with regard to technique of manufacture and function. But it was unlikely that this could be related to the dramatic sociopolitical changes in Puebla, now or in the past. Rims were a very significant feature neither in the potters' taxonomy nor in the results of quantitative analyses. Ears, however, as Deetz found, were a significant feature in Puebla, in both emic and quantitative analyses (Deetz 1965:75–80). This is not to say that ears will prove to be significant in other ceramic traditions, or even be present for analysis at some archaeological sites. Nonetheless, these results should alert us to the possibilities of such features that have not always been fully considered and cause us to consider them in the context of each site and pottery-producing community.

The preceding discussion brings me to consideration of the second trend in archaeology: the use of ethnographic research to generate and test hypotheses of archaeological import. In addition to some studies cited earlier (Arnold 1971; Friederich 1970; Kaplan 1976a, 1976b; Thompson 1958), the pioneering investigations of Thomas H. Charlton in the Valley of Teotihuacán attest to the knowledge and insight that might be gained from combining archaeology, ethnography, and ethnohistory (1969, 1972a, 1972b, 1975, 1981). Some techniques associated with both major trends in archaeology are extended to ethnography in this study. Other related techniques, classification schemes, and spectrochemical analyses (described in chapter 2) suggest that objective tests are not always indicative of cultural categories.

Two multivariate statistical techniques were applied: cluster analysis and nonmetric multidimensional scaling. Cluster analysis did yield a weight for the features or traits distinguished and a taxonomy of the pottery, based on the number and weight of these traits. Multidimensional scaling did yield dimensions that could be interpreted. As Sanday noted in a 1975 review of theoretical and applied papers on multidimensional scaling, the method is particularly suited to the archaeologist with a data base of material objects. But as she also noted "there are no contributions . . . dealing specifically with these types of data and the attendant sampling problems" (Sanday, Review of *Multidimensional Scaling, American Anthropologist* 77:107). I venture to suggest that the problems of application extend beyond sam-

pling to interpretation. In this study, ethnographic fieldwork rendered two dimensions interpretable and culturally significant, though the data were scaled up to five dimensions. Ethnography gave form and meaning to the results of cluster analysis and multidimensional scaling. Neither technique imposed a preexisting structure on the data. The structure that emerged supports a view of style as a system held in the minds of the culture bearers.

Linguistic models were extended into ethnography and the analysis of material culture. This study was an empirical test of the usefulness of such models for nonverbal behavior. The emic model has been seriously challenged in linguistics by Chomsky (1957, 1968) and by Chomsky and Hale (1969), and a new, more powerful model provided by the transformationalists reveals that there is a "quite incredible scope of human grammar" (Keesing 1971:16, 18; Postal 1972). I made no effort here to test the applicability to material culture of such concepts as *competence*, and particularly *deep structure* and *transformational rules*, which did not readily lend themselves to a viable methodology. The applications of the generative model to material culture are, in reality, metaphorical (Glassie 1969; Muller 1966, 1975); and the complex problems underlying such applications are made abundantly clear by Keesing (1971:17–20, 22–24). They may be related to the broader task of cognitive anthropology (1971:29–31, 42–45). Nonetheless, the elegance of the transformational-type rules makes them attractive. I believe the availability of such rules, like ours, for comparison later, may generate avenues of future research in the field.

Emic analysis has been under attack by the transformationalists for what is considered its particularistic approach to the study of language, its reliance on a taxonomic model, and its study of elements rather than relational systems of which elements are a part (1971:3, 5, 11, 19). Although, as some critics acknowledge, these drawbacks are not so much inherent in the model or the goals of emic analysis as in its practical result (1971). Being aware of the criticisms of the model and the uses made of it by ethnoscientists and others, I have tried to enunciate my meanings and reasons for using the model, despite its vulnerability. The emic model is used in an extended metaphorical analogy between language and pottery as a means of generating a structure for style. While this structure may be "surface," perhaps even "spurious" in the transformational sense, it remains an important demonstration on an available level in material culture (1971:20). The metaphor was consciously used to empower this study of

material culture with a replicable methodology based on features and rules contained in the model.

It seems worthwhile to cite two fundamental differences between studies of material culture and linguistics that led me to pursue the linguistic analogy, and, in particular, the emic model. One difference is the relative paucity of appropriate concepts and theory for study and comparison. Many studies have relied on subjective, intuitive, historical, and historical-materialist interpretations. The second difference is personal and epistemological: my present concerns focus on what underlies the observable differences in style rather than on what may be the profound similarities. It is not that I am unconcerned, but given the variables of media and the present state of applied theory, the search for universals, which seems to occupy grammarians, would be premature in the study of material culture.

This study has posed several questions. Is style in folk art a cognitive system of affective communication? Is it analogous to language, and can distinctive features, comparable to phonemes, be identified in a system of contrasts? How are these features organized to produce the whole, that is, the style itself? The description of a class of artifacts was a necessary and preliminary step in the several analyses. Black-on-red glazed folk pottery from the barrio of La Luz, Puebla, was chosen because it was a well-known and still-functional tradition with many practitioners. Potters to the local people, they were not actively involved in the foreign tourist market. The pottery was widely used, familiar, and regarded as utilitarian. Black-on-red glazed folk pottery was potentially as meaningful—in terms of symbolism and affective communication—as the more elaborate and self-consciously manipulated pottery made for tourists and for the elite.

This study has shown that style in folk pottery, even pottery as prosaic as cookware, is imbued with meaning relative to a cognitive system of ideas and values widely held in the culture. It has shown style to be an affective system of communication, with a structure analogous to language. The emic model and other methods were developed here and served to do the following: to notate style as a system in a simpler, more elegant way; to account for the surface differences in pottery form, design, and function; and to recover the ethos, or tone, and the worldview of the culture through analysis of recurrent themes, manifested in folk pottery style—carried in the mind, internalized, and deeply felt by the people and potters of Puebla.

APPENDIX
BIBLIOGRAPHY
INDEX

APPENDIX

Table A-1 Coded Responses to Pot 1, Based on Variables of Age, Status, and Sex

Coded Responses

	Variable	1	2	3	4	5	6	7	8	9	10	11	165	Total (No.)
Age	Elder	1	1	—	—	—	1	19	1	—	—	2	1	26
	Adult	—	—	1	2	—	—	19	1	—	2	—	—	25
	Youth	—	—	2	1	—	—	19	1	1	—	—	—	24
	Child	2	—	3	3	—	—	14	—	2	—	—	—	24
Status	Specialist	1	—	—	—	1	—	4	18	1	1	—	—	26
	Lower Class	—	1	2	—	—	—	25	3	2	2	—	1	36
	Middle Class	—	—	3	2	—	—	27	—	—	—	—	—	32
	Upper Class	3	—	1	4	—	1	19	—	1	—	2	—	31
Sex	Male	1	1	2	5	—	1	29	1	3	—	1	1	45
	Female	2	—	4	1	—	—	42	2	—	2	1	—	54
	No. of Samples	3	1	6	6	—	1	71	3	3	2	2	1	99

Percentage of Coded Responses to Pot 1

	Variable	1	2	3	4	5	6	7	8	9	10	11	165	Total (%)
Age	Elder	4	4	—	—	—	4	73	4	—	—	7	4	100
	Adult	—	—	4	8	—	—	76	4	—	8	—	—	100
	Youth	—	—	8	4	—	—	80	4	4	—	—	—	100
	Child	8	—	13	13	—	—	58	—	8	—	—	—	100
Status	Specialist	4	—	—	—	4	—	15	69	4	4	—	—	100
	Lower Class	—	3	6	—	—	—	68	8	6	6	—	3	100
	Middle Class	—	—	10	6	—	—	84	—	—	—	—	—	100
	Upper Class	10	—	3	13	—	3	62	—	3	—	6	—	100
Sex	Male	2	2	5	11	—	2	65	2	7	—	2	2	100
	Female	4	—	7	2	—	—	77	4	—	4	2	—	100
	No. of Samples	3	1	6	6	—	1	72	3	3	2	2	1	100

Table A-2 Coded Responses to Pot 2, Based on Variables of Age, Status, and Sex

Coded Responses

	Variable	1	2	3	4	7	8	12	13	14	15	16	17	Total (No.)
Age	Elder	—	1	1	—	24	—	—	—	—	—	—	—	26
	Adult	—	—	2	1	20	1	—	—	—	—	1	—	25
	Youth	2	—	3	—	19	—	—	—	—	—	—	—	24
	Child	3	—	1	2	15	—	—	—	2	—	—	1	24
Status	Specialist	—	—	—	—	7	—	6	5	—	1	7	—	26
	Lower Class	1	1	1	—	31	1	—	—	—	—	1	—	36
	Middle Class	2	—	5	1	23	—	—	—	1	—	—	—	32
	Upper Class	2	—	1	2	24	—	—	—	1	—	—	1	31
Sex	Male	2	1	2	2	34	1	—	—	2	—	1	—	45
	Female	3	—	5	1	44	—	—	—	—	—	—	1	54
	No. of Samples	5	1	7	3	78	1	—	—	2	—	1	1	99

Percentage of Coded Responses to Pot 2

	Variable	1	2	3	4	7	8	12	13	14	15	16	17	Total (%)
Age	Elder	—	4	4	—	92	—	—	—	—	—	—	—	100
	Adult	—	—	8	4	80	4	—	—	—	—	4	—	100
	Youth	8	—	13	—	79	—	—	—	—	—	—	—	100
	Child	13	—	4	8	63	—	—	—	8	—	—	4	100
Status	Specialist	—	—	—	—	27	—	23	19	—	4	27	—	100
	Lower Class	3	3	3	—	85	3	—	—	—	—	3	—	100
	Middle Class	6	—	16	3	72	—	—	—	3	—	—	—	100
	Upper Class	7	—	3	7	77	—	—	—	3	—	—	3	100
Sex	Male	4	2	4	4	78	2	—	—	4	—	2	—	100
	Female	6	—	9	2	81	—	—	—	—	—	—	2	100
	No. of Samples	5	1	7	3	79	1	—	—	2	—	1	1	100

Table A-3 Coded Responses to Pot 3, Based on Variables of Age, Status, and Sex

Coded Responses

	Variable	1	3	4	7	14	15	18	19	20	21	22	23	Total (No.)
Age	Elder	2	19	—	5	—	—	—	—	—	—	—	—	26
	Adult	—	18	1	4	1	—	1	—	—	—	—	—	25
	Youth	1	18	—	3	1	—	—	1	—	—	—	—	24
	Child	2	13	—	4	3	—	—	—	—	—	—	2	24
Status	Specialist	1	4	—	—	—	13	3	—	1	1	1	2	26
	Lower Class	1	26	—	8	—	—	1	—	—	—	—	—	36
	Middle Class	2	20	—	5	2	—	—	1	—	—	—	2	32
	Upper Class	2	22	1	3	3	—	—	—	—	—	—	—	31
Sex	Male	2	29	1	8	2	—	1	1	—	—	—	1	45
	Female	3	39	—	8	3	—	—	—	—	—	—	1	54
	No. of Samples	5	68	1	16	5	—	1	1	—	—	—	2	99

Percentage of Coded Responses to Pot 3

	Variable	1	3	4	7	14	15	18	19	20	21	22	23	Total (%)
Age	Elder	8	73	—	19	—	—	—	—	—	—	—	—	100
	Adult	—	72	4	16	4	—	4	—	—	—	—	—	100
	Youth	4	75	—	13	4	—	—	4	—	—	—	—	100
	Child	8	54	—	17	13	—	—	—	—	—	—	8	100
Status	Specialist	4	16	—	—	—	50	12	—	4	4	4	8	100
	Lower Class	3	72	—	22	—	—	3	—	—	—	—	—	100
	Middle Class	6	63	—	16	6	—	—	3	—	—	—	6	100
	Upper Class	6	71	3	10	10	—	—	—	—	—	—	—	100
Sex	Male	5	64	2	18	5	—	2	2	—	—	—	2	100
	Female	6	72	—	14	6	—	—	—	—	—	—	2	100
	No. of Samples	5	69	1	16	5	—	1	1	—	—	—	2	100

Table A-4 Coded Responses to Pot 4, Based on Variables of Age, Status, and Sex

Coded Responses

	Variable	1	3	7	14	15	23	24	25	Total (No.)
Age	Elder	4	17	2	—	—	3	—	—	26
	Adult	—	19	—	1	—	5	—	—	25
	Youth	—	19	—	2	—	3	—	—	24
	Child	—	14	2	3	—	3	—	2	24
Status	Specialist	—	2	—	—	1	7	16	—	26
	Lower Class	1	25	3	—	—	7	—	—	36
	Middle Class	3	22	—	—	—	5	—	2	32
	Upper Class	—	22	1	6	—	2	—	—	31
Sex	Male	1	28	4	3	—	7	—	2	45
	Female	3	41	—	3	—	7	—	—	54
	No. of Samples	4	69	4	6	—	14	—	2	99

Percentage of Coded Responses to Pot 4

	Variable	1	3	7	14	15	23	24	25	Total (%)
Age	Elder	15	65	8	—	—	12	—	—	100
	Adult	—	76	—	4	—	20	—	—	100
	Youth	—	79	—	8	—	13	—	—	100
	Child	—	58	8	13	—	13	—	8	100
Status	Specialist	—	8	—	—	4	27	61	—	100
	Lower Class	3	69	8	—	—	20	—	—	100
	Middle Class	9	69	—	—	—	16	—	6	100
	Upper Class	—	71	3	19	—	7	—	—	100
Sex	Male	2	62	9	7	—	16	—	4	100
	Female	6	75	—	6	—	13	—	—	100
	No. of Samples	4	70	4	6	—	14	—	2	100

Table A-5 Coded Responses to Pot 5, Based on Variables of Age, Status, and Sex

Coded Responses

	Variable	1	3	7	14	23	24	26	27	28	29	30	Total (No.)
Age	Elder	3	15	1	—	5	—	—	1	1	—	—	26
	Adult	1	18	—	1	2	—	—	—	—	3	—	25
	Youth	—	21	—	2	—	—	—	1	—	—	—	24
	Child	—	16	1	3	—	—	—	—	—	2	2	24
Status	Specialist	—	5	—	—	6	3	1	9	—	2	—	26
	Lower Class	3	26	2	—	1	—	—	2	—	2	—	36
	Middle Class	1	24	—	—	3	—	—	—	—	2	2	32
	Upper Class	—	20	—	6	3	—	—	—	1	1	—	31
Sex	Male	3	26	2	3	4	—	—	—	1	4	2	45
	Female	1	44	—	3	3	—	—	2	—	1	—	54
	No. of Samples	4	70	2	6	7	—	—	2	1	5	2	99

Percentage of Coded Responses to Pot 5

	Variable	1	3	7	14	23	24	26	27	28	29	30	Total (%)
Age	Elder	12	57	4	—	19	—	—	4	4	—	—	100
	Adult	4	72	—	4	8	—	—	—	—	12	—	100
	Youth	—	88	—	8	—	—	—	4	—	—	—	100
	Child	—	67	4	13	—	—	—	—	—	8	8	100
Status	Specialist	—	19	—	—	23	11	4	35	—	8	—	100
	Lower Class	8	71	6	—	3	—	—	6	—	6	—	100
	Middle Class	3	76	—	—	9	—	—	—	—	6	6	100
	Upper Class	—	65	—	19	10	—	—	—	3	3	—	100
Sex	Male	7	58	4	7	9	—	—	—	2	9	4	100
	Female	2	80	—	6	6	—	—	4	—	2	—	100
	No. of Samples	4	71	2	6	7	—	—	2	1	5	2	100

Table A-6 Coded Responses to Pot 6, Based on Variables of Age, Status, and Sex

Coded Responses

	Variable	1	3	7	31	33	34	35	36	37	38	Total (No.)
Age	Elder	8	—	12	—	—	4	—	—	2	—	26
	Adult	1	1	13	1	—	2	1	—	6	—	25
	Youth	2	—	10	1	—	6	1	—	4	—	24
	Child	2	1	11	5	1	4	—	—	—	—	24
Status	Specialist	—	1	1	—	—	—	—	1	9	14	26
	Lower Class	5	1	11	4	—	3	—	—	12	—	36
	Middle Class	3	1	19	3	—	4	2	—	—	—	32
	Upper Class	5	—	16	—	1	9	—	—	—	—	31
Sex	Male	7	1	21	4	1	6	1	—	4	—	45
	Female	6	1	25	3	—	10	1	—	8	—	54
	No. of Samples	13	2	46	7	1	16	2	—	12	—	99

Percentage of Coded Responses to Pot 6

	Variable	1	3	7	31	33	34	35	36	37	38	Total (%)
Age	Elder	31	—	46	—	—	15	—	—	8	—	100
	Adult	4	4	52	4	—	8	4	—	24	—	100
	Youth	8	—	42	4	—	25	4	—	17	—	100
	Child	8	4	46	21	4	17	—	—	—	—	100
Status	Specialist	—	4	4	—	—	—	—	4	34	54	100
	Lower Class	14	3	31	11	—	8	—	—	33	—	100
	Middle Class	9	3	60	9	—	13	6	—	—	—	100
	Upper Class	16	—	52	—	3	29	—	—	—	—	100
Sex	Male	16	2	47	9	2	13	2	—	9	—	100
	Female	11	2	46	6	—	18	2	—	15	—	100
	No. of Samples	13	2	47	7	1	16	2	—	12	—	100

Table A-7 Coded Responses to Pot 7, Based on Variables of Age, Status, and Sex

Coded Responses

	Variable	1	113	114	115	116	117	118	119	120	121	122	123	124	125	Total (No.)
Age	Elder	2	—	4	—	3	5	2	1	1	5	2	1	—	—	26
	Adult	1	—	1	—	—	—	2	—	1	15	4	1	—	—	25
	Youth	—	2	—	—	1	—	1	—	2	14	3	—	1	—	24
	Child	4	—	—	2	—	2	1	—	3	9	1	—	1	1	24
Status	Specialist	4	1	2	—	1	5	1	—	—	5	1	6	—	—	26
	Lower Class	2	—	2	2	3	1	—	—	—	20	4	—	2	—	36
	Middle Class	4	1	1	—	1	3	3	—	1	14	3	—	—	1	32
	Upper Class	1	1	2	—	—	3	3	1	6	9	3	2	—	—	31
Sex	Male	2	1	4	2	3	1	4	1	5	13	5	1	2	1	45
	Female	5	1	1	—	1	6	2	—	2	30	5	1	—	—	54
	No. of Samples	7	2	5	2	4	7	6	1	7	43	10	2	2	1	99

Percentage of Coded Responses to Pot 7

	Variable	1	113	114	115	116	117	118	119	120	121	122	123	124	125	Total (%)
Age	Elder	8	—	15	—	11	19	8	4	4	19	8	4	—	—	100
	Adult	4	—	4	—	—	—	8	—	4	60	16	4	—	—	100
	Youth	—	8	—	—	4	—	4	—	8	59	13	—	4	—	100
	Child	17	—	—	8	—	8	4	—	13	38	4	—	4	4	100
Status	Specialist	15	4	8	—	4	19	4	—	—	19	4	23	—	—	100
	Lower Class	6	—	6	6	8	2	—	—	—	55	11	—	6	—	100
	Middle Class	13	3	3	—	3	9	9	—	3	45	—	—	—	3	100
	Upper Class	3	3	6	—	—	10	10	3	19	29	10	7	—	—	100
Sex	Male	4	2	9	4	7	2	9	2	12	29	12	2	4	2	100
	Female	9	2	2	—	2	11	4	—	4	55	9	2	—	—	100
	No. of Samples	7	2	5	2	4	7	6	1	7	44	10	2	2	1	100

Table A-8 Coded Responses to Pot 8, Based on Variables of Age, Status, and Sex

Coded Responses

	Variable	1	7	31	34	39	40	41	42	43	44	45	46	47	51	Total (No.)
Age	Elder	—	1	—	6	1	—	4	1	—	—	1	12	—	—	26
	Adult	1	—	—	7	3	—	1	1	—	—	—	12	—	—	25
	Youth	—	1	—	12	—	—	—	2	2	1	—	6	—	—	24
	Child	6	2	2	10	—	1	—	1	—	—	—	2	—	—	24
Status	Specialist	—	—	—	1	—	—	—	—	—	—	—	5	19	1	26
	Lower Class	—	1	1	9	1	—	1	1	1	—	—	21	—	—	36
	Middle Class	3	—	1	15	3	1	2	—	—	1	—	6	—	—	32
	Upper Class	4	3	—	11	—	—	2	4	1	—	1	5	—	—	31
Sex	Male	4	3	1	20	2	1	2	2	—	—	—	10	—	—	45
	Female	3	1	1	15	2	—	3	3	2	1	1	22	—	—	54
	No. of Samples	7	4	2	35	4	1	5	5	2	1	1	32	—	—	99

Percentage of Coded Responses to Pot 8

	Variable	1	7	31	34	39	40	41	42	43	44	45	46	47	51	Total (%)
Age	Elder	—	4	—	23	4	—	15	4	—	—	4	46	—	—	100
	Adult	4	—	—	28	12	—	4	4	—	—	—	48	—	—	100
	Youth	—	4	—	50	—	—	—	8	8	4	—	26	—	—	100
	Child	26	8	8	42	—	4	—	4	—	—	—	8	—	—	100
Status	Specialist	—	—	—	4	—	—	—	—	—	—	—	19	73	4	100
	Lower Class	—	3	3	25	3	—	3	3	3	—	—	57	—	—	100
	Middle Class	9	—	3	48	9	3	6	—	—	3	—	19	—	—	100
	Upper Class	13	10	—	36	—	—	6	13	3	—	3	16	—	—	100
Sex	Male	9	7	2	45	4	2	4	4	—	—	—	23	—	—	100
	Female	5	2	2	28	4	—	5	5	4	2	2	41	—	—	100
	No. of Samples	14	8	4	36	4	1	5	5	2	1	1	32	—	—	100

Table A-9 Coded Responses to Pot 9, Based on Variables of Age, Status, and Sex

Coded Responses

	Variable	1	7	31	34	39	40	48	49	50	51	Total (No.)
Age	Elder	—	1	—	15	—	—	—	9	—	1	26
	Adult	2	—	—	13	1	—	—	9	—	—	25
	Youth	—	2	—	17	—	—	—	3	2	—	24
	Child	6	3	4	10	—	1	—	—	—	—	24
Status	Specialist	—	—	—	6	—	—	20	—	—	—	26
	Lower Class	—	1	3	19	—	—	—	13	—	—	36
	Middle Class	1	3	1	20	1	1	—	4	1	—	32
	Upper Class	7	2	—	16	—	—	—	4	1	1	31
Sex	Male	6	2	4	24	1	1	—	6	—	1	45
	Female	2	4	—	31	—	—	—	15	2	—	54
	No. of Samples	8	6	4	55	1	1	—	21	2	1	99

Percentage of Coded Responses to Pot 9

	Variable	1	7	31	34	39	40	48	49	50	51	Total (%)
Age	Elder	—	4	—	57	—	—	—	35	—	4	100
	Adult	8	—	—	52	4	—	—	36	—	—	100
	Youth	—	8	—	71	—	—	—	13	8	—	100
	Child	25	12	17	42	—	4	—	—	—	—	100
Status	Specialist	—	—	—	23	—	—	77	—	—	—	100
	Lower Class	—	3	8	53	—	—	—	36	—	—	100
	Middle Class	3	9	3	63	3	3	—	13	3	—	100
	Upper Class	23	6	—	52	—	—	—	13	3	3	100
Sex	Male	14	4	9	53	2	2	—	14	—	2	100
	Female	4	7	—	57	—	—	—	28	4	—	100
	No. of Samples	8	6	4	56	1	1	—	21	2	1	100

Table A-10 Coded Responses to Pot 10, Based on Variables of Age, Status, and Sex

Coded Responses

	Variable	1	7	31	33	34	41	48	49	51	52	53	Total (No.)
Age	Elder	1	1	—	—	16	—	—	6	—	—	2	26
	Adult	2	—	—	—	18	—	—	4	1	—	—	25
	Youth	—	1	—	1	18	1	—	2	—	—	1	24
	Child	6	5	3	—	9	—	—	—	—	1	—	24
Status	Specialist	—	—	—	—	5	—	3	1	4	6	7	26
	Lower Class	1	1	2	1	18	1	—	9	1	1	1	36
	Middle Class	2	4	1	—	21	—	—	3	—	—	1	32
	Upper Class	6	2	—	—	22	—	—	—	—	—	1	31
Sex	Male	7	3	3	—	27	—	—	3	—	1	1	45
	Female	2	4	—	1	34	1	—	9	1	—	2	54
	No. of Samples	9	7	3	1	61	1	—	12	1	1	3	99

Percentage of Coded Responses to Pot 10

	Variable	1	7	31	33	34	41	48	49	51	52	53	Total (%)
Age	Elder	4	4	—	—	61	—	—	23	—	—	8	100
	Adult	8	—	—	—	72	—	—	16	4	—	—	100
	Youth	—	4	—	4	75	4	—	9	—	—	4	100
	Child	25	21	13	—	37	—	—	—	—	4	—	100
Status	Specialist	—	—	—	—	19	—	12	4	15	23	27	100
	Lower Class	3	3	6	3	49	3	—	24	3	3	3	100
	Middle Class	6	13	3	—	66	—	—	9	—	—	3	100
	Upper Class	19	7	—	—	71	—	—	—	—	—	3	100
Sex	Male	15	7	7	—	60	—	—	7	—	2	2	100
	Female	4	7	—	2	63	2	—	16	2	—	4	100
	No. of Samples	9	7	3	1	62	1	—	12	1	1	3	100

Table A-11 Coded Responses to Pot 11, Based on Variables of Age, Status, and Sex

Coded Responses

	Variable	1	7	31	32	34	57	58	59	60	61	62	Total (No.)
Age	Elder	3	—	—	1	19	1	—	1	—	1	—	26
	Adult	3	—	—	—	16	—	—	4	—	1	1	25
	Youth	1	1	—	—	18	1	—	2	—	1	—	24
	Child	6	3	1	—	11	—	—	2	1	—	—	24
Status	Specialist	1	—	—	—	6	14	3	2	—	—	—	26
	Lower Class	5	—	—	—	27	2	—	2	—	—	—	36
	Middle Class	4	—	1	—	21	—	—	5	—	—	1	32
	Upper Class	4	4	—	1	16	—	—	2	1	3	—	31
Sex	Male	7	3	1	1	28	—	—	4	—	1	—	45
	Female	6	1	—	—	36	2	—	5	1	2	1	54
	No. of Samples	13	4	1	1	64	2	—	9	1	3	1	99

Percentage of Coded Responses to Pot 11

	Variable	1	7	31	32	34	57	58	59	60	61	62	Total (%)
Age	Elder	11	—	—	4	73	4	—	4	—	4	—	100
	Adult	12	—	—	—	64	—	—	16	—	4	4	100
	Youth	4	4	—	—	75	4	—	9	—	4	—	100
	Child	25	13	4	—	46	—	—	8	4	—	—	100
Status	Specialist	4	—	—	—	23	54	11	8	—	—	—	100
	Lower Class	13	—	—	—	75	6	—	6	—	—	—	100
	Middle Class	13	—	3	—	65	—	—	16	—	—	3	100
	Upper Class	13	13	—	3	52	—	—	6	3	10	—	100
Sex	Male	16	7	2	2	62	—	—	9	—	2	—	100
	Female	11	2	—	—	66	4	—	9	2	4	2	100
	No. of Samples	13	4	1	1	65	2	—	9	1	3	1	100

Table A-12 Coded Responses to Pot 12, Based on Variables of Age, Status, and Sex

Coded Responses

	Variable	1	113	114	116	117	118	123	124	126	127	128	129	130	131	133	134	145	Total (No.)
Age	Elder	2	—	—	1	—	1	—	—	7	—	—	10	—	1	3	1	—	26
	Adult	1	—	—	—	—	1	—	—	11	1	—	4	—	—	7	—	—	25
	Youth	2	1	—	—	—	—	1	1	11	—	—	5	—	—	2	1	—	24
	Child	3	1	1	—	—	—	—	1	11	1	1	2	1	—	—	2	—	24
Status	Specialist	1	—	2	—	4	3	4	—	6	—	—	1	—	2	2	—	1	26
	Lower Class	4	—	—	1	—	—	—	—	14	—	—	6	1	—	8	2	—	36
	Middle Class	2	1	1	—	—	—	—	1	16	1	1	5	—	1	2	1	—	32
	Upper Class	2	—	—	—	—	2	1	1	10	1	—	10	—	—	2	1	—	31
Sex	Male	2	1	1	1	—	2	1	—	18	1	1	11	1	—	2	3	—	45
	Female	6	1	—	—	—	—	—	2	22	1	—	10	—	1	10	1	—	54
	No. of Samples	8	2	1	1	—	2	1	2	40	2	1	21	1	1	12	4	—	99

Percentage of Coded Responses to Pot 12

	Variable	1	113	114	116	117	118	123	124	126	127	128	129	130	131	133	134	145	Total (%)
Age	Elder	8	—	—	4	—	4	—	—	26	—	—	38	—	4	12	4	—	100
	Adult	4	—	—	—	—	4	—	—	44	4	—	16	—	—	28	—	—	100
	Youth	8	4	—	—	—	—	4	4	46	—	—	20	—	—	8	4	—	100
	Child	14	4	4	—	—	—	—	4	46	4	4	8	4	—	—	8	—	100
Status	Specialist	4	—	8	—	15	12	15	—	22	—	—	4	—	8	8	—	4	100
	Lower Class	11	—	—	3	—	—	—	—	38	—	—	17	3	—	22	6	—	100
	Middle Class	6	3	3	—	—	—	—	3	51	3	3	16	—	3	6	3	—	100
	Upper Class	7	3	—	—	—	7	3	3	32	3	—	32	—	—	7	3	—	100
Sex	Male	4	2	2	2	—	4	2	—	41	2	2	25	2	—	4	8	—	100
	Female	11	2	—	—	—	—	—	4	41	2	—	18	—	2	18	2	—	100
	No. of Samples	8	2	1	1	—	2	1	2	41	2	1	21	1	1	12	4	—	100

Table A-13 Coded Responses to Pot 13, Based on Variables of Age, Status, and Sex

Coded Responses

	Variable	1	7	31	33	34	49	53	54	55	56	Total (No.)
Age	Elder	—	1	—	—	23	—	—	2	—	—	26
	Adult	2	—	—	—	21	1	—	—	1	—	25
	Youth	2	1	—	1	15	1	—	4	—	—	24
	Child	4	2	3	—	14	—	—	—	—	1	24
Status	Specialist	2	1	—	—	4	—	1	18	—	—	26
	Lower Class	—	1	1	—	26	1	—	6	1	—	36
	Middle Class	2	2	2	—	25	1	—	—	—	—	32
	Upper Class	6	1	—	1	22	—	—	—	—	1	31
Sex	Male	6	1	2	1	30	2	—	2	—	1	45
	Female	2	3	1	—	43	—	—	4	1	—	54
	No. of Samples	8	4	3	1	73	2	—	6	1	1	99

Percentage of Coded Responses to Pot 13

	Variable	1	7	31	33	34	49	53	54	55	56	Total (%)
Age	Elder	—	4	—	—	88	—	—	8	—	—	100
	Adult	8	—	—	—	84	4	—	—	4	—	100
	Youth	8	4	—	4	63	4	—	17	—	—	100
	Child	17	8	13	—	58	—	—	—	—	4	100
Status	Specialist	8	4	—	—	15	—	4	69	—	—	100
	Lower Class	—	3	3	—	72	3	—	16	3	—	100
	Middle Class	6	6	6	—	79	3	—	—	—	—	100
	Upper Class	19	3	—	3	70	—	—	—	—	3	100
Sex	Male	13	2	5	2	66	5	—	5	—	2	100
	Female	3	6	2	—	80	—	—	7	2	—	100
	No. of Samples	8	4	3	1	74	2	—	6	1	1	100

Table A-14 Coded Responses to Pot 14, Based on Variables of Age, Status, and Sex

Coded Responses

	Variable	1	31	33	34	41	42	43	46	63	64	65	66	68	69	70	71	Total (No.)
Age	Elder	2	—	—	7	1	1	1	3	3	—	—	1	1	1	2	3	26
	Adult	2	—	1	10	—	1	1	3	—	1	—	1	—	—	1	4	25
	Youth	3	—	—	8	—	1	—	3	1	—	—	—	—	3	3	2	24
	Child	10	1	—	5	—	—	1	1	2	1	1	1	—	—	1	—	24
Status	Specialist	3	—	—	2	—	—	—	—	—	—	—	—	1	18	—	2	26
	Lower Class	4	—	1	9	—	1	1	6	2	—	—	2	1	4	1	4	36
	Middle Class	5	—	—	11	—	—	—	2	3	2	—	—	—	—	5	3	32
	Upper Class	8	—	—	10	1	2	2	2	1	—	1	1	—	—	1	2	31
Sex	Male	12	—	1	13	1	1	2	3	1	2	—	3	1	1	2	2	45
	Female	5	1	—	17	—	2	1	7	5	—	1	—	—	3	5	7	54
	No. of Samples	16	1	1	30	1	3	3	10	6	2	1	3	1	4	7	9	99

Percentage of Coded Responses to Pot 14

	Variable	1	31	33	34	41	42	43	46	63	64	65	66	68	69	70	71	Total (%)
Age	Elder	8	—	—	27	4	4	4	11	11	—	—	4	4	4	8	11	100
	Adult	8	—	4	40	—	4	4	12	—	4	—	4	—	—	4	16	100
	Youth	13	—	—	32	—	4	—	13	4	—	—	—	—	13	13	8	100
	Child	43	4	—	21	—	—	4	4	8	4	4	4	—	—	4	—	100
Status	Specialist	12	—	—	8	—	—	—	—	—	—	—	—	4	68	—	8	100
	Lower Class	11	—	3	25	—	3	3	17	5	—	—	5	3	11	3	11	100
	Middle Class	16	3	—	35	—	—	—	6	9	6	—	—	—	—	16	9	100
	Upper Class	25	—	—	32	3	7	7	7	3	—	3	3	—	—	3	7	100
Sex	Male	28	—	2	30	2	2	4	7	2	4	—	7	2	2	4	4	100
	Female	9	2	—	31	—	4	2	13	9	—	2	—	—	6	9	13	100
	No. of Samples	16	1	1	31	1	3	3	10	6	2	1	3	1	4	7	9	100

Table A-15 Coded Responses to Pot 15, Based on Variables of Age, Status, and Sex

Coded Responses

	Variable	1	2	3	4	7	14	17	33	72	73	74	75	76	77	78	79	80	81	87	91	166	Total (No.)
Age	Elder	3	3	1	2	—	8	—	—	1	1	—	2	—	—	2	—	—	—	1	2	—	26
	Adult	4	—	6	—	2	7	—	—	—	1	—	2	—	—	—	—	1	1	—	—	1	25
	Youth	3	1	5	1	1	8	—	—	—	1	1	2	—	1	—	—	—	—	—	—	—	24
	Child	9	1	1	1	1	4	1	1	—	—	—	3	—	—	—	—	—	—	—	—	2	24
Status	Specialist	1	1	4	—	1	—	—	—	—	1	—	1	1	10	4	1	1	—	—	—	—	26
	Lower Class	6	2	6	1	—	7	—	—	—	1	—	8	—	1	1	—	1	—	—	—	2	36
	Middle Class	6	1	6	2	—	11	1	—	—	1	—	1	—	—	—	—	—	1	1	1	—	32
	Upper Class	7	2	1	1	4	9	—	1	1	1	—	—	—	—	1	—	—	—	—	1	1	31
Sex	Male	12	2	7	—	3	11	—	1	—	1	—	1	—	1	2	—	—	—	—	1	3	45
	Female	7	3	6	4	1	16	1	—	1	2	1	8	—	—	—	—	1	1	1	1	—	54
	No. of Samples	19	5	13	4	4	27	1	1	1	3	1	9	—	1	2	—	1	1	1	2	3	99

Percentage of Coded Responses to Pot 15

	Variable	1	2	3	4	7	14	17	33	72	73	74	75	76	77	78	79	80	81	87	91	166	Total (%)
Age	Elder	11	11	4	8	—	30	—	—	4	4	—	8	—	—	8	—	—	—	4	8	—	100
	Adult	16	—	24	—	8	28	—	—	—	4	—	8	—	—	—	—	4	4	—	—	4	100
	Youth	13	4	21	4	4	34	—	—	—	4	4	8	—	4	—	—	—	—	—	—	—	100
	Child	38	4	4	4	4	17	4	4	—	—	—	13	—	—	—	—	—	—	—	—	8	100
Status	Specialist	4	4	15	—	4	—	—	—	—	4	—	4	4	38	15	4	4	—	—	—	—	100
	Lower Class	17	5	17	3	—	19	—	—	—	3	—	22	—	3	3	—	3	—	—	—	5	100
	Middle Class	19	3	19	6	—	35	3	—	—	3	—	3	—	—	—	—	—	3	3	3	—	100
	Upper Class	23	7	3	3	13	30	—	3	3	3	3	—	—	—	3	—	—	—	—	3	3	100
Sex	Male	27	4	16	—	7	25	—	2	—	2	—	2	—	2	4	—	—	—	—	2	7	100
	Female	13	5	11	7	2	29	2	—	2	4	2	15	—	—	—	—	2	2	2	2	—	100
	No. of Samples	19	5	13	4	4	28	1	1	1	3	1	9	—	1	2	—	1	1	1	2	3	100

Table A-16 Coded Responses to Pot 16, Based on Variables of Age, Status, and Sex

Coded Responses

	Variable	1	2	3	4	7	14	16	65	83	84	165	Total (No.)
Age	Elder	1	1	—	—	21	—	—	—	—	1	2	26
	Adult	1	—	3	1	13	1	—	1	—	—	5	25
	Youth	1	—	1	—	19	—	—	—	1	—	2	24
	Child	3	1	3	—	16	—	—	—	—	—	1	24
Status	Specialist	1	—	—	—	7	—	5	—	—	9	4	26
	Lower Class	1	1	2	—	24	—	—	1	—	1	6	36
	Middle Class	3	—	3	—	23	—	—	—	—	—	3	32
	Upper Class	2	1	2	1	22	1	—	—	1	—	1	31
Sex	Male	6	2	2	1	30	1	—	—	1	1	1	45
	Female	—	—	5	—	39	—	—	1	—	—	9	54
	No. of Samples	6	2	7	1	69	1	—	1	1	1	10	99

Percentage of Coded Responses to Pot 16

	Variable	1	2	3	4	7	14	16	65	83	84	165	Total (%)
Age	Elder	4	4	—	—	81	—	—	—	—	4	7	100
	Adult	4	—	12	4	52	4	—	4	—	—	20	100
	Youth	4	—	4	—	79	—	—	—	4	—	9	100
	Child	13	4	13	—	66	—	—	—	—	—	4	100
Status	Specialist	4	—	—	—	27	—	19	—	—	35	15	100
	Lower Class	3	3	6	—	66	—	—	3	—	3	16	100
	Middle Class	9	—	9	—	73	—	—	—	—	—	9	100
	Upper Class	7	3	7	3	71	3	—	—	3	—	3	100
Sex	Male	13	5	5	2	67	2	—	—	2	2	2	100
	Female	—	—	9	—	72	—	—	—	2	—	17	100
	No. of Samples	6	2	7	1	70	1	—	1	1	1	10	100

Table A-17 Coded Responses to Pot 17, Based on Variables of Age, Status, and Sex

Coded Responses

	Variable	1	7	31	34	51	52	53	100	167	168	Total (No.)
Age	Elder	1	1	—	20	—	—	—	—	1	3	26
	Adult	1	—	1	13	—	—	—	1	—	9	25
	Youth	1	1	—	16	—	—	—	—	1	5	24
	Child	2	2	3	13	—	—	—	—	—	4	24
Status	Specialist	1	—	—	7	1	1	3	—	6	7	26
	Lower Class	1	—	—	20	—	—	—	—	2	13	36
	Middle Class	—	2	3	21	—	—	—	—	—	6	32
	Upper Class	4	2	1	21	—	—	—	1	—	2	31
Sex	Male	3	1	3	32	—	—	—	1	—	5	45
	Female	2	3	1	30	—	—	—	—	2	16	54
	No. of Samples	5	4	4	62	—	—	—	1	2	21	99

Percentage of Coded Responses to Pot 17

	Variable	1	7	31	34	51	52	53	100	167	168	Total (%)
Age	Elder	4	4	—	77	—	—	—	—	4	11	100
	Adult	4	—	4	52	—	—	—	4	—	36	100
	Youth	4	4	—	67	—	—	—	—	4	21	100
	Child	8	8	13	54	—	—	—	—	—	17	100
Status	Specialist	4	—	—	27	4	4	11	—	23	27	100
	Lower Class	3	—	—	55	—	—	—	—	6	36	100
	Middle Class	—	6	9	66	—	—	—	—	—	19	100
	Upper Class	13	6	3	69	—	—	—	3	—	6	100
Sex	Male	7	2	7	71	—	—	—	2	—	11	100
	Female	4	6	2	55	—	—	—	—	4	29	100
	No. of Samples	5	4	4	63	—	—	—	2	2	21	100

Table A-18 Coded Responses to Pot 18, Based on Variables of Age, Status, and Sex

Coded Responses

	Variable	1	65	118	125	135	136	137	138	139	140	141	142	143	145	146	147	148
Age	Elder	5	—	—	4	2	—	2	—	1	2	1	1	—	—	5	—	—
	Adult	4	—	—	4	3	—	1	—	1	—	1	—	—	—	2	—	1
	Youth	2	1	—	—	1	—	—	—	1	—	1	—	1	1	8	—	—
	Child	7	—	—	—	—	1	1	—	—	—	—	—	—	—	9	1	—
Status	Specialist	6	—	1	1	1	—	1	2	1	—	3	—	—	—	4	—	—
	Lower Class	11	1	—	2	2	—	1	—	3	—	—	—	1	—	4	—	1
	Middle Class	5	—	—	1	1	1	1	—	—	1	1	—	—	1	10	1	—
	Upper Class	2	—	—	5	3	—	2	—	—	1	2	1	—	—	10	—	—
Sex	Male	8	1	—	4	4	1	4	—	—	1	1	1	1	—	8	1	—
	Female	10	—	—	4	2	—	—	—	3	1	2	—	—	1	16	—	1
	No. of Samples	18	1	—	8	6	1	4	—	3	2	3	1	1	1	24	1	1

Percentage of Coded Responses to Pot 18

	Variable	1	65	118	125	135	136	137	138	139	140	141	142	143	145	146	147	148
Age	Elder	19	—	—	15	8	—	8	—	4	8	4	4	—	—	19	—	—
	Adult	16	—	—	16	12	—	4	—	4	—	4	—	—	—	8	—	4
	Youth	9	4	—	—	4	—	—	—	4	—	4	—	4	4	34	—	—
	Child	29	—	—	—	—	4	4	—	—	—	—	—	—	—	38	4	—
Status	Specialist	23	—	4	4	4	—	4	8	4	—	11	—	—	—	15	—	—
	Lower Class	30	3	—	5	5	—	3	—	8	—	—	—	3	—	11	—	3
	Middle Class	16	—	—	3	3	3	3	—	—	3	3	—	—	3	32	3	—
	Upper Class	7	—	—	16	10	—	7	—	—	3	7	3	—	—	32	—	—
Sex	Male	19	2	—	9	9	2	9	—	—	2	2	2	2	—	19	2	—
	Female	18	—	—	7	4	—	—	—	5	2	4	—	—	2	29	—	2
	No. of Samples	18	1	—	8	6	1	4	—	3	2	3	1	1	1	25	1	1

continued

Table A-18 *(continued)*

Coded Responses

	Variable	149	150	151	152	153	154	155	156	157	158	159	160	161	162	163	164	Total (No.)
Age	Elder	—	—	—	—	3	—	—	—	—	—	—	—	—	—	—	—	26
	Adult	1	—	—	2	—	—	—	1	1	1	1	—	—	—	—	1	25
	Youth	1	2	—	—	—	1	—	1	—	—	—	1	—	1	1	—	24
	Child	—	1	—	—	—	—	1	—	—	—	—	—	3	—	—	—	24
Status	Specialist	—	1	1	3	—	—	—	—	—	—	—	—	—	—	1	—	26
	Lower Class	2	1	—	—	1	—	1	—	1	1	1	—	—	1	1	—	36
	Middle Class	—	1	—	1	1	1	—	1	—	—	—	1	2	—	—	1	32
	Upper Class	—	1	—	1	1	—	—	1	—	—	—	—	1	—	—	—	31
Sex	Male	—	1	—	—	3	—	1	2	—	1	1	—	—	—	1	—	45
	Female	2	2	—	2	—	1	—	—	1	—	—	1	3	1	—	1	54
	No. of Samples	2	3	—	2	3	1	1	2	1	1	1	1	3	1	1	1	99

Percentage of Coded Responses to Pot 18

	Variable	149	150	151	152	153	154	155	156	157	158	159	160	161	162	163	164	Total (%)
Age	Elder	—	—	—	—	11	—	—	—	—	—	—	—	—	—	—	—	100
	Adult	4	—	—	8	—	—	—	4	4	4	4	—	—	—	—	4	100
	Youth	4	9	—	—	—	4	—	4	—	—	—	4	—	4	4	—	100
	Child	—	4	—	—	—	—	4	—	—	—	—	—	13	—	—	—	100
Status	Specialist	—	4	4	11	—	—	—	—	—	—	—	—	—	—	4	—	100
	Lower Class	5	3	—	—	3	—	3	—	3	3	3	—	—	3	3	—	100
	Middle Class	—	3	—	3	3	3	—	3	—	—	—	3	7	—	—	3	100
	Upper Class	—	3	—	3	3	—	—	3	—	—	—	—	3	—	—	—	100
Sex	Male	—	2	—	—	7	—	2	4	—	2	2	—	—	—	2	—	100
	Female	4	4	—	4	—	2	—	—	2	—	—	2	5	2	—	2	100
	No. of Samples	2	3	—	2	3	1	1	2	1	1	1	1	3	1	1	1	100

Table A-19 Coded Responses to Pot 19, Based on Variables of Age, Status, and Sex

Coded Responses

	Variable	1	3	4	7	14	23	82	125	165	166	Total (No.)
Age	Elder	3	17	—	2	2	—	—	—	—	2	26
	Adult	1	14	—	1	2	—	—	—	—	7	25
	Youth	—	12	—	2	3	1	2	—	—	4	24
	Child	—	15	1	4	1	2	—	1	—	—	24
Status	Specialist	—	11	—	—	—	1	—	—	1	13	26
	Lower Class	2	19	—	4	1	1	—	—	—	9	36
	Middle Class	1	20	—	4	4	1	—	1	—	1	32
	Upper Class	1	20	1	1	3	—	2	—	—	3	31
Sex	Male	3	26	—	7	1	1	2	1	—	4	45
	Female	1	33	1	2	7	1	—	—	—	9	54
	No. of Samples	4	59	1	9	8	2	2	1	—	13	99

Percentage of Coded Responses to Pot 19

	Variable	1	3	4	7	14	23	82	125	165	166	Total (%)
Age	Elder	11	65	—	8	8	—	—	—	—	8	100
	Adult	4	56	—	4	8	—	—	—	—	28	100
	Youth	—	50	—	8	13	4	8	—	—	17	100
	Child	—	63	4	17	4	8	—	4	—	—	100
Status	Specialist	—	42	—	—	—	4	—	—	4	50	100
	Lower Class	6	53	—	11	3	3	—	—	—	25	100
	Middle Class	3	62	—	13	13	3	—	3	—	3	100
	Upper Class	3	65	3	3	10	—	6	—	—	10	100
Sex	Male	7	58	—	16	2	2	4	2	—	9	100
	Female	2	61	2	4	13	2	—	—	—	16	100
	No. of Samples	4	60	1	9	8	2	2	1	—	13	100

Table A-20 Coded Responses to Pot 20, Based on Variables of Age, Status, and Sex

Coded Responses

	Variable	1	3	4	7	12	14	23	37	82	165	166	Total (No.)
Age	Elder	4	2	—	18	—	—	—	—	—	2	—	26
	Adult	1	5	—	9	—	1	—	—	—	7	2	25
	Youth	2	4	—	15	—	—	—	—	—	2	1	24
	Child	1	7	1	13	—	—	—	1	1	—	—	24
Status	Specialist	—	—	—	7	1	—	1	—	—	14	3	26
	Lower Class	2	5	—	19	—	—	—	1	—	7	2	36
	Middle Class	2	6	—	23	—	—	—	—	—	1	—	32
	Upper Class	4	7	1	13	—	1	—	—	1	3	1	31
Sex	Male	6	5	—	26	—	1	—	1	—	3	3	45
	Female	2	13	1	29	—	—	—	—	1	8	—	54
	No. of Samples	8	18	1	55	—	1	—	1	1	11	3	99

Percentage of Coded Responses to Pot 20

	Variable	1	3	4	7	12	14	23	37	82	165	166	Total (%)
Age	Elder	15	8	—	69	—	—	—	—	—	8	—	100
	Adult	4	20	—	36	—	4	—	—	—	28	8	100
	Youth	8	17	—	63	—	—	—	—	—	8	4	100
	Child	4	29	4	55	—	—	—	4	4	—	—	100
Status	Specialist	—	—	—	27	4	—	4	—	—	54	11	100
	Lower Class	6	14	—	52	—	—	—	3	—	19	6	100
	Middle Class	6	19	—	72	—	—	—	—	—	3	—	100
	Upper Class	13	23	3	42	—	3	—	—	3	10	3	100
Sex	Male	13	11	—	58	—	2	—	2	—	7	7	100
	Female	4	24	2	53	—	—	—	—	2	15	—	100
	No. of Samples	8	18	1	56	—	1	—	1	1	11	3	100

Table A-21 Coded Responses to Pot 21, Based on Variables of Age, Status, and Sex

Coded Responses

	Variable	1	2	3	4	7	14	24	74	75	81	83	86	87	88	125	141	166	Total (No.)
Age	Elder	2	8	8	2	1	1	—	—	—	1	1	1	—	1	—	—	—	26
	Adult	2	4	5	4	1	5	—	—	—	—	—	—	—	—	2	1	1	25
	Youth	—	6	6	3	—	4	—	1	1	—	2	—	—	—	—	—	1	24
	Child	—	2	13	5	2	1	—	—	—	—	—	—	—	—	—	—	—	24
Status	Specialist	2	10	3	1	—	—	1	—	1	—	—	—	8	—	—	—	—	26
	Lower Class	1	11	11	5	2	2	—	—	1	—	—	—	—	—	2	—	1	36
	Middle Class	—	6	11	3	2	5	—	1	1	—	1	—	—	—	—	1	1	32
	Upper Class	3	3	10	6	—	4	—	—	—	1	2	1	—	1	—	—	—	31
Sex	Male	2	5	15	10	2	3	—	—	—	—	3	—	—	1	2	—	2	45
	Female	2	15	17	4	2	8	—	1	2	1	—	1	—	—	—	1	—	54
	No. of Samples	4	20	32	14	4	11	—	1	2	1	3	1	—	1	2	1	2	99

Percentage of Coded Responses to Pot 21

	Variable	1	2	3	4	7	14	24	74	75	81	83	86	87	88	125	141	166	Total (%)
Age	Elder	8	30	30	8	4	4	—	—	—	4	4	4	—	4	—	—	—	100
	Adult	8	16	20	16	4	20	—	—	—	—	—	—	—	—	8	4	4	100
	Youth	—	25	25	13	—	17	—	4	4	—	8	—	—	—	—	—	4	100
	Child	—	8	55	21	8	4	—	—	4	—	—	—	—	—	—	—	—	100
Status	Specialist	8	38	11	4	—	—	4	—	4	—	—	—	31	—	—	—	—	100
	Lower Class	3	31	31	14	5	5	—	—	3	—	—	—	—	—	5	—	3	100
	Middle Class	—	19	35	9	6	16	—	3	3	—	3	—	—	—	—	3	3	100
	Upper Class	10	10	32	19	—	13	—	—	—	3	7	3	—	3	—	—	—	100
Sex	Male	4	11	34	23	4	7	—	—	—	—	7	—	—	2	4	—	4	100
	Female	4	27	31	7	4	15	—	2	4	2	—	2	—	—	—	3	—	100
	No. of Samples	4	20	33	14	4	11	—	1	2	1	3	1	—	1	2	1	2	100

Table A-22 Coded Responses to Pot 22, Based on Variables of Age, Status, and Sex

Coded Responses

	Variable	1	2	3	4	7	14	17	72	73	74	75	83	87	89	90	91	92	125	141	166	Total (No.)
Age	Elder	2	7	—	4	1	2	—	4	1	—	2	1	1	—	—	—	1	—	—	—	26
	Adult	1	4	3	4	—	—	—	5	1	—	3	—	—	—	—	1	—	1	1	1	25
	Youth	1	2	5	1	—	8	—	1	2	—	3	—	—	—	1	—	—	—	—	—	24
	Child	5	1	5	3	—	2	1	—	1	2	4	—	—	—	—	—	—	—	—	—	24
Status	Specialist	2	—	2	1	—	—	—	—	13	—	2	—	—	6	—	—	—	—	—	—	26
	Lower Class	2	5	8	5	—	2	—	3	5	—	5	—	—	—	—	—	—	1	—	—	36
	Middle Class	2	6	4	1	1	6	1	4	—	—	3	1	—	—	1	—	—	—	1	1	32
	Upper Class	5	3	1	6	—	4	—	3	—	2	4	—	1	—	—	1	1	—	—	—	31
Sex	Male	6	6	5	9	1	5	—	3	1	—	3	1	1	—	1	1	—	1	—	1	45
	Female	3	8	8	3	—	7	1	7	4	2	9	—	—	—	—	—	1	—	1	—	54
	No. of Samples	9	14	13	12	1	12	1	10	5	2	12	1	1	—	1	1	1	1	1	1	99

Percentage of Coded Responses to Pot 22

	Variable	1	2	3	4	7	14	17	72	73	74	75	83	87	89	90	91	92	125	141	166	Total (%)
Age	Elder	8	26	—	15	4	8	—	15	4	—	8	4	4	—	—	—	4	—	—	—	100
	Adult	4	16	12	16	—	—	—	20	4	—	12	—	—	—	—	4	—	4	4	4	100
	Youth	4	8	21	4	—	34	—	4	8	—	13	—	—	—	4	—	—	—	—	—	100
	Child	21	4	21	13	—	8	4	—	4	8	17	—	—	—	—	—	—	—	—	—	100
Status	Specialist	8	—	8	3	—	—	—	—	50	—	8	—	—	23	—	—	—	—	—	—	100
	Lower Class	6	14	21	14	—	6	—	8	14	—	14	—	—	—	—	—	—	3	—	—	100
	Middle Class	6	19	13	3	3	19	3	13	—	—	9	3	—	—	3	—	—	—	3	3	100
	Upper Class	16	10	3	20	—	13	—	10	—	6	13	3	—	—	—	3	3	—	—	—	100
Sex	Male	14	14	11	20	2	11	—	7	2	—	7	2	2	—	2	2	—	2	—	2	100
	Female	5	15	15	5	—	13	2	13	7	4	17	—	—	—	—	—	2	—	2	—	100
	No. of Samples	9	15	13	12	1	12	1	10	5	2	12	1	1	—	1	1	1	1	1	1	100

Table A-23 Coded Responses to Pot 23, Based on Variables of Age, Status, and Sex

Coded Responses

	Variable	1	2	3	4	7	14	15	17	18	75	93	94	95	96	141	166	Total (No.)
Age	Elder	3	5	8	2	4	3	—	—	—	—	—	1	—	—	—	—	26
	Adult	—	1	11	4	3	4	—	—	—	—	—	—	—	—	1	1	25
	Youth	—	—	13	2	2	5	—	—	—	1	—	1	—	—	—	—	24
	Child	—	1	14	2	4	2	—	1	—	—	—	—	—	—	—	—	24
Status	Specialist	1	—	8	1	—	—	5	—	1	—	1	5	2	1	—	1	26
	Lower Class	1	2	23	3	4	1	—	—	—	—	—	2	—	—	—	—	36
	Middle Class	—	3	15	—	5	5	—	1	—	1	—	—	—	—	1	1	32
	Upper Class	2	2	8	7	4	8	—	—	—	—	—	—	—	—	—	—	31
Sex	Male	1	3	17	7	8	8	—	—	—	—	—	—	—	—	—	1	45
	Female	2	4	29	3	5	6	—	1	—	1	—	2	—	—	1	—	54
	No. of Samples	3	7	46	10	13	14	—	1	—	1	—	2	—	—	1	1	99

Percentage of Coded Responses to Pot 23

	Variable	1	2	3	4	7	14	15	17	18	75	93	94	95	96	141	166	Total (%)
Age	Elder	12	19	31	7	15	12	—	—	—	—	—	4	—	—	—	—	100
	Adult	—	4	44	16	12	16	—	—	—	—	—	—	—	—	4	4	100
	Youth	—	—	55	8	8	21	—	—	—	4	—	4	—	—	—	—	100
	Child	—	4	59	8	17	8	—	4	—	—	—	—	—	—	—	—	100
Status	Specialist	4	—	30	4	—	—	19	—	4	—	4	19	8	4	—	4	100
	Lower Class	3	6	63	8	11	3	—	—	—	—	—	6	—	—	—	—	100
	Middle Class	—	9	47	—	16	16	—	3	—	3	—	—	—	—	3	3	100
	Upper Class	6	6	26	23	13	26	—	—	—	—	—	—	—	—	—	—	100
Sex	Male	2	7	38	15	18	18	—	—	—	—	—	—	—	—	—	2	100
	Female	4	7	53	6	9	11	—	2	—	2	—	4	—	—	2	—	100
	No. of Samples	3	7	47	10	13	14	—	1	—	1	—	2	—	—	1	1	100

Table A-24 Coded Responses to Pot 24, Based on Variables of Age, Status, and Sex

Coded Responses

	Variable	1	2	3	4	7	14	17	21	81	83	96	97	165	166	Total (No.)
Age	Elder	1	1	1	1	20	—	—	—	1	—	—	—	—	1	26
	Adult	1	—	1	—	21	1	—	—	—	—	—	—	1	—	25
	Youth	1	—	1	—	21	—	—	—	—	1	—	—	—	—	24
	Child	2	1	6	—	14	—	1	—	—	—	—	—	—	—	24
Status	Specialist	—	—	2	—	6	—	—	1	—	—	15	1	1	—	26
	Lower Class	1	1	6	1	27	—	—	—	—	—	—	—	—	—	36
	Middle Class	1	—	2	—	26	—	1	—	—	—	—	—	1	1	32
	Upper Class	3	1	1	—	23	1	—	—	1	1	—	—	—	—	31
Sex	Male	2	2	5	1	31	1	—	—	—	1	—	—	1	1	45
	Female	3	—	4	—	45	—	1	—	1	—	—	—	—	—	54
	No. of Samples	5	2	9	1	76	1	1	—	1	1	—	—	1	1	99

Percentage of Coded Responses to Pot 24

	Variable	1	2	3	4	7	14	17	21	81	83	96	97	165	166	Total (%)
Age	Elder	4	4	4	4	76	—	—	—	4	—	—	—	—	4	100
	Adult	4	—	4	—	84	4	—	—	—	—	—	—	4	—	100
	Youth	4	—	4	—	88	—	—	—	—	4	—	—	—	—	100
	Child	8	4	25	—	59	—	4	—	—	—	—	—	—	—	100
Status	Specialist	—	—	8	—	23	—	—	4	—	—	57	4	4	—	100
	Lower Class	3	3	16	3	75	—	—	—	—	—	—	—	—	—	100
	Middle Class	3	—	6	—	82	—	3	—	—	—	—	—	3	3	100
	Upper Class	10	3	3	—	75	3	—	—	3	3	—	—	—	—	100
Sex	Male	5	5	11	2	69	2	—	—	—	2	—	—	2	2	100
	Female	6	—	7	—	83	—	2	—	2	—	—	—	—	—	100
	No. of Samples	5	2	9	1	77	1	1	—	1	1	—	—	1	1	100

Table A-25 Coded Responses to Pot 25, Based on Variables of Age, Status, and Sex

Coded Responses

	Variable	1	2	3	7	11	31	33	34	35	37	81	96	98	99	100	101	165	Total (No.)
Age	Elder	4	1	—	17	1	—	—	—	—	1	1	—	—	—	1	—	—	26
	Adult	1	—	—	22	—	—	—	—	—	1	—	—	—	—	—	—	1	25
	Youth	2	—	—	14	—	1	—	1	2	4	—	—	—	—	—	—	—	24
	Child	1	—	3	15	—	2	1	2	—	—	—	—	—	—	—	—	—	24
Status	Specialist	2	—	—	1	—	—	—	—	—	10	—	5	1	2	—	5	—	26
	Lower Class	1	1	3	25	—	—	—	—	—	6	—	—	—	—	—	—	—	36
	Middle Class	1	—	—	23	—	3	—	2	2	—	—	—	—	—	—	1	—	32
	Upper Class	6	—	—	20	1	—	1	1	—	—	1	—	—	—	1	—	—	31
Sex	Male	4	1	3	27	—	2	1	1	1	3	—	—	—	—	1	—	1	45
	Female	4	—	—	41	1	1	—	2	1	3	1	—	—	—	—	—	—	54
	No. of Samples	8	1	3	68	1	3	1	3	2	6	1	—	—	—	1	—	1	99

Percentage of Coded Responses to Pot 25

	Variable	1	2	3	7	11	31	33	34	35	37	81	96	98	99	100	101	165	Total (%)
Age	Elder	15	4	—	65	4	—	—	—	—	4	4	—	—	—	4	—	—	100
	Adult	4	—	—	88	—	—	—	—	—	4	—	—	—	—	—	—	4	100
	Youth	8	—	—	59	—	4	—	4	8	17	—	—	—	—	—	—	—	100
	Child	4	—	13	63	—	8	4	8	—	—	—	—	—	—	—	—	—	100
Status	Specialist	8	—	—	4	—	—	—	—	—	38	—	19	4	8	—	19	—	100
	Lower Class	3	3	8	69	—	—	—	—	—	17	—	—	—	—	—	—	—	100
	Middle Class	3	—	—	72	—	10	—	6	6	—	—	—	—	—	—	3	—	100
	Upper Class	20	—	—	65	3	—	3	3	—	—	3	—	—	—	3	—	—	100
Sex	Male	9	2	7	61	—	4	2	2	2	7	—	—	—	—	2	—	2	100
	Female	7	—	—	76	2	2	—	4	2	5	2	—	—	—	—	—	—	100
	No. of Samples	8	1	3	69	1	3	1	3	2	6	1	—	—	—	1	—	1	100

Table A-26 Coded Responses to Pot 26, Based on Variables of Age, Status, and Sex

Coded Responses

	Variable	1	7	25	31	33	34	41	49	51	54	55	102	168	Total (No.)
Age	Elder	2	1	1	—	—	21	—	—	—	1	—	—	—	26
	Adult	3	1	—	—	—	18	—	—	—	1	1	—	1	25
	Youth	—	2	—	—	—	19	—	—	—	3	—	—	—	24
	Child	4	3	—	2	1	14	—	—	—	—	—	—	—	24
Status	Specialist	1	—	—	—	—	6	1	1	1	14	—	2	—	26
	Lower Class	1	—	—	—	1	29	—	—	—	4	1	—	—	36
	Middle Class	1	3	1	2	—	23	—	—	—	1	—	—	1	32
	Upper Class	7	4	—	—	—	20	—	—	—	—	—	—	—	31
Sex	Male	6	2	1	2	1	29	—	—	—	3	—	—	1	45
	Female	3	5	—	—	—	43	—	—	—	2	1	—	—	54
	No. of Samples	9	7	1	2	1	72	—	—	—	5	1	—	1	99

Percentage of Coded Responses to Pot 26

	Variable	1	7	25	31	33	34	41	49	51	54	55	102	168	Total (%)
Age	Elder	8	4	4	—	—	81	—	—	—	4	—	—	—	100
	Adult	12	4	—	—	—	72	—	—	—	4	4	—	4	100
	Youth	—	8	—	—	—	79	—	—	—	13	—	—	—	100
	Child	17	13	—	8	4	58	—	—	—	—	—	—	—	100
Status	Specialist	4	—	—	—	—	23	4	4	4	54	—	7	—	100
	Lower Class	3	—	—	—	3	80	—	—	—	11	3	—	—	100
	Middle Class	3	10	3	6	—	72	—	—	—	3	—	—	3	100
	Upper Class	23	14	—	—	—	65	—	—	—	—	—	—	—	100
Sex	Male	13	5	2	5	2	64	—	—	—	7	—	—	2	100
	Female	5	9	—	—	—	80	—	—	—	4	2	—	—	100
	No. of Samples	9	7	1	2	1	73	—	—	—	5	1	—	1	100

Table A-27 Coded Responses to Pot 27, Based on Variables of Age, Status, and Sex

Coded Responses

	Variable	1	3	7	25	31	33	34	65	74	103	104	105	106	107	108	109	110	111	Total (No.)
Age	Elder	3	—	2	—	—	—	—	—	—	—	10	—	1	—	1	1	8	—	26
	Adult	4	1	3	1	1	1	—	—	—	—	5	—	—	—	—	—	7	2	25
	Youth	3	1	4	—	—	—	—	—	—	—	6	—	—	—	—	1	9	—	24
	Child	6	—	6	—	1	—	1	1	2	—	—	—	—	—	—	1	6	—	24
Status	Specialist	1	—	1	—	—	—	—	—	—	1	14	4	2	1	—	—	2	—	26
	Lower Class	4	1	6	1	—	1	—	—	—	—	8	—	1	—	—	1	12	1	36
	Middle Class	6	1	5	—	1	—	1	—	1	—	4	—	—	—	1	2	10	—	32
	Upper Class	6	—	4	—	1	—	—	1	1	—	9	—	—	—	—	—	8	1	31
Sex	Male	11	1	7	1	2	1	—	1	1	—	5	—	1	—	—	1	13	—	45
	Female	5	1	8	—	—	—	1	—	1	—	16	—	—	—	1	2	17	2	54
	No. of Samples	16	2	15	1	2	1	1	1	2	—	21	—	1	—	1	3	30	2	99

Percentage of Coded Responses to Pot 27

	Variable	1	3	7	25	31	33	34	65	74	103	104	105	106	107	108	109	110	111	Total (%)
Age	Elder	11	—	8	—	—	—	—	—	—	—	38	—	4	—	4	4	31	—	100
	Adult	16	4	12	4	4	4	—	—	—	—	20	—	—	—	—	—	28	8	100
	Youth	13	4	17	—	—	—	—	—	—	—	25	—	—	—	—	4	37	—	100
	Child	25	—	25	—	4	—	4	4	9	—	—	—	—	—	—	4	25	—	100
Status	Specialist	4	—	4	—	—	—	—	—	—	4	53	15	8	4	—	—	8	—	100
	Lower Class	11	3	16	3	—	3	—	—	—	—	22	—	3	—	—	3	33	3	100
	Middle Class	19	3	16	—	3	—	3	—	3	—	13	—	—	—	3	6	31	—	100
	Upper Class	20	—	13	—	3	—	—	3	3	—	29	—	—	—	—	—	26	3	100
Sex	Male	25	2	16	2	5	2	—	2	2	—	11	—	2	—	—	2	29	—	100
	Female	9	2	15	—	—	—	2	—	2	—	29	—	—	—	2	4	31	4	100
	No. of Samples	16	2	15	1	2	1	1	1	2	—	21	—	1	—	1	3	31	2	100

Table A-28 Coded Responses to Pot 28, Based on Variables of Age, Status, and Sex

	Variable	1	11	34	104	110	112	Total (No.)
Age	Elder	—	—	—	—	26	—	26
	Adult	—	—	—	—	25	—	25
	Youth	—	3	—	—	21	—	24
	Child	1	—	—	—	23	—	24
Status	Specialist	—	—	1	1	19	5	26
	Lower Class	1	—	—	—	35	—	36
	Middle Class	—	3	—	—	29	—	32
	Upper Class	—	—	—	—	31	—	31
Sex	Male	—	3	—	—	42	—	45
	Female	1	—	—	—	53	—	54
	No. of samples	1	3	—	—	95	—	99

Percentage of Coded Responses to Pot 28

	Variable	1	11	34	104	110	112	Total (%)
Age	Elder	—	—	—	—	100	—	100
	Adult	—	—	—	—	100	—	100
	Youth	—	13	—	—	87	—	100
	Child	4	—	—	—	96	—	100
Status	Specialist	—	—	4	4	73	19	100
	Lower Class	3	—	—	—	97	—	100
	Middle Class	—	9	—	—	91	—	100
	Upper Class	—	—	—	—	100	—	100
Sex	Male	—	7	—	—	93	—	100
	Female	2	—	—	—	98	—	100
	No. of Samples	1	3	—	—	96	—	100

BIBLIOGRAPHY

Acosta, Jorge

1971 Archaeological Explorations at Cholula. In *Cholula Ciudad Sagrada*, pp. 6–11, 12–24. *Artes de Mexico* No. 140. Mexico D.F.

Adams, Marie Jeanne

1973 Structural Aspects of a Village Art. *American Anthropologist* 75:265–279.

1974 Symbols of the Organized Community in East Suma, Indonesia. *Bijldrazen voor Taal-Land-Volkerkunde* (The Hague) 130 (2, 3):324–347.

1977 Style in Southeast Asian Materials Processing: Some Implications for Ritual and Art. In *Material Culture: Styles, Organization, and Dynamics of Technology*, edited by H. Lechtman and R. Merrill, pp. 21–52. West Publishing, St. Paul, Minnesota.

Anawalt, Patricia Rieff

1981 Indian Clothing Before Cortes: Mesoamerican Costumes from the Codices. *The Civilization of the American Indians Series* No. 156. University of Oklahoma Press, Norman.

1990 The Emperor's Cloak: Aztec Pomp, Toltec Circumstance. *American Antiquity* 55:291–307.

Archives of the Cathedral of Puebla, Puebla, Mexico

1657–1681 Book 1, Marriages of the Indians.

1629–1699 Book 1, Marriages of Negroes and Mulattoes.

Archives of the Municipality of Puebla (AMP), Puebla, Mexico

1797 Document 22.

Archives of the Parish of Santo Angel, Puebla, Puebla, Mexico

1657–1699 Book 1, Marriages of the Parish of Santo Angel, Puebla de los Ángeles.

1777–1805 Book 5, Marriages of the Parish of Santo Angel, Puebla de los Ángeles.

1817–1828 Book 7, Marriages of the Parish of Santo Angel, Puebla de los Ángeles.

1833–1840 Book 33, Marriages of the Parish of Santo Angel, Puebla de los Ángeles.

Arnold, Dean

1971 Ethnomineralogy of Ticul, Yucatán Potters: Etics and Emics. *American Antiquity* 36:20–40.

1975 The Ceramic Ecology of the Ayacucho Basin, Peru: Implications for Prehistory. *Current Anthropology* 16:183–205.

1978a Ceramic Variability, Environment and Culture History Among the Pokom in the Valley of Guatemala. In *The Spatial Organization of Culture*, edited Ian Hodder, pp. 39–59. University of Pittsburgh Press, Pittsburgh.

1978b The Ethnography of Pottery Making in the Valley of Guatemala. In *The Ceramics of Kaminaljuyu, Guatemala*, edited by Ronald K. Wetherington, pp. 327–400. The Pennsylvania State University Press, University Park.

1980 Localized Exchange: An Ethnoarchaeological Perspective. In *Models and Methods in Regional Exchange*, edited by Robert E. Fry, pp. 147–150. SAA Papers No. 1. Society for American Archaeology, Washington, D.C.

Atkins, John R.

1974 GRAFIK: A General Relational Algebra for Investigating Kinship. In *Genealogical Mathematics*, edited by Paul Ballonoff, pp. 27–52. Mouton, The Hague.

Balfet, Helene

1965 Ethnographic Observations in North Africa and Archaeological Interpretation: The Pottery of Maghreb. In *Ceramics and Man*, edited by Frederick R. Matson, pp. 161–177. Viking Fund Publications in Anthropology, No. 41. Aldine, Chicago.

Basso, Keith

1976 "Wise Words" of the Western Apache: Metaphor and Semantic Theory. In *Meaning in Anthropology*, edited by K. Basso and H. Selby, pp. 93–122. University of New Mexico Press, Albuquerque.

Berlin, Brent, James Boster, and John O'Neill

1980 *The Perceptual Bases of Ethnobiological Classification: Evidence from Aguaruna Jívaro Ornithology.* Studies in Jívaro Ethnobiology Report No. 6. Language Behavior Research Laboratory, Berkeley.

Berlin, Brent, Dennis E. Breedlove, and Peter H. Raven

1973 General Principles of Classification and Nomenclature in Folk Biology. *American Anthropologist* 75:214–242.

1974 *Principles of Tzeltal Plant Classification: An Introduction to the Botanical Ethnography of a Mayan-Speaking People of Highland Chiapas.* Academic Press, New York.

Berlin, Brent, and Paul Kay

1969 *Basic Color Terms: Their Universality and Evolution.* University of California Press, Berkeley.

Berreman, Gerald D.

1966 Anemic and Emetic Analysis in Social Anthropology. *American Anthropologist* 68:346–354.

Bierhorst, John [translator]

1984 *Mitos y Leyendas de los Aztecas.* Litográfica Maico, Mexico.

1985 *Cantares Mexicano: Songs of the Aztecs.* Stanford University Press, Stanford.

Binford, L. [editor]

1978 *Nunamiut Ethnoarchaeology.* Academic Press, New York.

1979 *For Theory Building in Archaeology.* Academic Press, New York.

Birmingham, Judy

1975 Traditional Potters of the Kathmandu Valley: An Ethnoarchaeological Study. *Man* 10:370–386.

Blanton, Richard E.

1976 Anthropological Studies of Cities. *Annual Review of Anthropology* 5:249–264.

1978 *Monte Alban: Settlement Patterns of the Ancient Zapotec Capital.* Academic Press, New York.

Bordaz, Jacques

1964 *Pre-Columbian Ceramic Kilns at Peñitas, A Post Classic Site in Coastal Nayarít, Mexico.* Ph.D. dissertation, Columbia University. University Microfilms, Ann Arbor.

Braithwaite, M.

1982 Decoration as Ritual Symbol: A Theoretical Proposal and an Ethnographic Study in Southern Sudan. In *Symbolic and Structural Archaeology,* edited by I. Hodder. Cambridge University Press, Cambridge.

Braun, David P.

1983 Pots as Tools. In *Archaeological Hammers and Theories,* edited by J. A. Moore and A. S. Keene, pp. 107–134. Academic Press, New York.

Brill, Robert H. [editor]

1971 *Science and Archaeology.* MIT Press, Cambridge, Massachusetts.

Brown, Cecil

1976 General Principles of Human Anatomical Nomenclature and Speculations on the Growth of Partonomic Nomenclature. *American Ethnologist* 3:400–424.

Brumfiel, Elizabeth

1976 *Specialization and Exchange at the Late Postclassic (Aztec) Community of Huexotla, Mexico.* Unpublished Ph.D. dissertation, University of Michigan, Ann Arbor.

1980 Specialization, Market Exchange, and the Aztec State: A View for Huexotla. *Current Anthropology* 21:459–478.

Brundage, Burr Cartwright

1982 *The Phoenix of the Western World: Quetzalcoatl and the Sky Religion.* University of Oklahoma Press, Norman.

Bucher, Bernadette

1981 *Icon and Conquest: A Structural Analysis of Illustrations of de Bry's Great Voyages.* University of Chicago Press, Chicago.

Buhler, Roald

1971 *P-STAT Version.* Princeton University, Princeton, New Jersey.

Bulmer, Ralph

1967 Why Is the Cassowary Not a Bird? A Problem of Zoological Taxonomy Among the Karam of the New Guinea Highlands. *Man* 2:5–25.

Bunzel, Ruth L.

1929 *The Pueblo Potter: A Study of Creative Imagination in Primitive Art.* Columbia University Contributions to Anthropology No. 8. Columbia University, New York.

1972 *The Pueblo Potter: A Study of Creative Imagination in Primitive Art.* Reprinted. Dover Publications, New York. Originally published 1929, Columbia University Press, New York.

Burgess, D., W. Kempton, and R. E. Maclaury

1983 Tarahumara Color Modifiers: Category Structure Presaging Evolutionary Change. *American Ethnologist* 10:133–149.

Burland, C. A.

1968 *The Gods of Mexico.* Capricorn Books, New York.

Burling, Robbins

1964 Cognition and Componential Analysis: God's Truth or Hocus-Pocus? *American Anthropologist* 66:20–28.

Calderón de la Barca, Fanny

1970 *Life in Mexico*, edited by Howard T. Fisher and Marion Hall Fisher. Reprinted. Doubleday, Garden City, New York. Originally published 1843, Little and Brown, Boston.

Carmone, F. J., Jr., and Patrick J. Robinson

1968 WAGS: An IBM 7040/360–65 Program to Compute Weighted Agreement Scores for Multidimensional Scaling. *Journal of Marketing Research* 5:95–98.

Carneiro, Robert L.

1968 Ascertaining, Testing and Interpreting Sequences of Cultural Development. *Southwestern Journal of Anthropology* 24:354–374.

1969 The Measurement of Cultural Development in the Ancient Near East and in Anglo-Saxon England. *Transactions of the New York Academy of Sciences* Series II, 31:1013–1023, New York.

1970 Scale Analysis, Evolutionary Sequences, and the Rating of Cultures. In *Handbook of Method in Cultural Anthropology*, edited by Raoul Naroll and Ronald Cohen, pp. 834–871. Natural History Press, Garden City, New York.

1974 The Four Faces of Evolution. In *Handbook of Social and Cultural Anthropology*, edited by John J. Honigmann, pp. 89–110. Rand McNally, Chicago.

Carrasco, David

1982 *Quetzalcoatl and the Irony of Empire: Myths and Prophecies in the Aztec Tradition.* The University of Chicago Press, Chicago.

Carrera Stampa, Manuel

1954 *Los Grémios Mexicanos: La Organización Gremial en Nueva España 1521–1861.* Ibero Americana de Publicaciones, S.A., Mexico.

Carrión, Antonio

1897 *Historia de la Ciudad de la Puebla de Los Ángeles.* 2 vols. Tipográfica de las Escuelas Salesianas de Artes y Oficios, Puebla.

Caso, Alfonso

1953 *El Pueblo del Sol.* Fondo de Cultura Económica, Mexico.

Castro, Efraín

1966 Desarollo urbano de la ciudad de Puebla. In *Puebla. Artes de Mexico.* 81/82, XIII:8–10, 21–23, 34. Foto Ilustradores, S.A. de C.V., Mexico.

1973 Comentario. In *Primera Mesa Redonda, Los Recursos Naturales del Estado de Puebla y su Aprovechamiento*, edited by Efraín Castro, pp. 17–28. Instituto Mexicano de Recursos Naturales Renovables, A.C., Mexico.

Cervantes, Enrique A.

1939 *Loza blanca y azulejo de Puebla.* 2 vols. Mexico.

Chang, K. C.

1967 *Rethinking Archaeology.* Random House, New York.

Chapman, R., I. Kinnes, and K. Randsborg [editors]

1981 *The Archaeology of Death.* Cambridge University Press, Cambridge.

Charlton, Thomas H.

1968 Archaeology and History: 1519–1969, The Emerging Picture in the Teotihuacán Valley, Mexico. Ms. on file, 000136, pp. 1–27. Department of Anthropology, University of Iowa, Iowa City.

1969 Ethnohistory and Archaeology: Post-Conquest Aztec sites. *American Antiquity* 34:176–177.

1972a Population Trends in the Teotihuacan Valley, A.D. 1400–1969. In *World Archaeology*, vol. 4, edited by Derek Roe, pp. 106–123. Routledge & Kegan Paul, London.

1972b *Post-Conquest Development in the Teotihuacán Valley, Mexico. Part I. Excavations.* Office of the State Archaeologist Report No. 5, Iowa City.

1975 Contemporary Central American Ceramics: A View from the Past. Paper presented at a Research Seminar on Art, Artisans and Societies, University of Leicester, Leicester.

1976 Historical Archaeology in the Valley of Mexico. Proceedings of the XLII International Congress of Americanists, Paris. 3:21–33.

1981 Archaeology, Ethnohistory, and Ethnology: Interpretive Interfaces. In *Advances in Archaeological Method and Theory*, vol. 4, edited by Michael B. Schiffer, pp. 129–159. Academic Press, New York.

Chomsky, Noam

1957 *Syntax Structures.* Mouton, The Hague.

1968 *Language and Mind.* Harcourt Brace and World, New York.

Chomsky, Noam, and Morris Hale

1969 *The Sound Pattern of English.* Harper & Row, New York.

Clarke, David L.

1978 *Analytical Archaeology.* Metheun, London.

Codex Borbonicus

1988 *Descripción, Historia y Exposición Del Códice Borbónico (Edicion facsimilar) por Francisco Del Paso Y Troncoso, con un commentario explicativo por E.-T. Hamy.* Originally published 1898, Salvador Landi, Florence, Italy. Fifth Edition, Singlo Veintiuno, Mexico D.F.

Codex Borgia

1904–1909 *Eine altmexikanische Bilderschrift der Bibliothek der Congregatio de Propaganda Fide, Herausgegeben auf Kosten Seiner Excellenz des Herzogs von Loubat, Correspondirenden Mitgliedes des Institut de France.* 3 vols. Edited by Dr. Eduard Seler. Berlin.

Coe, Michael D., and Gordon Whittaker

1982 *Aztec Sorcerers in Seventeenth-Century Mexico. The Treatise on Superstitions by Hernando Ruíz de Alarcon.* Institute for Mesoamerican Studies No. 7. State University of New York, Albany.

Colton, Harold S.

1955 *Pottery Types of the Southwest.* Ceramic Series No. 3A. Museum of Northern Arizona, Flagstaff.

Conkey, Margaret W.

1978 Style and Information in Cultural Evolution: Towards a Predictive Model for the Paleolithic. In *Social Archaeology: Beyond Subsistence and Dating,* edited by Charles L. Redman, Mary Jane Berman, Edward V. Curtin, William T. Langhorne, Jr., Nina M. Versaggi, and Jeffery C. Wanser, pp. 61–85. Academic Press, New York.

1980 Context, Structure and Efficacy in Paleolithic Art and Design. In *Symbol as Sense,* edited by Mary Jane LeCron Foster and Stanley H. Brandes, pp. 225–248. Academic Press, New York.

Conklin, Harold

1955 Hanunóo Color Categories. *Southwestern Journal of Anthropology* 1:339–343.

1969 Lexicographical Treatment of Folk Taxonomies. In *Cognitive Anthropology,* edited by Stephen Tyler, pp. 41–59. Holt, Rinehart & Winston, New York.

1972 *Folk Classification: A Topically Arranged Bibliography of Contemporary and Background References Through 1971.* Department of Anthropology, Yale University, New Haven, Connecticut.

Cowgill, George L.

1968 Archaeological Applications of Factor, Cluster and Proximity Analysis. *American Antiquity* 33:367–375.

Cowgill, George L., Jeffrey H. Altschul, and Rebecca S. Sload

1984 Spatial Analysis of Teotihuacán: A Mesoamerican Metropolis. In *Intrasite Spatial Analysis in Archaeology,* edited by Harold Hietala, pp. 154–195. University of Cambridge Press, Cambridge.

D'Andrade, Roy G., Naomi R. Quinn, Sara Beth Nerlove, and A. Kimball Romney

1972 Categories of Disease in American-English and Mexican-Spanish. In *Multidemensional Scaling: Theory and Applications in the Behavioral Sciences. Vol I: Theory,* edited by Roger N. Shepard, A. Kimball Romney, and Sara Beth Nerlove, pp. 9–54. Seminar Press, New York.

David, Nicholas, and Hilke Hennig

1972 *The Ethnography of Pottery: A Fulani Case in Archaeological Perspective.* McCaleb Module in Anthropology No. 21. Addison-Wesley, Reading, Massachusetts.

D'Azevedo, Warren L.

1958 A Structural Approach to Esthetics: Toward a Definition of Art in Anthropology. *American Anthropologist* 60:702–714.

DeBoer, Warren R., and Donald W. Lathrap

1979 The Making and the Breaking of Shipibo-Conibo Ceramics. In *Ethnoarchaeology: Implications of Ethnography for Archaeology,* edited by Carol Kramer, pp. 102–138. Columbia University Press, New York.

Deetz, James

1965 *The Dynamics of Stylistic Change in Arikara Ceramics.* Illinois Studies in Anthropology No. 4. University of Illinois, Urbana.

Dethlefsen, E., and J. Deetz.

1966 Death's Head, Cherubs, and Willow Trees: Experimental Archaeology in Colonial Cemeteries. *American Antiquity* 31:502–510.

Diaz, May N.

1966 *Tonalá: Conservatism, Responsibility and Authority in a Mexican Town.* University of California Press, Berkeley.

Díaz del Castillo, Bernal

1968 *The Discovery and Conquest of Mexico 1517–1521.* Edited by Génaro Garcia, translated with an introduction by A. P. Maudslay. Introduction to the American edition by Irving A. Leonard. Noonday Press, Farrar, Strauss and Giroux, New York.

Dougherty, Janet W. D. [editor]

1985 *Directions in Cognitive Anthropology.* University of Illinois Press, Urbana.

Dougherty, J. W. D., E. Ohnuki-Tierney, J. W. Fernandez, and N. E. Whitten, Jr. [editors]

1982 Symbolism and Cognition, II. *American Ethnologist* 9(4).

Douglas, Mary

1966 *Purity and Danger: An Analysis of Concepts of Pollution and Taboo.* Routledge & Kegan Paul, London.

1967 The Meaning of Myth, with Special Reference to "La Geste d'Asdiwal." In *The Structural Study of Myth and Totemism,* edited by Edmund Leach, pp. 49–69. ASA No. 5. Tavistock, London.

1973 *Natural Symbols, Explorations in Cosmology.* Vintage Books, New York.

Douglas, Mary [editor]

1982 *Essays in the Sociology of Perception.* Routledge & Kegan Paul, Boston.

Dunnel, Robert C.

1978 Style and Function: A Fundamental Dichotomy. *American Antiquity* 43:192–202.

Durkheim, E., and M. Mauss

1963 *Primitive Classification*. Translated by Rodney Needham. Cohen and West, London.

Erickson, Jonathan E., and Suzanne P. DeAtley

1976 Reconstructing Ceramic Assemblages: An Experiment to Derive the Morphology and Capacity of Parent Vessels from Sherds. *American Antiquity* 41:484–489.

Faris, James C.

1972 *Nuba Personal Art*. University of Toronto Press, Toronto.

Flannery, Kent V., and Joyce Marcus [editors]

1983 *The Cloud People: Divergent Evolution of the Zapotec and Mixtec Civilizations*. Academic Press, New York.

Ford, James

1954 The Type Concept Revisited. *American Anthropologist* 56:42–53.

1972 *A Quantitative Method for Deriving Cultural Chronology*. Pan American Union Technical Manual No. 1. General Secretariat, OAS, Department of Social Affairs, Washington, D.C.

Foster, George M.

1948 Some Implications of Modern Mexican Mold-Made Pottery. *Southwestern Journal of Anthropology* 4:356–370.

1955 Contemporary Pottery Techniques in Southern and Central Mexico. *Middle American Research Institute Publications* 22:1–48. Tulane University, New Orleans.

1960 Life-Expectancy of Utilitarian Pottery in Tzintzuntzán, Michoacán, Mexico. *American Antiquity* 25:606–609.

1965 The Sociology of Pottery: Questions and Hypotheses Arising from Contemporary Mexican Work. In *Ceramics and Man*, edited by Frederick R. Matson, pp. 43–61. Viking Fund Publications in Anthropology No. 41. Aldine, Chicago.

Fournier, Dominique

1981 Le Pulque: Boisson, Nourriture, Capital. Ms. on file, University of Paris, Paris.

Freed, R., and S. Freed

1963 Utilitarian Pottery Manufacture in a North Indian Village. *Anthropological Quarterly* 36:34–42.

Friederich, Margaret (Hardin) H.

1970 Design Structure and Social Interaction: Archaeological Implications of an Ethnographic Analysis. *American Antiquity* 55:332–343.

Furbee, L., and R. A. Benfer

1983 Cognitive and Geographic Maps: A Study of Individual Variation Among Tojolabal Mayans. *American Anthropologist* 85:305–334.

Furst, Jill L.

1978 *Codex Vindobonensis Mexicanus I: A Commentary*. Institute for Mesoamerican Studies Publication No. 4. State University of New York, Albany.

Garcia, Emma

1972 *Los Barrios Antiguos de Puebla*. Centros de Estúdios Históricos de Puebla, Puebla, Mexico.

Geertz, Clifford

1973 *The Interpretation of Cultures: Selected Essays*. Basic Books, New York.

Gellner, Ernest

1982 What is Structuralisme? In *Theory and Explanation in Archaeology*, edited by C. Renfrew, M. J. Rowlands, and B. A. Segraves, pp. 97–123. Academic Press, New York.

Gibson, Charles

1964 *The Aztecs Under Spanish Rule: A History of the Indians of the Valley of Mexico, 1519–1810*. Standford University Press, Stanford.

1966 *Spain in America*. Harper & Row, New York.

Glassie, Henry

1969 *Pattern in the Material Folklife of the Eastern United States*. Folklore and Folklife Monograph No. 1. University of Pennsylvania, Philadelphia.

1975 *Folk Housing in Middle Virginia: Structural Analysis of Historical Artifacts*. University of Tennessee Press, Knoxville.

Gonçalves de Lima, Oswaldo

1956 *El Maguey y el Pulque en los Códices Mexica*. Fondo de Cultura Económica, Mexico.

Good, A.

1983 A Symbolic Type and Its Transformations: The Case of South Indian Ponkal. *Contributions to South Asian Sociology* 17:223–244.

Goodman, L. A., and William H. Kruskal

1954 Measures of Associations for Cross Classifications. *American Statistical Association Journal* 49:732–764.

1959 Measures of Association for Cross Classifications, II: Further Discussion and References. *American Statistical Association Journal* 54:123–163.

1963 Measures of Association for Cross Classifications, III: Approximate Sampling Theory. *American Statistical Association Journal* 58:310–364.

1972 Measures of Association for Cross Classifications, IV: Simplification of Asymptotic Variances. *American Statistical Association Journal* 67:415–421.

Gould, R. [editor]

1978 *Explanations in Ethnoarchaeology*. University of New Mexico Press, Albuquerque.

Graves, Michael W.

1981 *Ethnoarchaeology of Kalinga Ceramic Design*. Ph.D. dissertation, University of Arizona. University Microfilms, Ann Arbor.

Green, Paul E.

1975 On the Robustness of Multidimensional-Scaling Techniques. *Journal of Marketing Research* 12:73–81.

Green, Paul E., and Donald S. Tull

1978 *Research for Marketing Decisions*. 4th ed. Prentice-Hall, Englewood Cliffs, New Jersey.

Guerrero, Raul Guerrero

1980 *El Pulque*. Instituto Nacional de Antropología e História, Mexico, D.F.

Gunn, Joel

1977 Idiosyncratic Chipping Style as a Demographic Indicator: A Proposed Application to the South Hills Region of Idaho and Utah. In *The Individual in Prehistory: Studies of Variability in Style in Prehistoric Technologies*, edited by James N. Hill and Joel Gunn, pp. 167–204. Academic Press, New York.

Guttman, Louis

1941 An Outline of the Statistical Theory of Prediction. In *Prediction of Personal Adjustment*, edited by P. Horst, Paul Wallin, and Louis Guttman, pp. 253–311. Bulletin No. 48, Social Science Research Council (U.S.), Committee on Social Adjustment. Indiana University, Bloomington.

Hall, E. T.

1971 Two Examples of the Use of Chemical Analysis in the Solution of Archaeological Problems. In *Science and Archaeology*, edited by R. H. Brill, pp. 156–164. MIT Press, Cambridge, Massachusetts.

Hallpike, Christopher R.

1979 *The Foundations of Primitive Thought*. Clarendon Press, Oxford.

Hammel, E. [editor]

1965 Formal Semantic Analysis. *American Anthropologist* 67:II.

Hamy, Jules T. E.

1979 *Codice Borbonico: Manuserito Mexicano de la Biblioteca del Palais Borbon*. 1st ed. Mexico D.F.

Harbottle, G.

1970 Neutron Activation Analysis of Potsherds from Knossos and Mycenae. *Archaeometry* 12:23–34.

Hardin, Margaret

1975 The Ethnoarchaeology of Decorative Art Styles. Paper presented at the 74th Annual Meeting of the American Anthropological Association, San Francisco.

1976 The Analysis of Substylistic Contrasts in Context Sparse Ethnological Collections: Individual Style in Classic Zuni Polychrome. Paper presented at the 75th Annual Meeting of the American Anthropological Association, Washington, D.C.

1977 Representational Components in Art Styles: A Comparison of Tarascan and Zuni Cases. Paper presented at the 76th Annual Meeting of the American Anthropological Association, Houston.

Harris, Marvin

1968 *The Rise of Anthropological Theory*. Crowell, New York.

Hassig, Ross

1985 *Trade, Tribute and Transportation: The Sixteenth-Century Political Economy of the Valley of Mexico*. University of Oklahoma Press, Norman.

1988 *Aztec Warfare: Imperial Expansion and Political Control*. University of Oklahoma Press, Norman.

Hayden, Brian

1984 Are Emic Types Relevant to Archaeology? *Ethnohistory* 31:79–92.

Hayden, Brian, and Aubrey Cannon

1984 *The Structure of Material Systems: Ethnoarchaeology in the Maya Highlands*. SAA Papers No. 3. Society for American Archaeology, Washington, D.C.

Hays, T. E.

1983 Ndumba Folk Biology and General Principles of Ethnobiological Classification and Nomenclature. *American Anthropologist* 85:592–611.

Heider, Eleanor Rosch

1971 'Focal' Color Areas and Development of Color Names. *Developmental Psychology* 4:447–455.

1972 Probabilities, Sampling and Ethnographic Method: The Case of Dani Color Names. *Man* 7:448–466.

Hendry, Jean Clare

1957 *Atzompa: A Pottery-Producing Village of Southern Mexico*. Ph.D. dissertation, Cornell University. University Microfilms, Ann Arbor.

Hietala, Harold [editor]

1984 *Intrasite Spatial Analysis in Archaeology*. Cambridge University Press, Cambridge.

Hill, James N.

1967 Structure, Function and Change at Broken K Pueblo. In *Chapters in the Prehistory of Eastern Arizona III*, edited by Paul S. Martin, John B. Rinaldo, William A. Longacre, Constance Cronin, Leslie G. Freeman, Jr., and James Schoenwetter, pp. 158–167. Fieldiana No. 59. Chicago Natural History Museum, Chicago.

1968 Broken K Pueblo: Patterns of Form and Function. In *New Perspectives in Archaeology*, edited by Sally R. Binford and Lewis R. Binford, pp. 103–142. Aldine, Chicago.

1970 *Broken K Pueblo*. Anthropological Papers No. 18. University of Arizona, Tucson.

Hill, J., and R. Evans

1972 A Model for Classification and Typology. In *Models in Archaeology*, edited by D. Clarke, pp. 231–273. Methuen, London.

Hill, J., and J. Gunn [editors]

1977 *The Individual in Prehistory*. Academic Press, New York.

Hodder, Ian

1981 *Pattern of the Past*. Cambridge University Press, Cambridge.

1982 *Symbols in Action*. Cambridge University Press, Cambridge.

1983 *The Present Past*. Rica Press, New York.

Hodder, Ian [editor]

1982 *Symbolic and Structural Archaeology*. Cambridge University Press, Cambridge.

Hodge, Mary G.

1984 Aztec City-States. In *Studies in Latin American Ethnohistory and Archaeology*, vol. 3, edited by Joyce Marcus. Memoir No. 18, Museum of Anthropology, University of Michigan, Ann Arbor.

Hodson, F. R., D. G. Kendall, and P. Tautu [editors]

1971 *Proceedings of the Anglo-Romanian Conference, Mamia, 1970*. Royal Society of London and the Academy of the Socialist Republic of Romania. Aldine, Chicago.

Holm, Bill

1965 *Northwest Coast Indian Art: An Analysis of Form*. University of Washington Press, Seattle.

Hunn, Eugene

1975 *Cognitive Processes in Folk Ornithology: The Identification of Gulls*. Working Paper No. 42. Language of Behavior Research Lab, Berkeley.

1976 Toward a Perceptual Model of Folk Classification. *American Ethnologist* 3:508–524.

1977 *Tzeltal Folk Zoology: Classification of Discontinuities in Nature*. Academic Press, New York.

1982 The Utilitarian Factor in Folk Biological Classification. *American Anthropologist* 84:830–847.

Jara, Alvaro

1972 *Plata y Pulque en el Siglo XVIII Mexicano*. Working Paper No. 9. Centre of Latin American Studies, University of Cambridge, Cambridge.

Jelinek, Arthur J.

1976 Form, Function and Style in Lithic Analysis. In *Cultural Change and Continuity*, edited by Charles E. Cleland, pp. 19–33. Academic Press, New York.

Johnson, Stephen C.

1967 Hierarchical Clustering Schemes. *Psychometrika* 32:241–254.

Kaplan, Flora S.

1976a *Cognition and Style: An Analysis Based on a Mexican Pottery Tradition*. Ph.D. dissertation, City University of New York. University Microfilms, Ann Arbor.

1976b *Learning and Transmission of Style Among Folk-Urban Potters in the Valley of Puebla, Mexico*. Proceedings of the XLI International Congress of Americanists, 3:243–250, Mexico City.

1977a Structuralism and the Analysis of Folk Art. Paper presented at the 76th Annual Meeting of the American Anthropological Association, Houston.

1977b Symbolism in Mexican Utilitarian Pottery. *Centerpoint* 2:33–41.

1980 *Una Tradición Alfarera: Conocimiento y éstilo*. Instituto Nacional Indígenista, Mexico City.

1985 The Measuring, Mapping, and Meaning of Pots. *American Anthropologist* 87:357–364.

1990 Pottery for the Dead: Role and Function of Black Ware in Puebla, Mexico. In *Ceramics and Civilization: Roles and Functions of Ceramics in Society*, vol. 5, edited by W. David Kingery. American Ceramic Society, Westerville, Ohio.

Kaplan, Flora S., and David M. Levine

1981 Cognitive Mapping of a Folk Taxonomy of Mexican Pottery: A Multivariate Approach. *American Anthropologist* 83:868–884.

Kaplan, Flora S., and Gerald I. Spielholtz

1977 La Pérdida de Mercados en la Cerámica. *América Indígena* 37(4):1043–1055.

Kay, Paul, and W. Kempton

1984 What Is the Sapir-Whorf Hypothesis? *American Anthropologist* 86:65–79.

Kay, Paul, and Chad K. McDaniel

1978 The Linguistic Significance of the Meanings of Basic Color Terms. *Language* 54:610–646.

Keesing, Roger

1972 Paradigms Lost: The New Ethnography and the New Linguistics. *Southwest Journal of Anthropology* 28:299–332.

Kempton, Willett

1981 *The Folk Classification of Ceramics: A Study of Cognitive Prototypes.* Academic Press, New York.

Kimball Romney, A., and R. D'Andrade [editors]

1964 Transcultural Studies in Cognition. *American Anthropologist* 66:II.

Kintigh, K. W.

1984 Measuring Archaeological Diversity by Comparison with Simulated Assemblages. *American Antiquity* 49:44–54.

Kohler, Ulrich

1976 Mushrooms, Drugs and Potters: A New Approach to the Function of Precolumbian Mesoamerican Mushroom Stones. *American Antiquity* 41:145–153.

Kowaleski, Stephen A., Charles Spencer, and Elsa Redmond

1978 Description of Ceramic Categories. Appendix II. In *Monte Alban: Settlement Patterns of the Ancient Capital*, edited by Richard E. Blanton, pp. 167–193. Academic Press, New York.

Kramer, C. [editor]

1979 *Ethnoarchaeology.* University of New Mexico Press, Albuquerque.

Krickeberg, Walter

1976 *Las Antiguas Culturas Mexicanas.* Fondo del Cultura Económica, Mexico, D.F.

Krieger, A.

1944 The Typological Concept. *American Antiquity* 9:271–288.

1960 Archaeological Typology in Theory and Practice. In *Men and Cultures: Selected Papers of the 5th International Congress of Anthropological and Ethnological Sciences*, edited by A. C. Wallace, pp. 141–151. University of Pennsylvania Press, Philadelphia.

1964 New World Lithic Typology Project: Part II. *American Antiquity* 29:489–493.

Kroeber, Alfred

1940 Statistical Classification. *American Antiquity* 6:29–44.

Kruskal, Joseph B.

1964a Multidimensional Scaling by Optimizing the Goodness of Fit to a Nonmetric Hypothesis. *Psychometrika* 29:1–27.

1964b Nonmetric Multidimensional Scaling, a Numerical Method. *Psychometrika* 29:115–129.

Kruskal, Joseph B., and Myron Wish

1978 *Multidimensional Scaling.* Paper on Quantitative Applications in the Social Sciences, vol. II. Sage University, Beverly Hills.

Lameiras, Brixit, Juan Palacios, and Manuel Romero de Terreros

1968 *Alfarería Poblana.* Editorial Novario, Mexico.

Langacker, R. W.

1967 *Language and Its Structure.* Harcourt, Brace, New York.

Lawrence, D. H.

1950 *Mornings in Mexico.* William Heinemann, London.

1955 *The Plumed Serpent.* Vintage Books, New York.

Leach, Edmund R.

1958 Magical Hair. *Journal of the Royal Anthropological Institute of Great Britain and Ireland* 88:147–164.

1961 Aesthetics. In *British Broadcasting Corporation Third programme (Radio Program), The Institutions of Primitive Society. A Series of Broadcast Talks by E. E. Evans-Pritchard and Others*, edited by E. E. Evans-Pritchard, pp. 25–38. Free Press, Glencoe, Illinois.

LeBlanc, Steven A.

1975 Micro-Seriation: A Method for Fine Chronologic Differentiation. *American Antiquity* 40:22–38.

Leicht, Hugo

1934 *Las Calles de Puebla.* Companía Editorial Continental, S.A., Barcelona, Spain.

Lennenberg, Eric H., and John M. Roberts

1956 *The Language of Experience: A Study in Methodology.* International Journal of American Linguistics Memoir No. 13. Indiana University Press, Bloomington.

Leon-Portilla, Miguel

1975 *Pre-Columbian Literatures of Mexico.* University of Oklahoma Press, Norman.

Levine, David M.

1975a FORTRAN IV Program. Department of Statistics, Bernard M. Baruch College, City University of New York, New York.

1975b A Monte Carlo Study of Kruskal's Variance-Based Measure of Stress. *Psychometrika* 43:307–315.

Lévi-Strauss, Claude

1963 *Structural Anthropology.* Translated by Claire Jacobson and Brooke Grundfest Schoepf. Basic Books, New York.

1964 *Tristes Tropiques.* 1st ed. Translated by John Russell. Atheneum, New York.

1970 *The Raw and the Cooked.* Translated by John Weightman and Doreene Weightman. Jonathan Cape, London.

1977 *Structural Anthropology 2.* Allen Lane, London.

Lévy-Bruhl, Lucien

1926 *How Natives Think.* Translated by L. A. Clare. Reprinted. Allen & Unwin, London. Originally published in 1910 as *Les Fonctions mentales dans les sociétés inférieures.* F. Alcan, Paris.

Linton, Ralph

1936 *The Study of Man: An Introduction.* D. Appleton-Century, New York.

1944 North American Cooking Pots. *American Antiquity* 9:369–380.

Lischka, Joseph J.

1975 The Broken K Revisited: A Short Discussion of Factor Analysis. *American Antiquity* 40:220–227.

Longacre, W.

1981 Kalinga Pottery: An Ethnoarchaeological Study. In *Patterns of the Past*, edited by I. Hodder, G. Isaac, and N. Hammond, pp. 49–66. Cambridge University Press, Cambridge.

Lounsbury, Floyd G.

1964 The Structural Analysis of Kinship Semantics. In *Proceedings of the Ninth International Congress of Linguistics*, edited by H. G. Lunt, pp. 1073–1093. Mouton, The Hague.

Lyons, John

1970a *New Horizons in Linguistics.* Penguin, London.

1970b *Noam Chomsky.* Viking Press, New York.

Managhau, John

1990 Sacrifice, Death, and the Origins of Agriculture within Codex Vienna. *American Antiquity* 55:291–307.

Marquina, Ignacio

1971 Introduction. La Pintura En Cholula. In *Cholula Ciudad Sagrada*, Pp. 5, 25–40. *Artes de Mexico* No. 140. Mexico D.F.

Matson, Frederick R.

1965 Ceramic Ecology: An Approach to the Study of Early Cultures of the Near East. In *Ceramics and Man*, edited by F. Matson, pp. 202–217. Viking Fund Publications in Anthropology, New York.

Meltzer, David J.

1980 Style and Function in a Class of Tools. Paper presented at the 45th Annual Meeting of the Society for American Archaeology, Philadelphia.

Mervis, C., and E. Rosch

1981 Categorization of Natural Objects. *Annual Review of Psychology* 32:89–115.

Miller, Daniel

1982 Structures and Strategies: An Aspect of the Relationship Between Social Hierarchy and Cultural Change. In *Structural and Symbolic Archaeology*, edited by I. Hodder, pp. 89–98. Cambridge University Press, Cambridge.

1985 *Artifacts as Categories: A Study of Ceramic Variability.* Cambridge University Press, Cambridge.

Miller, Daniel, and C. Tilley [editors]

1984 *Ideology, Power and Prehistory.* Cambridge University Press, Cambridge.

Miller, Virginia E.

1988 *The Role of Gender in Precolumbian Art and Architecture.* University Press of America, Lanham, Maryland.

Millon, Rene

1973 *The Teotihuacán Map, Part One: Text.* University of Texas Press, Austin.

1976 Social Relations in ancient Teotihuacán. In *The Valley of Mexico*, edited by E. R. Wolf, pp. 205–248. University of New Mexico Press, Albuquerque.

Mueller, James W.

1974 The Use of Sampling in Archaeological Survey. *American Antiquity* 39:II. SAA Memoirs No. 28. Society for American Archaeology, Washington, D.C.

Müller, Florencia

1971 El Arte Cerámico de Cholula. In *Cholula Ciudad Sagrada*, pp. 41–49. *Artes de Mexico* No. 140. Mexico D.F.

1978 *La Alfarería de Cholula.* SEP/INAH, Mexico D.F.

Müller, Florencia, and Barbara Hopkins

1977 *A Guide to Mexican Ceramics.* SEP, Mexico D.F.

Muller, Jon D.

1966 Archaeological Analysis of Art Styles. *Tennessee Archaeologist* 22:25–39.

1971 Style and Culture Contact. In *Man Across the Seas*, edited by C. Riley and J. G. Kelly, pp. 66–78. University of Texas Press, Austin.

1975 Generative Algorithms in Art. Paper presented at the 74th Annual Meeting of the American Anthropological Association, San Francisco.

1977 Individual Variations in Art Styles. In *The Individual in Prehistory*, edited by J. Hill and J. Gunn, pp. 23–29. Academic Press, New York.

1980　Structural Studies of Art Styles. In *The Visual Arts: Plastic and Graphic*, edited by Justine M. Cordwell, pp. 139–211. Mouton, The Hague.

Munn, Nancy

1962　Walbiri Graphic Signs: An Analysis. *American Anthropologist* 64:972–984.

1971　Visual Categories: An Approach to the Study of Representational Systems. In *Art and Aesthetics in Primitive Societies: A Critical Anthology*, edited by Carol Jopling, pp. 335–355. Dutton, New York.

1973　*Walbiri Iconography: Graphic Representation and Cultural Symbolism in a Central Australian Society*. Cornell University Press, Ithaca, New York.

1974　The Spatial Presentation of Cosmic Order in Walbiri Iconography. In *Primitive Art and Society*, edited by Anthony Forge, pp. 193–220. Oxford University Press, Oxford.

Narroll, Raoul

1956　A Preliminary Index of Social Development. *American Anthropologist* 58:687–715.

Neff, Hector, and Ronald L. Bishop

1988　Plumbate Origins and Development. *American Antiquity* 53:505–522.

Nelson, Ben A. [editor]

1985　*Decoding Prehistoric Ceramics*. Southern Illinois University Press, Carbondale.

Nicholson, Henry B.

1976　Preclassic Mesoamerican Iconography from the Perspective of the Postclassic: Problems in Interpretational Analysis. In *Origins of Religious Art and Iconography in Preclassic Mesoamerica*, edited by Henry B. Nicholson, pp. 157–176. Latin American Studies Series No. 31. University of California at Los Angeles, Latin American Center Publications, Los Angeles.

Nicholson, Henry B., with Thelma D. Sullivan

1988　*Smoke and Mist: Mesoamerican Studies in Memory of Thelma D. Sullivan*, edited by J. Kathryn Josserand and Karen Darkin. British Archeological Reports, International Series, vol. 402 (i–ii), Oxford University Press, Oxford.

Nutini, Hugo

1970　Labor Migration and Family Structure in the Puebla-Tlaxcala Area, Mexico. In *The Social Anthropology of Latin America*, edited by Walter Goldschmidt and Harry Hoijer, pp. 80–103. University of California, Los Angeles.

Otto, John Solomon

1980　Race and Class on Antebellum Plantations. In *Archaeological Perspectives on Ethnicity in America*, edited by Robert L. Schuyler, pp. 3–13. Baywood, Farmingdale, New York.

Pastron, Allen G.

1974　Preliminary Ethnoarchaeological Investigations Among the Tarahumara. In *Ethnoarchaeology*, edited by C. B. Donnan and C. W. Clewlow, Jr., pp. 93–114, Monograph No. 4. Archaeological Survey, Institute of Archaeology. University of California, Los Angeles.

Paul, Robert A.

1976　The Sherpa Temple as a Model of the Psyche. *American Ethnologist* 3:131–146.

Payne, William O.

1970　*A Potter's Analysis of the Pottery from Labityeco Tomb 2*. Boletín de Estudios Oaxacaenos No. 29, pp. 1–8. Museo Frissell de Arte Zapoteca, Mitla, Oaxaca, Mexico.

Paz, Octavio

1961　*The Labyrinth of Solitude, Life and Thought in Mexico*. Grove Press, New York.

Perlman, I., and F. Asaro

1969　Pottery Analysis by Neutron Activation. *Archaeometry* 2:21–52.

Piaget, Jean

1970　*Structuralism*. Edited and translated by Chaninah Maschler. Basic Books, New York.

Plog, Stephen

1976　Measurement of Prehistoric Interaction Between Communities. In *The Early Mesoamerican Village*, edited by K. Flannery, pp. 255–272. Academic Press, New York.

1978　Social Interaction and Stylistic Similarity: A Reanalysis. In *Advances in Archaeological Method and Theory*, vol. 1, edited by Michael B. Schiffer, pp. 143–182. Academic Press, New York.

1980　*Stylistic Variations in Prehistoric Ceramics: Design Analysis in the American Southwest*. Cambridge University Press, Cambridge.

1983　Analysis of Styles in Artifacts. *Annual Review of Anthropology* 12:125–142.

Postal, Paul M.

1972　The Best Theory. In *Goals in Linguistic Theory*, edited by Stanley Peters, pp. 131–176. Prentice Hall, Englewood Cliffs, New Jersey.

Read, Dwight

1974　Some Comments on Typologies in Archaeology and an Outline of a Methodology. *American Antiquity* 34:216–242.

Redfield, Robert

1941　*The Folk Culture of Yucatán*. The University of Chicago Press, Chicago.

1965　Culture Change in the Yucatán. In *Contemporary Cultures and Societies of Latin America*, edited by Dwight Heath and Richard N. Adams, pp. 17–29. Random House, New York.

Redfield, Robert, and Alfonso Villa Rojas

1934 *Chan Kom: A Maya Village.* Carnegie Institute of Washington Publication No. 448. Carnegie Institute, Washington, D.C.

Redmond, Elsa M.

1979 A Terminal Formative Ceramic Workshop in the Tehuacán Valley. *In Prehistoric Social, Political and Economic Development in the Area of Tehuacán Valley,* edited by Robert D. Drennan, pp. 111–127. Technical Report No. 11, Research Report No. 6, Museum of Anthropology, University of Michigan, Ann Arbor.

Reina, Ruben E., and Robert M. Hill II

1978 *The Traditional Pottery of Guatemala.* University of Texas Press, Austin.

Rendon, Silvia

1950 Modern Pottery of Riotenco San Lorenzo, Cuauhtitlan. *Middle American Research Records* 1(15):251–267. Middle American Research Institute, Tulane University, New Orleans.

Rice, Glen Eugene

1978 Ceramic Continuity and Change in the Valley of Guatemala: A Technological Analysis. In *The Ceramics of Kaminaljuyu,* edited by Ronald K. Wetherington, pp. 401–510. Pennsylvania State University Press, University Park.

Roberts, John M., Saburo Morita, and L. Keith Brown

1986 Personal Categories for Japanese Sacred Places and Gods: Views Elicited from a Conjugal Pair. *American Anthropologist* 88:807–824.

Roe, Peter G.

1974 *A Further Exploration of the Rowe Chavin Seriation and Its Implications for North Coast Chronology.* Studies in Pre-Columbian Art and Archaeology No. 13. Dumbarton Oaks Research Library and Collections, Washington, D.C.

1975 Comparing Panoan Art Styles Through Componential Analysis. Paper presented at the 74th Annual Meeting of the American Anthropological Association, San Francisco.

1976 Archaism, Form and Decoration: An Ethnographic and Archaeological Case Study from the Peruvian Montana. *Nawpa Pacha* 14:73–94, Plates XXVI–XXIX.

1978 Recent Discoveries in Chavin Art: Some Speculations on Methodology and Significance in the Analysis of a Figural Style. *El Dorado,* vol. III, No. 1, April.

1980 Art and Residence Among the Shipibo Indians: A Study in Microacculturation. *American Anthropologist* 82:42–71.

Romney, A. Kimball, R. N. Shepard, and Sara Beth Nerlove

1972 *Multidimensional Scaling: Theory and Applications in the Behavioral Sciences. Vol. II: Applications.* Seminar Press, New York.

Romney, A. Kimball, R. N. Shepard, Sara Beth Nerlove, and Roy Goodwin D'Andrade [editors]

1964 *Transcultural Studies in Cognition.* AAA Special Publication No. 66, No. 3., Part 2. American Anthropological Association, Washington, D.C.

Rosch, Eleanor H.

1973 On the Internal Structure of Perceptual and Semantic Categories. In *Cognitive Development and the Acquisition of Language,* edited by Timothy E. Moore, pp. 111–144. Academic Press, New York.

Rosch, Eleanor H., and Barbara Lloyd

1978 *Cognition and Categorization.* Erlbaum, Hillsdale, New Jersey.

Rosch, Eleanor H., and Carolyn Mervis

1975 Family Resemblances: Studies in the Internal Structure of Categories. *Cognitive Psychology* 7:573–605.

Ross, Marc Howard

1986 Female Political Participation: A Cross Cultural Explanation. *American Anthropologist* 88:843–858.

Rouse, Irving

1960 The Classification of Artifacts in Archaeology. *American Antiquity* 25:313–323.

Russell, Jeffrey

1968 *Medieval Civilization.* John Wiley & Sons, New York.

Sackett, James R.

1977 The Meaning of Style in Archaeology: A General Model. *American Antiquity* 42:369–380.

Sahagún, Fray Bernardino de

1959 *The Merchants.* Book 9, Part X. Edited by C. E. Dibble and A. J. O. Anderson. University of Utah Press, Salt Lake City.

1982 *Florentine Codex: General History of the Things of New Spain.* Edited by A. J. O. Anderson and C. E. Dibble. University of Utah Press, Salt Lake City.

Sanday, Peggy R.

1975 Review of *Multidimensional Scaling: Theory and Applications in the Behavioral Sciences. Vol. 5: Theory,* edited by Roger N. Shepard, A. Kimball Romney, and Sara Beth Nerlove. *American Anthropologist* 77:106–107.

Sayre, Edward U., Lui-Heung Chan, and Jeremy A. Sabloff

1971 High-Resolution Gamma Ray Spectroscopic Analyses of Mayan Fine Orange Pottery. In *Science and Archaeology,* edited by R. H. Brill, pp. 165–181. MIT Press, Cambridge, Massachusetts.

Sepúlveda, Maria Teresa

1973 El Barrio de los Olleros en Tixtla, Gro. *Instituto Nacional de Antropología e Historia, Boletín Época* 2(5):15–24.

Shankman, Paul

1969 Le Roti et Le Bouilli: Lévi-Strauss' Theory of Cannibalism. *American Anthropologist* 71:54–69.

Shapiro, G.

1984 Ceramic Vessels, Site Permanence, and Group Size: A Mississippian Example. *American Antiquity* 49:696–712.

Shepard, Anna O.

1956 *Ceramics for the Archaeologist.* Carnegie Institute Publication No. 609. Carnegie Institute, Washington, D.C.

1963 *Beginnings of Ceramic Industrialization: An Example from the Oaxaca Valley.* Notes from a Ceramic Laboratory No. 2. Carnegie Institute, Washington, D.C.

1971 Ceramic Analysis: The Interrelations of Methods; The Relations of Analysts and Archaeologists. In *Science and Archaeology*, edited by R. H. Brill, pp. 55–63. MIT Press, Cambridge, Massachusetts.

Shepard, Roger N.

1962a The Analysis of Proximities: Multidimensional Scaling with an Unknown Distance Function, I. *Psychometrika* 27:125–140.

1962b The Analysis of Proximities: Multidimensional Scaling with an Unknown Distance of Function, II. *Psychometrika* 27:219–246.

1974 Representation of Structure in Similarity Data: Problems and Prospects. *Psychometrika* 39:373–421.

Sierra, Justo

1969 *The Political Evolution of the Mexican People.* Translated by Charles Ramsdell. Notes and New Introduction by Edmundo O'Gorman. Prologue by Alfonso Reyes. Texas Pan American Series. University of Texas Press, Austin.

Smith, Cyril

1971 Science in the Service of History. In *Science and Archaeology*, edited by R. H. Brill, pp. 53–54. MIT Press, Cambridge, Massachusetts.

Smith, Marion F., Jr.

1979 Putting the "Pot" Back into "Potsherd": Vessel Form and Capacity from Archaeological Sherds. Paper presented at the Annual Meeting of the Archaeological Society of South Carolina, Columbia.

1983 *The Study of Ceramic Function from Artifact Size to Shape.* Ph.D. dissertation, University of Oregon. University Microfilms, Ann Arbor.

Smith, Michael E.

1987 The Expansion of the Aztec Empire: Alase Study in the Correlation of Diachronic Ardeano and Ethnohistorical Data. *American Antiquity* 52:37–54.

Sneath, Peter H. A., and Robert R. Sokal

1973 *Numerical Taxonomy: The Principles and Practice of Numerical Classification.* W. H. Freeman, San Francisco.

Spaulding, Albert C.

1953 Statistical Techniques for the Discovery of Artifact Types. *American Antiquity* 18:305–313.

1976 Multifactor Analysis of Association: An Application to Owasco Ceramics. In *Cultural Change and Continuity*, edited by C. E. Cleland, pp. 59–68. Academic Press, New York.

1982 Structure in Archeological Data: Nominal Variables. In *Essays in Archeological Typology*, edited by R. Whallon and J. Brown, pp. 1–20. Center for American Archeology Press, Evanston, Illinois.

Speth, John D., and Gregory A. Johnson

1976 Problems in the Use of Correlation for the Investigation of Tool Kits and Activity Areas. In *Cultural Change and Continuity*, edited by C. E. Cleland, pp. 35–57. Academic Press, New York.

Spielholtz, Gerald I., and Flora S. Kaplan

1980 The Problem with Lead in Mexican Folk Pottery. *Talanta* (International Journal of Analytical Chemistry) 27:997–1000.

Spores, Ronald

1984 *The Mixtecs in Ancient and Colonial Times.* University of Oklahoma Press, Norman.

Stanislawski, Michael B.

1978 If Pots Were Mortal. In *Explorations in Ethnoarchaeology*, edited by Richard A. Gould, pp. 201–227. University of New Mexico Press, Albuquerque.

Stanislawski, Michael B., and Barbara B. Stanislawski

1978 Hopi and Hopi-Tewa Ceramic Tradition Networks. In *Spatial Organization of Culture*, edited by Ian Hodder, pp. 61–76. University of Pittsburgh Press, Pittsburgh.

Stark, Barbara L.

1984 An Ethnoarchaeological Study of a Mexican Pottery Industry. *Journal of New World Archaeology* 6(2):4–14.

Stolmaker, Charlotte

1976 Examples of Stability and Change from Santa Maria Atzompa. *In Markets in Oaxaca*, edited by Scott Cook and Martin Diskin, pp. 189–207. University of Texas Press, Austin.

Stone, Doris, and Conchita Turnbull

1941 A Sula-Ulua Pottery Kiln. *American Antiquity* 7:39–47.

Sturtevant, William G.

1967 Seminole Men's Clothing. In *Essays on the Verbal and Visual Arts: Proceedings of the 1966 Annual Spring Meeting of the American Ethnological Society*, edited by June Helm, pp. 160–174. University of Washington Press, Seattle.

1968 Studies in Ethnoscience. In *Theory in Anthropology: A Sourcebook*, edited by Robert A. Manners and David Kaplan, pp. 475–500. Aldine, Chicago.

Tekiner, Roselle

1971 *The Panpipe As Indicator of Culture Contact; A Test of Tolstoy's Method in Long-Range Comparison*. Unpublished Ph.D. dissertation, The Graduate Center, City University of New York, New York.

Thompson, R. H.

1958 Modern Yucatán Maya Pottery Making. SAA Memoir, *American Antiquity* 15:II.

Tolstoy, Paul

1963 Cultural Parallels Between Southeast Asia and Mesoamerica in the Manufacture of Bark Cloth. *Transactions of the New York Academy of Sciences* Series II, 25:646–662. New York.

1966 Method in Long-Range Comparison. *36th Annual Congress of Americanists* 1:69–89. Seville.

1974 Mesoamerica. In *Prehispanic America*, edited by Shirley Gorenstein, Richard Forbis, Paul Tolstoy, Edward P. Lanning, pp. 29–64. St. Martin's Press, New York.

Turner, Victor W.

1967 *The Forest of Symbols: Aspects of Ndembu Ritual*. Cornell University Press, Ithaca, New York.

1969 *The Ritual Process: Structure and Anti-Structure*. Aldine, Chicago.

Tyler, Stephen A. [editor]

1969 *Cognitive Anthropology: Readings*. Holt, New York.

Tylor, Edward B.

1879 On the Game of Patolli in Ancient Mexico and Its Probable Asiatic Origin. *Journal of the Royal Anthropological Institute of Great Britain and Ireland* 8:116–129.

1889 On a Method of Investigating the Development of Institutions: Applied to Laws of Marriage and Descent. *Journal of the Royal Anthropological Institute of Great Britain and Ireland* 18:245–272.

Vaillant, G. C. [editor]

1940 *A Sacred Almanac of the Aztecs*. Limited edition. American Museum of Natural History, New York.

Van de Velde, Paul, and Henriette Romeike Van de Velde

1939 The Black Pottery of Coyotepec, Oaxaca, Mexico. *Southwest Museum Papers* 13:7–43.

Véytia, Mariano Fernandez de Echevarría y

1931 *La Historia de la Fundación de la Ciudad de Puebla de los Ángeles en Nueva España*. 2 vols. Imprenta Labor, Mixcoac, D.F.

Warren, Dennis M., and J. Kweku Andrews

1977 *An Ethnoscientific Approach to Akan Arts and Aesthetics*. Working Papers in the Traditional Arts No. 3. ISHI Press, Philadelphia.

Washburn, Dorothy K. [editor]

1983 *Structure and Cognition in Art*. Cambridge University Press, Cambridge.

Wertime, T. A.

1973 The Beginnings of Metallurgy: A New Look. *Science* 182:875–886.

Weymouth, John W.

1973 X-Ray Diffraction Analysis of Prehistoric Pottery. *American Antiquity* 38:339–344.

Whallon, Robert, Jr.

1972 A New Approach to Pottery Typology. *American Antiquity* 37:13–33.

Whallon, Robert, and James Brown [editors]

1982 *Essays in Archeological Typology*. Center for American Archeology Press, Evanston, Illinois.

Whitecotton, Joseph W.

1977 *The Zapotecs: Princes, Priests and Peasants*. University of Oklahoma Press, Norman.

Wierzbicka, A.

1984 Apples Are Not a "Kind of Fruit": The Semantics of Human Categorization. *American Ethnologist* 11:313–328.

Willey, Gordon R.

1962 The Early Great Styles and the Rise of the Pre-Columbian Civilizations. *American Anthropologist* 64:1–14.

Willey, Gordon R., and Phillip Phillips

1958 *Method and Theory in American Archaeology*. University of Chicago Press, Chicago.

Williams, Barbara J., and Carlos A. Ortíz-Solorio

1981 Middle American Folk Soil Taxonomy. *Annals of the Association of American Geographers* 71:335–358.

Winter, Marcus C.

1984 Exchange in Formative Highland Oaxaca. In *Trade and Exchange in Early Mesoamerica*, edited by Kenneth G. Hirth, pp. 179–214. University of New Mexico Press, Albuquerque.

Winter, Marcus C., and William O. Payne

1976 Hornos para Cerámica Hallados en Monte Alban. *Instituto Nacional de Antropología e Historia Boletín* 16 (época II):37–40.

Witherspoon, Gary

1977 *Language and Art in the Navajo Universe.* University of Michigan Press, Ann Arbor.

Wittgenstein, L.

1953 *Philosophical Investigations.* Macmillan, New York.

Wobst, H. M.

1977 Stylistic Behavior and Information Exchange. In *For the Director: Essays in Honor of James B. Griffin*, edited by C. Cleland, pp. 317–342. Anthropological Papers No. 61, Museum of Anthropology, University of Michigan, Ann Arbor.

Wolf, Alvin W.

1969 Social Structural Bases of Art. *Current Anthropology* 10:3–44.

Wolf, Eric R.

1959 *Sons of the Shaking Earth.* University of Chicago Press, Chicago.

1968 The Virgin of Guadalupe: A Mexican National Symbol. In *Readings in Anthropology*, vol. 2, edited by Morton Fried, pp. 34–39. Crowell, New York.

1969 Society and Symbols in Latin Europe and in the Islamic Near East. *Anthropological Quarterly* 42(3).

Wolf, Eric R. [editor]

1976 *The Valley of Mexico: Studies in Prehispanic Ecology and Society.* University of New Mexico Press, Albuquerque.

Yalman, Nur

1967 The Raw: The Cooked: Nature: Culture: Observations on Le Crut et le Cuit. In *The Structural Study of Myth and Totemism*, edited by Edmund Leach, pp. 71–89. ASA No. 5. Tavistock, London.

INDEX

Anthropologist Flora S. Kaplan is professor and director of the Museum Studies Program, Graduate School of Arts and Science, New York University. She received her doctorate from the Graduate Center of the City University of New York (CUNY). She has done fieldwork in Mexico, Nigeria, and the United States. From 1983 to 1985 Dr. Kaplan was a Fulbright professor at the University of Benin, where she taught and did research on royal women. She has published works about art and cognitive systems, graffiti, pottery, and museums. She taught anthropology at Herbert H. Lehman College, CUNY, before moving to New York University in 1976. A former curator of African, Oceanic, and New World Art at The Brooklyn Museum, Dr. Kaplan in her current teaching brings anthropological theory and method to the study of museums, exhibitions, and collections.